IMAGES
of America

SAUK RAPIDS AND
BENTON COUNTY

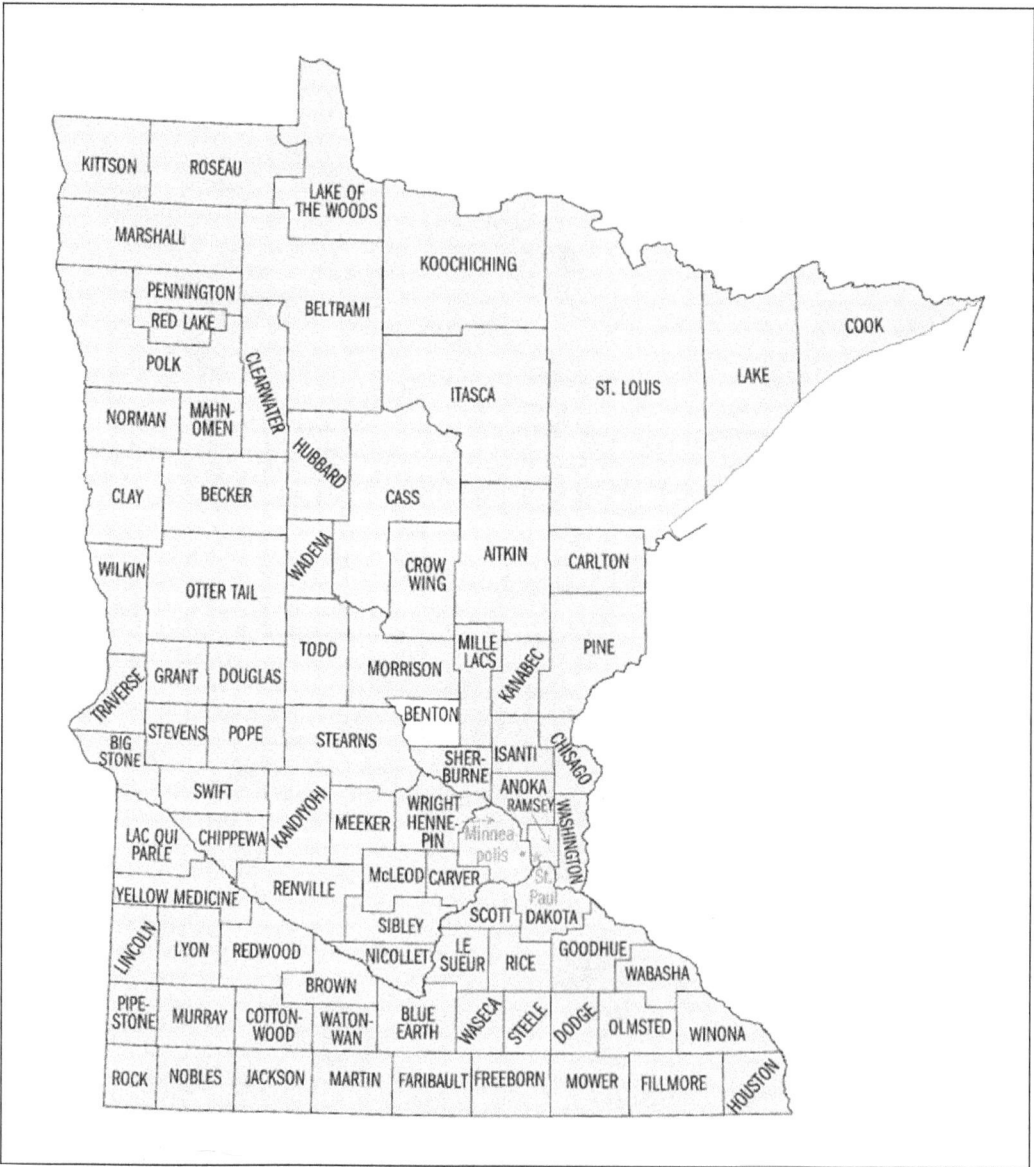

Benton County is located in the center of the state where it comprises 408 square miles. It was one of the first Minnesota counties established in 1849, and it was organized on January 7, 1850. The population has grown from 418 residents in 1850 to 34,226 today. There are 13,460 housing units in the county and the area is a center for education and retail. Benton County is one of the state's top areas for families, business and industries to live, work and prosper together.

IMAGES
of America

SAUK RAPIDS AND BENTON COUNTY

Ronald Christopher Zurek

ARCADIA
PUBLISHING

Published by Arcadia Publishing
Charleston, South Carolina

Library of Congress Catalog Card Number: 200202516

For all general information contact Arcadia Publishing at:
Telephone 843-853-2070
Fax 843-853-0044
E-mail sales@arcadiapublishing.com
For customer service and orders:
Toll-Free 1-888-313-2665

Visit us on the Internet at www.arcadiapublishing.com

For Julie,

Celebrating sixteen years of marriage in 2002,

"The most wonderful sixteen years of my life."

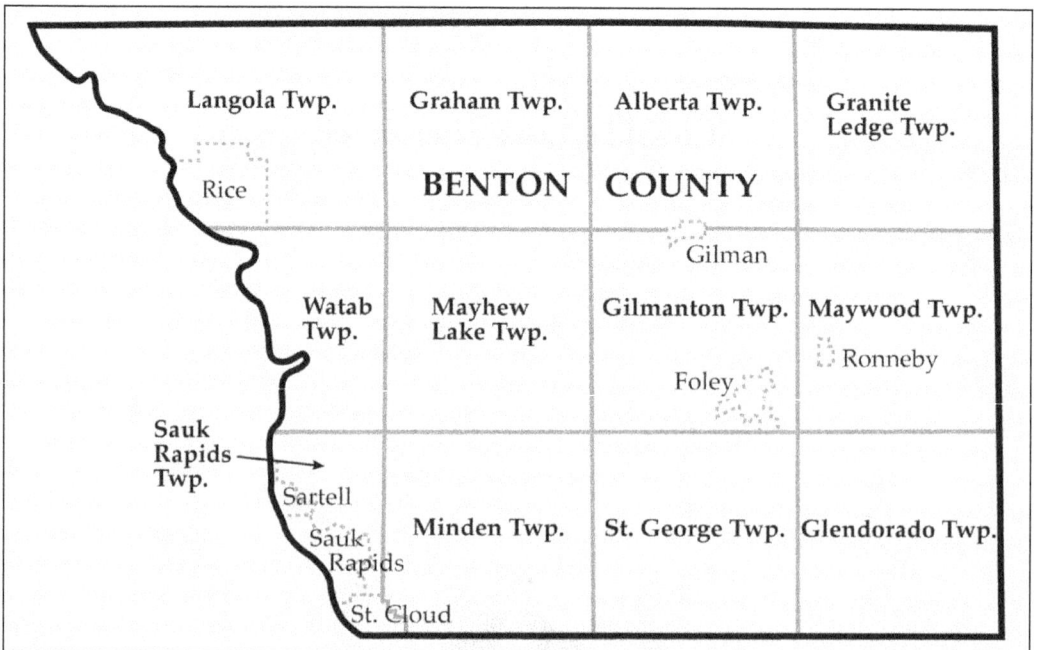

Benton County is divided into 12 townships. Two-thirds of the population of the county is in the western one-fourth of the county, which parallels the Mississippi River. In this area lie the cities of East St. Cloud, Sauk Rapids, Sartell, and the City of Rice. (Custom map by designmaps.com.)

CONTENTS

P E M B I N A

I T A S C A

M A H K A H T A

W A H N A H T A

D A H K O T A H

W A B A S H A W

BENTON

RAMSEY

WASHINGTON

WISCONSIN

I O W A

MINNESOTA
TERRITORY
showing the
ORIGINAL COUNTIES
1849-1851

SCALE OF MILES

6

INTRODUCTION

Minnesota became an independent territory in 1849, after which nine original counties were established—Benton, Dakotah, Itasca, Mahkahta, Pembina, Ramsey, Wabashaw, Wahnahta, and Washington. Seven other counties—Aitken, Anoka, Crow Wing, Isanti, Mille Lacs, Morrison, and Sherburne—were partly formed from the original Benton County land. Counties such as Cass, Itasca, Lake, Morrison, Pembina, St. Louis and Sherburne combined their records with Benton County before the start of their official records.

Benton County is named in honor of Senator Thomas Hart Benton of St. Louis, Missouri, a strong advocate of the free land laws that eventually led to the growth and development of the Minnesota country. Benton was born near Hillsboro, North Carolina, in 1782 and attended schools in that state. Later, he was admitted to the law school of William and Mary College in Williamsburg, Virginia. He passed the bar in Nashville, Tennessee, and started practice in Franklin, Tennessee. He died in 1858, and is buried at Bellefontaine Cemetery, St. Louis, Missouri.

In the center of the County is the city of Foley, the County Seat. The County's biggest city, Sauk Rapids, approximately 70 miles northwest of Minneapolis, is on the western edge and adjoins St. Cloud. It is more than five times as large as Foley, with over 10,000 residents, and its name refers to the Mississippi River rapids at the edge of downtown. Further north along the western border is Sartell, which is split by the River. About two-thirds of the town is in Stearns County on the west bank and the rest is on the eastern, or Benton County, side of the River with a little over 2,000 residents.

The two great Indian "families" of major importance in the history of the area are the Sioux (or Dakota) and the Chippewa (or Ojibwe). The first European visitors to the Minnesota territory, traders and explorers, found it controlled mainly by the Sioux. The "Spirit or Holy Lake," Mille Lacs, was long regarded as the focal point of the allied Dakota tribes. The Chippewa, being in the possession of firearms obtained from French traders, kept the Sioux under constant pressure to move throughout the 18th century. By 1785, after decades of warfare and a number of major battles, Minnesota was divided between the Chippewa in the forested canoe country of the north and the Sioux in the hills, valleys, and prairies of the south and the west.

The St. Paul and Pacific completed Minnesota's first railroad, reaching close to ten miles, between St. Paul and St. Anthony (now Minneapolis) in 1862. The railroad was reorganized under the leadership of James Jerome Hill in 1878, and eventually became the Great Northern in 1889. From the older centers in Minnesota, tracks reached out to the west, north, and south. The Northern Pacific, the first railroad to connect the state with Seattle, Washington, and the Pacific Coast, was completed under the guidance of Henry Villard in 1893. Several

railways connected with Chicago, while others reached out into the wheat lands of the Dakotas, Montana, and western Canada. And it was this network of Great Northern railways that connected Benton county to the world.

St. Cloud began as three separate settlements on the Mississippi River, which were founded by three extremely different men. A former slave owner, who was involved in the fur trade, brought slave-owning Southerners to the area and began one of the town sites. A professional town entrepreneur who attracted Protestants opposed to slavery began a second settlement. The third site was intended for a sawmill, which drew Catholics from Germany. In spite of the differences, the three settlements eventually merged into one city in 1856.

On April 14, 1886, a cyclone touched down in the late afternoon in St. Cloud and headed directly towards Sauk Rapids. When the cyclone paused at the Mississippi River it appeared to move slowly, as if trying to decide its next course of destruction. As it moved towards Sauk Rapids it crushed half of the wagon bridge spanning the river. Its next target was Stanton's large flouring mill, which was totally destroyed. It next took Demeule's store and the Northern Pacific depot before heading downtown, leaving only one building standing but heavily damaged—Wood's store. The courthouse, church, school house, post office, newspaper offices, hotels, and numerous homes all went down one by one, forty-nine in total. Streets were blocked with debris. Many died and hundreds were injured in this town of about 1,000, including many leaders and prominent citizens. After the cyclone devastated Sauk Rapids it moved north toward Rice, about thirteen miles away, which also sustained heavy damage.

During the early years, most of the population that inhabited Benton County was separated by their nationalities. For example, immigrants from Germany, Sweden, and Poland settled on the hill overlooking Sauk Rapids; while the English, Irish, and French Canadians resided in the valley. As time passed the distinct nationalities started to merge together as one. Some of their family histories are told in this book.

Early businesses and industries played a big part in the economic development of Benton County. The creamery cooperatives and the sawmills contributed to the growth of Benton County. As the hardwood forests were being depleted, granite deposits were discovered. Area granite companies began shipping granite to sites all over the world. Minnesota ranks as a leader in the production of granite. St. Cloud is the center of that industry and is known affectionately as "Granite City." Granite produced in the area can be found in monuments in Washington D.C.

I want to thank Connie Driscoll, Executive Director of the Benton County Historical Society and Museum, for her hospitality and generous assistance in my research. Also thanks to Fred Joesting, a retired teacher and museum volunteer, for his help in sorting material. Many photographs from their archives and some from the Joseph D. Kotsmith Foley Historical Collection are included in this book.

One

MILLE LACS BAND OF OJIBWE INDIANS (CHIPPEWA)

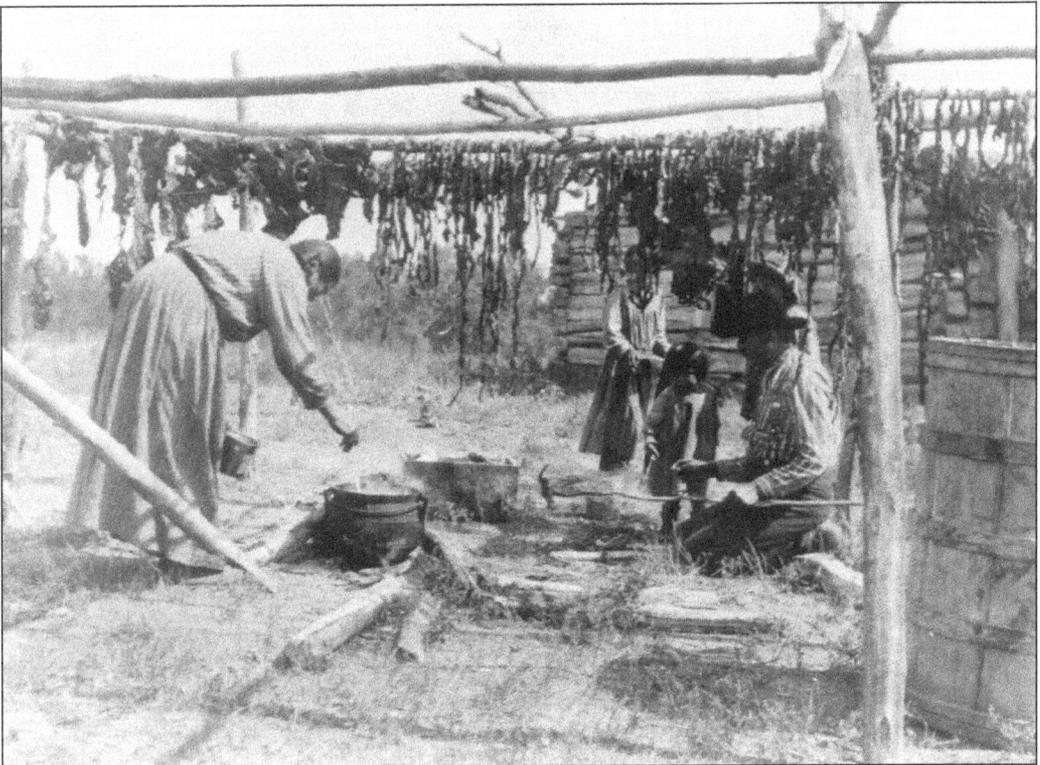

"Mille Lacs" (*pronounced 'mil 'laks*) is a French term used by early explorers and fur traders meaning "1,000 Lakes," and referred to this central Minnesota region. The Ojibwe people have been living in this area since 1400 A.D., 400 years before any Europeans settled the area. Indian menus included fish and meat, and what they could not eat fresh Chippewa women dried or smoked and kept it in store for the winter. (Courtesy of Minnesota Historical Society.)

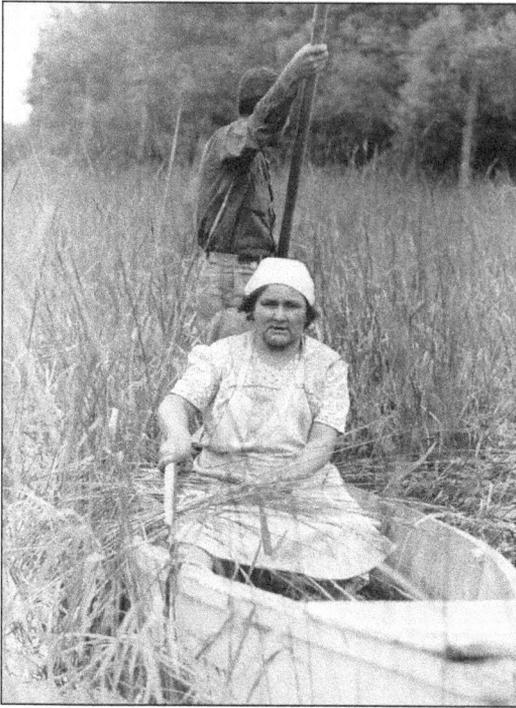

Since wild rice grows in water, the grain is harvested from canoes or other watercraft. The early Ojibwe pushed their canoes through the watery fields with long poles, because paddles would have bruised the plants. A second harvester in each canoe, usually a woman, bent the tall plants over with a long stick. With another stick she tapped the grain heads so that the ripe kernels rained out into the craft. (Courtesy of Monroe Killy photo, Minnesota Historical Society.)

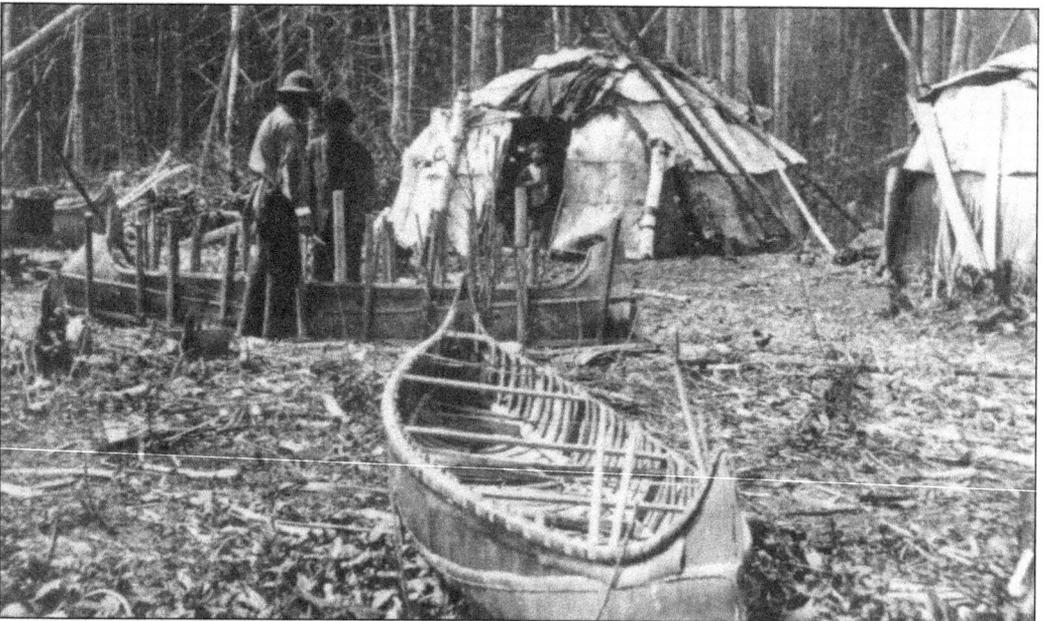

Birchbark canoes, used for traveling, gathering wild rice, and hunting, were still being made by some Chippewa in the early twentieth century. Woodwork for framing is most frequently made of white cedar. This is a lightweight and decay resistant wood that can be readily split to form gunwales, ribs, and internal sheathing. The sheathing is laid into place then the cedar ribs are cut to length and driven into place. This stretches the bark covering very tightly. The finished canoe is as solid as a completely wooden boat. (Courtesy of Charles A. Zimmerman photo, Minnesota Historical Society.)

Wild rice is gathered in September, before it ripens. Traditionally, it was cured to loosen the hulls. To do this the rice was dried in the sun on large sheets of bark then parched over a slow fire while being stirred with a wooden paddle. The man then pours the parched rice slowly into a large birchbark-winnowing tray, so the wind can carry away the hulls. (Courtesy of Gordon R. Sommers photo, Minnesota Historical Society.)

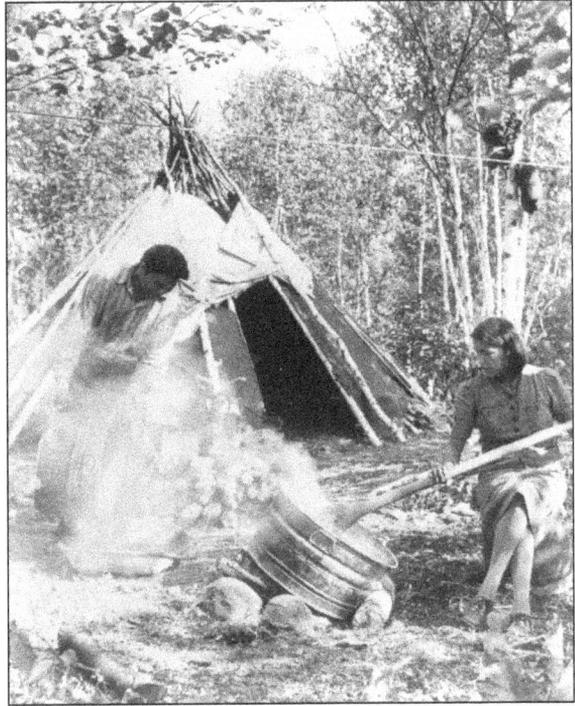

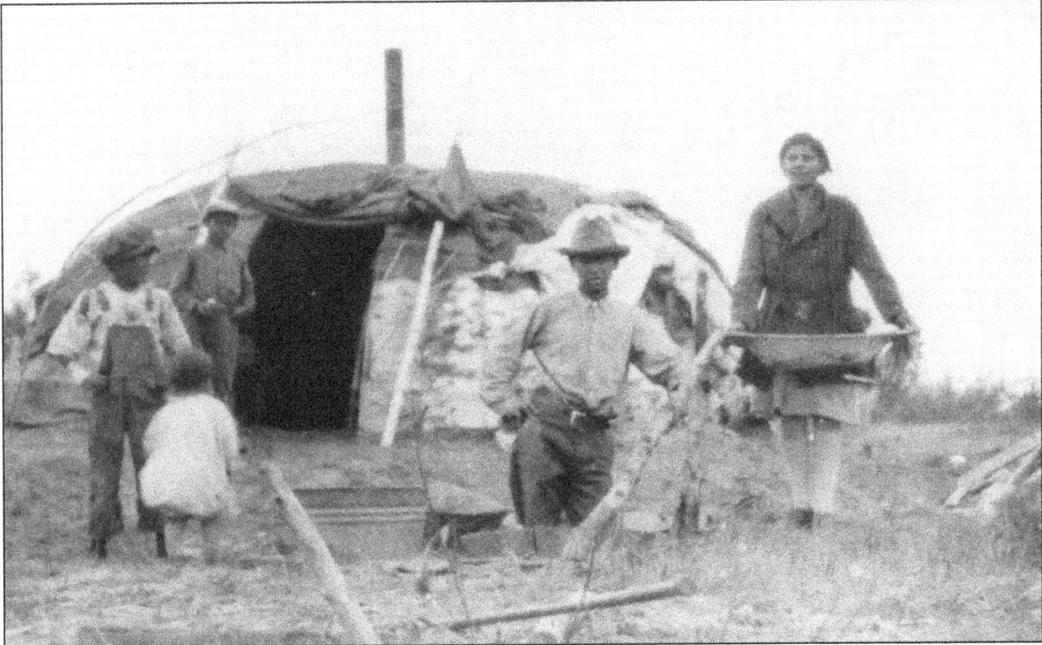

After the rice was parched over a slow fire to crack the hulls, it was poured into a shallow pit lined with tanned hide. A man wearing new moccasins then tramped the rice to knock the remaining hulls off. He held onto strong wooden supports so that the only part of his weight was on the grain. In the 1920s photo above, the grain is in a wooden tub. Note the wigwam in the background, which was dome-shaped, had an oval floor plan, and was occupied by one or two families. (Courtesy of Minnesota Historical Society.)

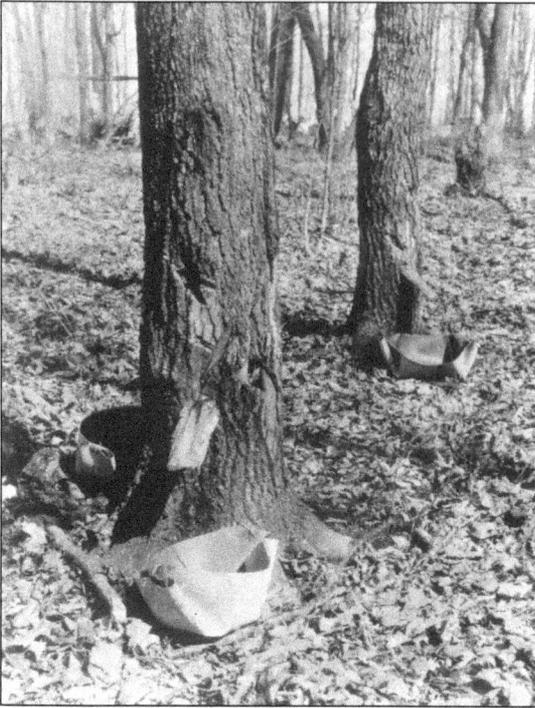

To tap the maple trees for their sweet sap, the men cut a 3 1/2-inch diagonal cut in the trunk of each tree, stuck a spout made from an elderberry branch into the slit, and placed a birchbark container known as a "makuk" under the spout to collect the sap. A single tap hole will produce 20–25 gallons of sap in a season, and because it is perishable must be used within 4–5 days of collection. When enough sap was collected, the Chippewa would start to boil it over a fire. (Courtesy of T.J. Horton photo, Minnesota Historical Society.)

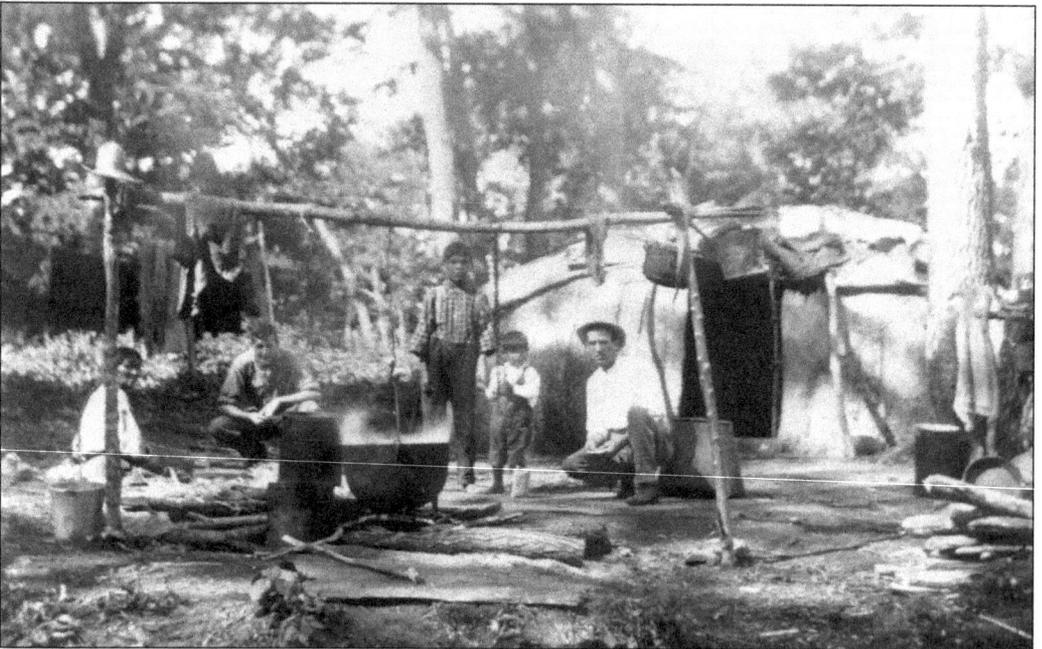

Most of the sap was boiled down to sugar in an iron kettle. The kettle was obtained by trading with the French voyageurs. It takes 30–40 gallons of average maple sap to boil down to 1 gallon of syrup. If the harvest was plentiful, children were given birchbark cones filled with maple syrup for them to eat. When the boiled sugar was about to granulate it was poured from a trough into makuks of birchbark. This was the basic seasoning eaten with grains, fish, fruits and vegetables, and with dried berries all year round. (Courtesy of Minnesota Historical Society)

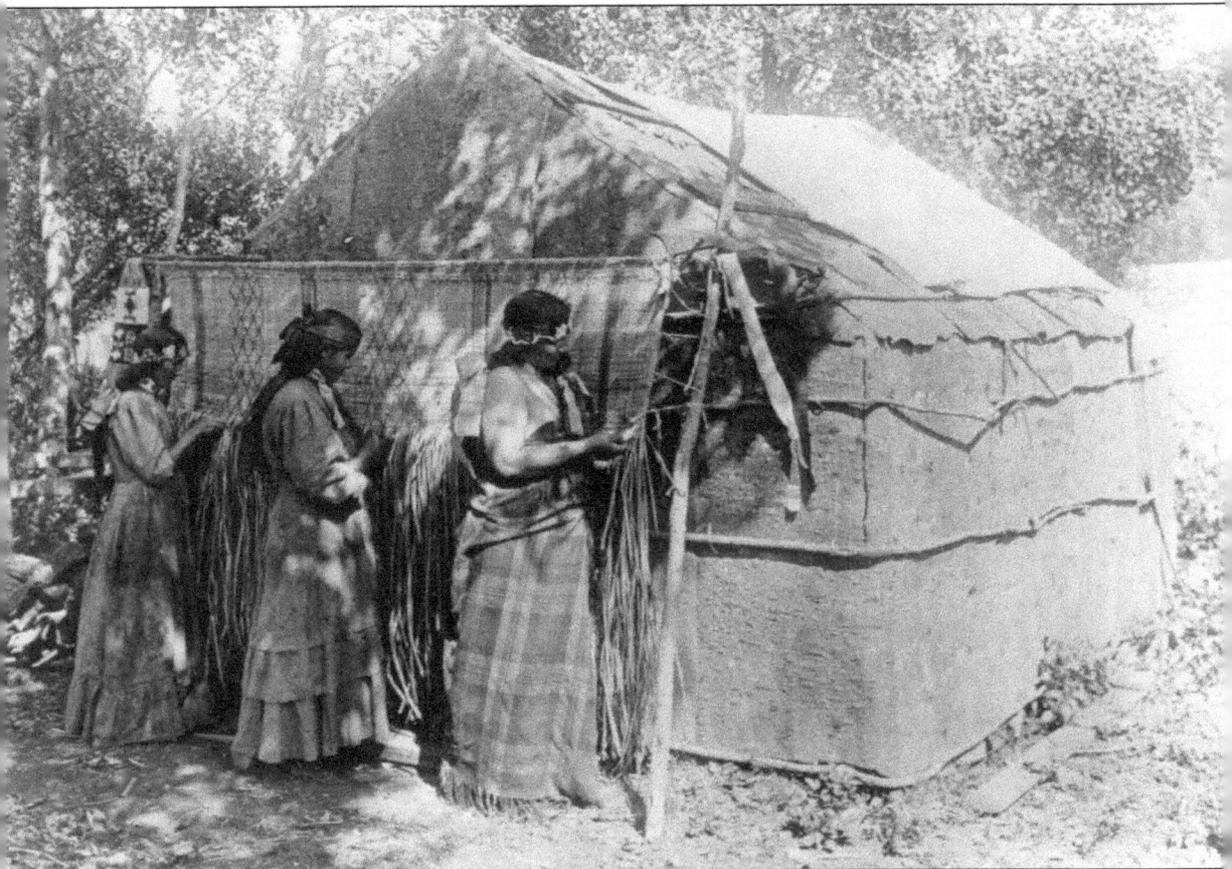

Chippewa women are shown weaving mats in the shade of a tree. Cattail reeds and basswood fibers served as the warp and woof. Weaving was usually done in the damp morning or evening air so that the rushes would not dry out. In addition to the woven reed mats, wigwams were covered in winter with a thick layer of dirt and sod, propped up against the sides and on top of the roof after the late fall rains stopped. (Courtesy of A.A. Richardson photo, Minnesota Historical Society.)

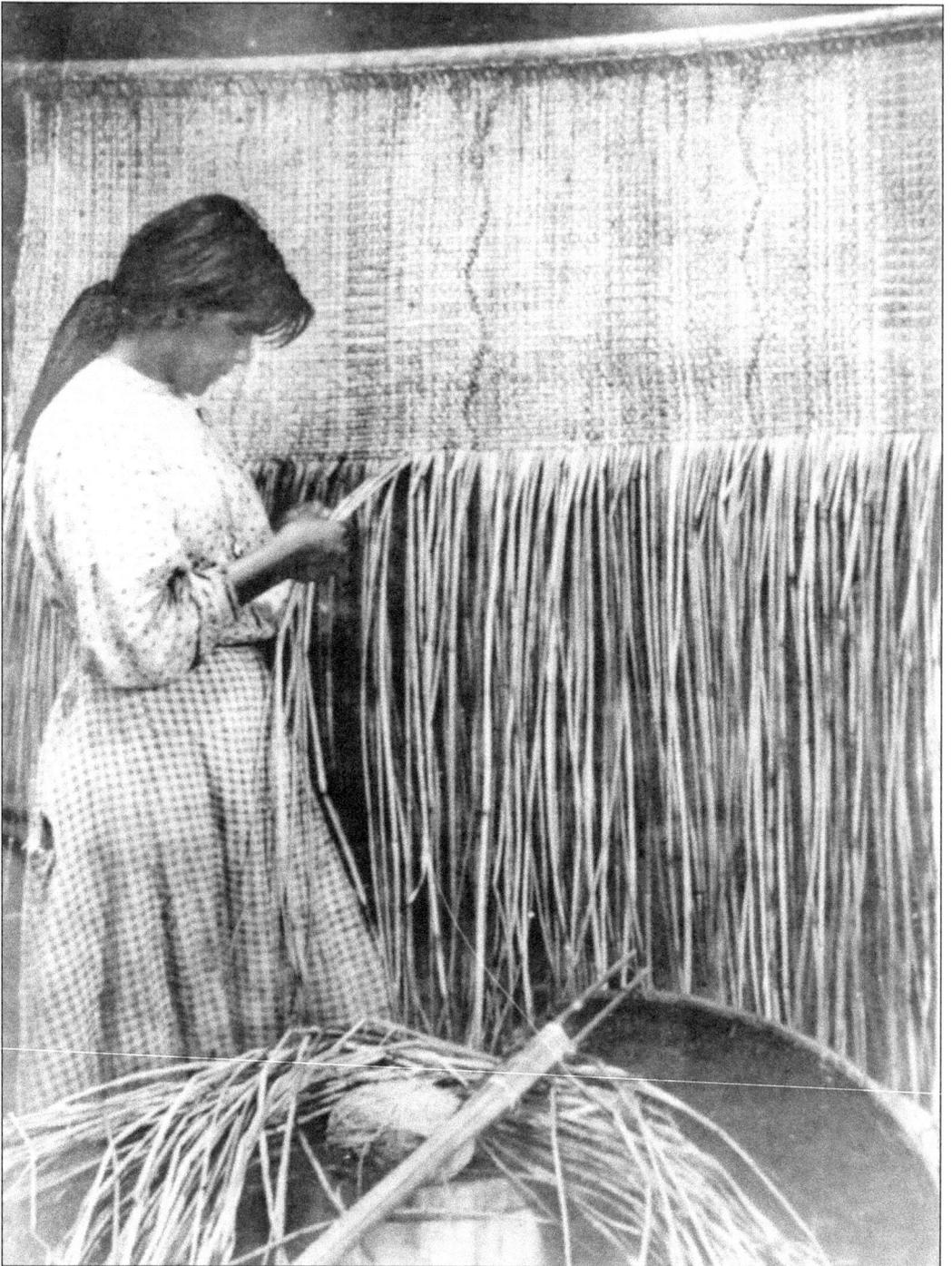

Ojibwe women wove mats, like this one, out of reeds gathered in marshes and strands of twine made from long strips of a white wood, probably basswood. The completed mats, which measured up to 60 feet long, were applied to the roofs and floors of wigwams. A double layer of reed mats was water-resistant and provided satisfactory protection from the rain and snow. (Courtesy of Minnesota Historical Society.)

14

Two

THE GREAT NORTHERN PACIFIC RAILROAD

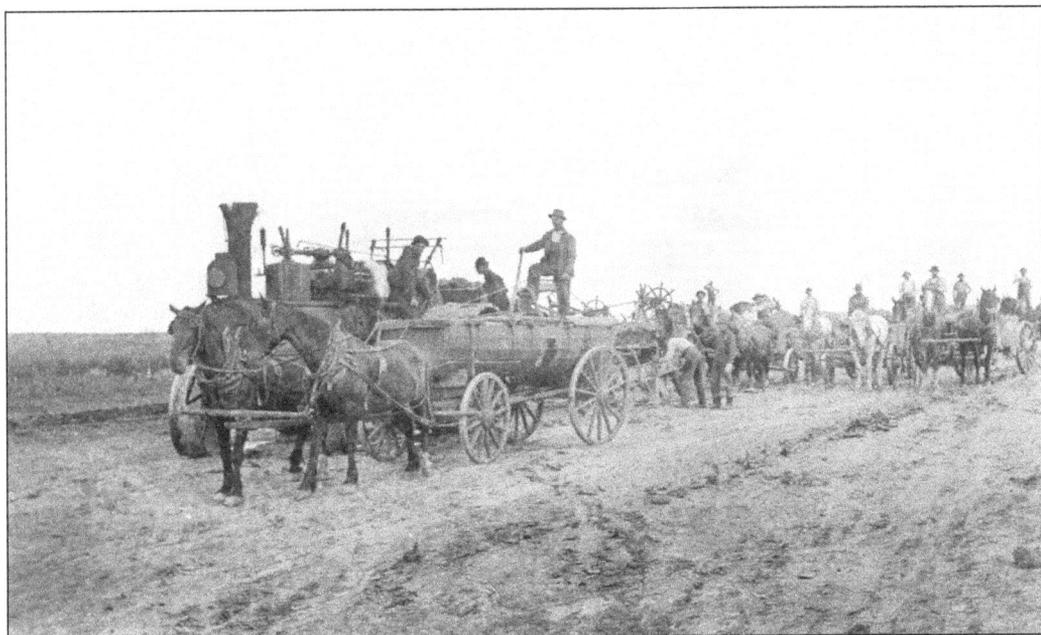

Previously, settlers used the rivers to get to their destinations. There were rough trails across the county, some in the wooded areas were "improved" with logs laid crosswise close together and covered with a layer of dirt. Slowly the trails were straightened and bettered until they were fairly adequate for most of the year. Then the railroad came. The railroad changed how the townspeople transported themselves and their goods.

Railroad camps such as these sprang up all over the county. Between 1866 and 1868, James Jerome Hill, a forwarding agent in St. Paul for the Mississippi River Steamboat Company, realized that railroads had the potential to become the chief form of transportation in the northwest. When the financial panic of 1873 hit the entire nation, the Northern Pacific went bankrupt and lost its rights to the St. Paul & Pacific, the predecessor to the Great Northern Railway.

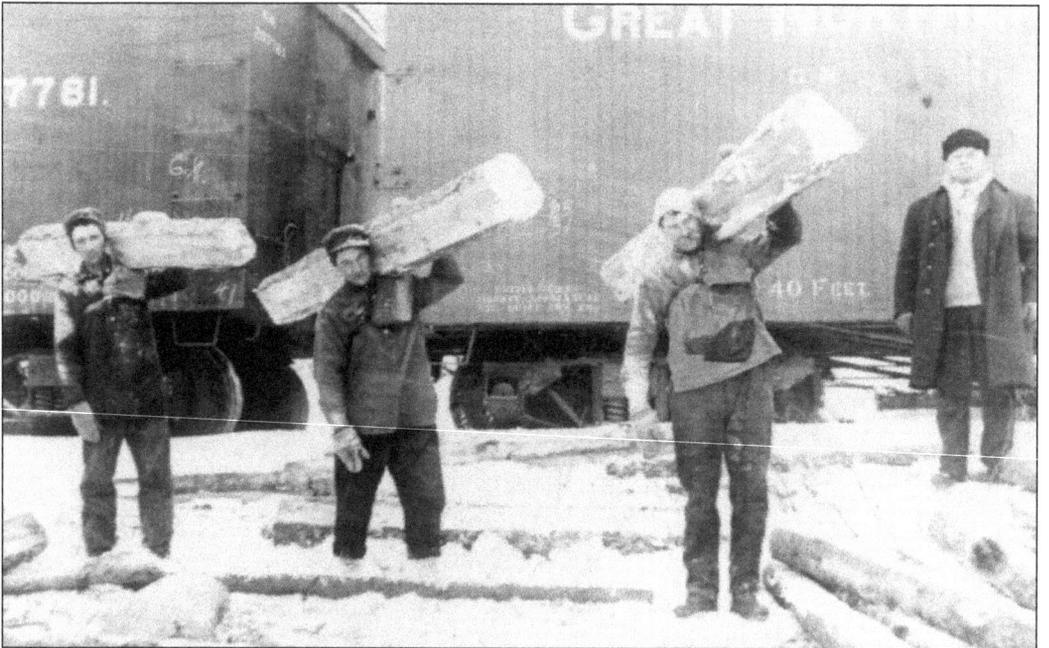

After the bankruptcy, James Hill formed a new company with several Minnesota businessmen and purchased the St. Paul & Pacific for 25¢ on the dollar. Later he bought rails, freight cars, locomotives, and hired laborers. He pushed the workers hard and they laid more than one mile of track daily. Hill encouraged settlement by letting immigrants travel halfway across the country on his railroad for $10 if they would settle along the route.

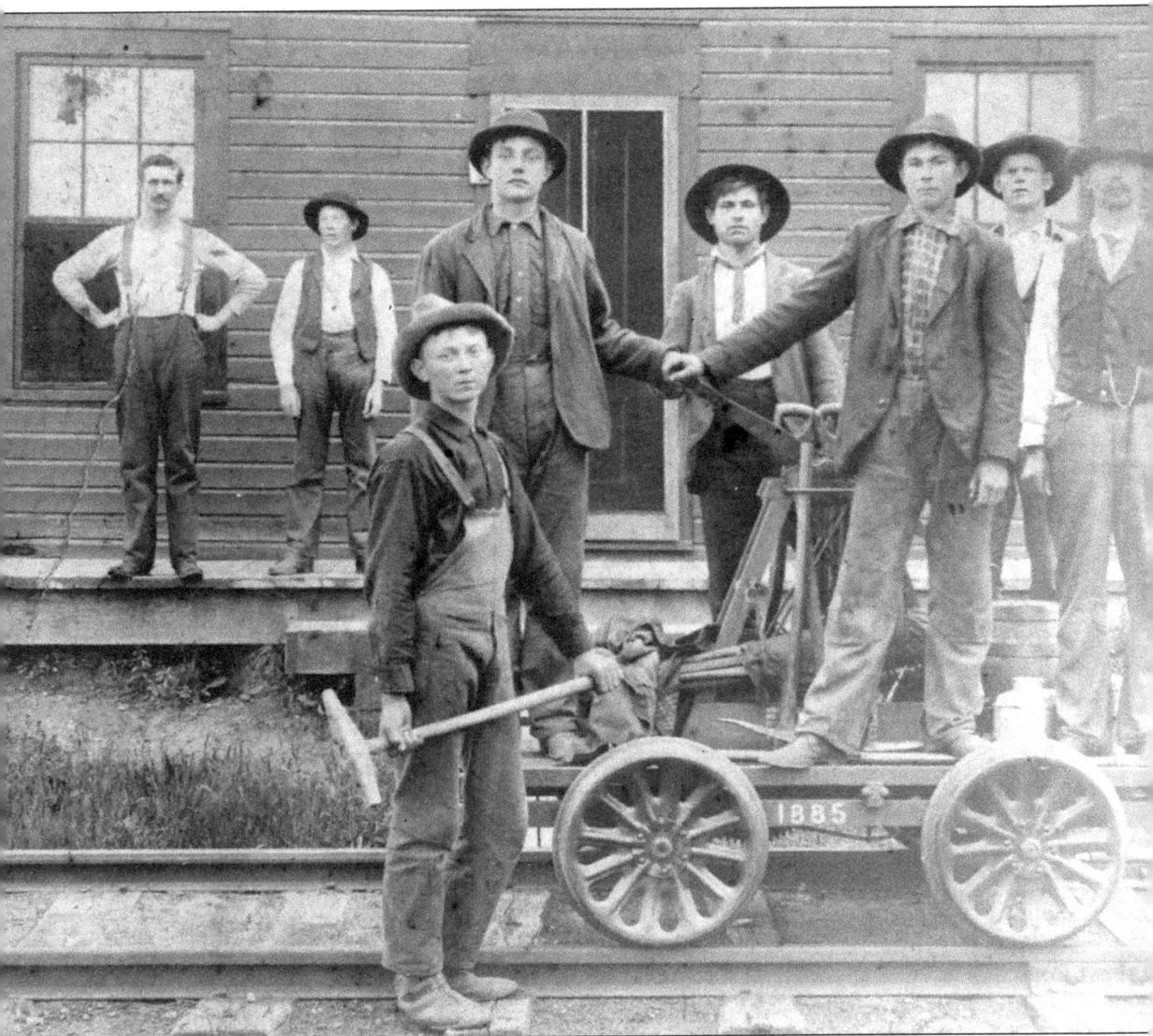

The railroad came to Foley on December 4, 1882, with Great Northern service from St. Cloud to Hinckley connecting the Duluth line to the east and St. Cloud line to the west. The above photo shows the Foley depot as it looked in 1912. The depot was a busy place in the early days as four freight trains and two passenger trains made runs each day. Two freight trains went east, two westbound, and the passenger train made an east and west run each day. Arrival times were always exciting, as mail was delivered and many people would go to the depot to meet friends and relatives or just to check out the activities. Freight trains were busy hauling merchandise for local stores. Shipments would be unloaded from the rail cars onto high wheel wagons. Jim Kotsmith is shown holding a sledgehammer in front of the handcar. The others pictured are unidentified.

James Hill was very successful in his business, but his accomplishments would not have been obtained without his construction crews. Gathering around a handcar, from left to right, are Jim Murray, Fred Youso, unidentified, Tony Albright, and Jim Murray's two children pictured in the rear. The others are unidentified.

In January of 1850, Sauk Rapids was the County Seat of Benton County. Sixteen years later the Seat was moved to Watab, though it returned back to Sauk Rapids in 1859. Eight years later, in 1867, the St. Paul and Pacific Railroad reached Sauk Rapids. This photo, taken at the turn of the century, shows unidentified men waiting patiently for the next inbound train loaded with passengers and goods for the merchants.

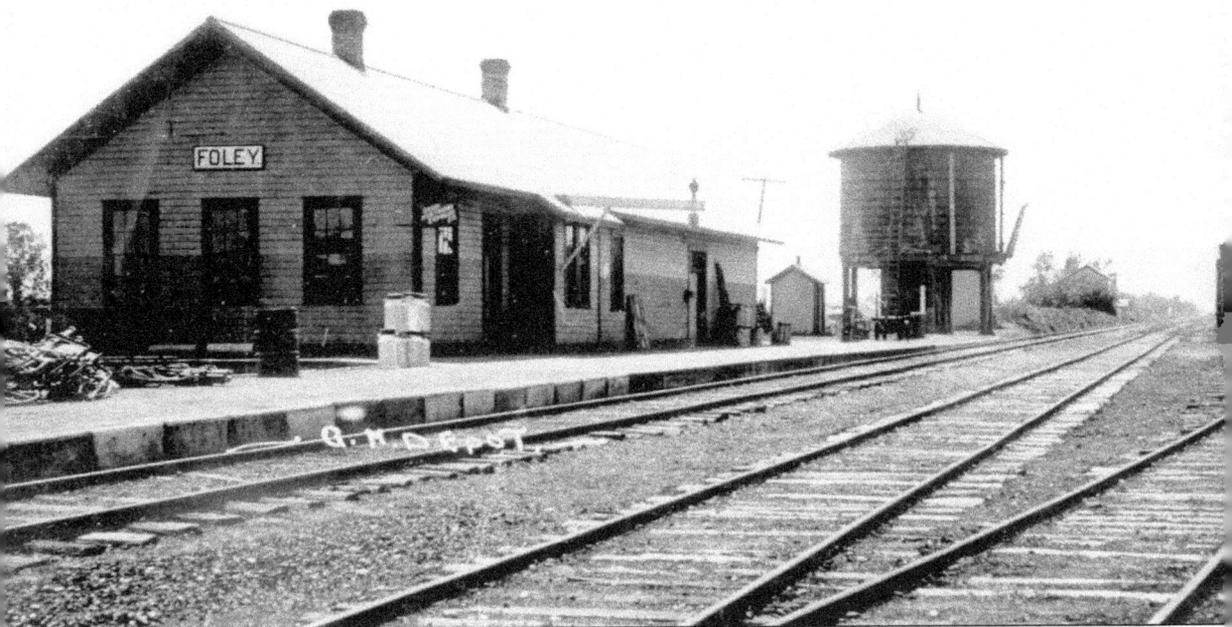

Rail clerks at the Great Northern Depot in Foley would check the merchandise and dray line operators would deliver the merchandise to the stores on wood wheel dray wagons. Bob Lloyd's City Dray was one of the oldest dray companies. Frank E. Henry Dray and Livery operated another. Leon Axtelle was another dray line operator for many years. Notice the cream cans in the foreground and the freight wagon near the water tower, an early Foley landmark for many years. The steam locomotives would fill their tanks at the tower. The small frame building was the water pump house. A gas engine was used to pump the water into the tank and a water gauge showed how much water was in the tank. The waterspout facing the tracks would be pulled down and filled the tanker of the locomotive. If you climbed the water tower using the stepladder you could see some of the buildings in St. Cloud on a clear day.

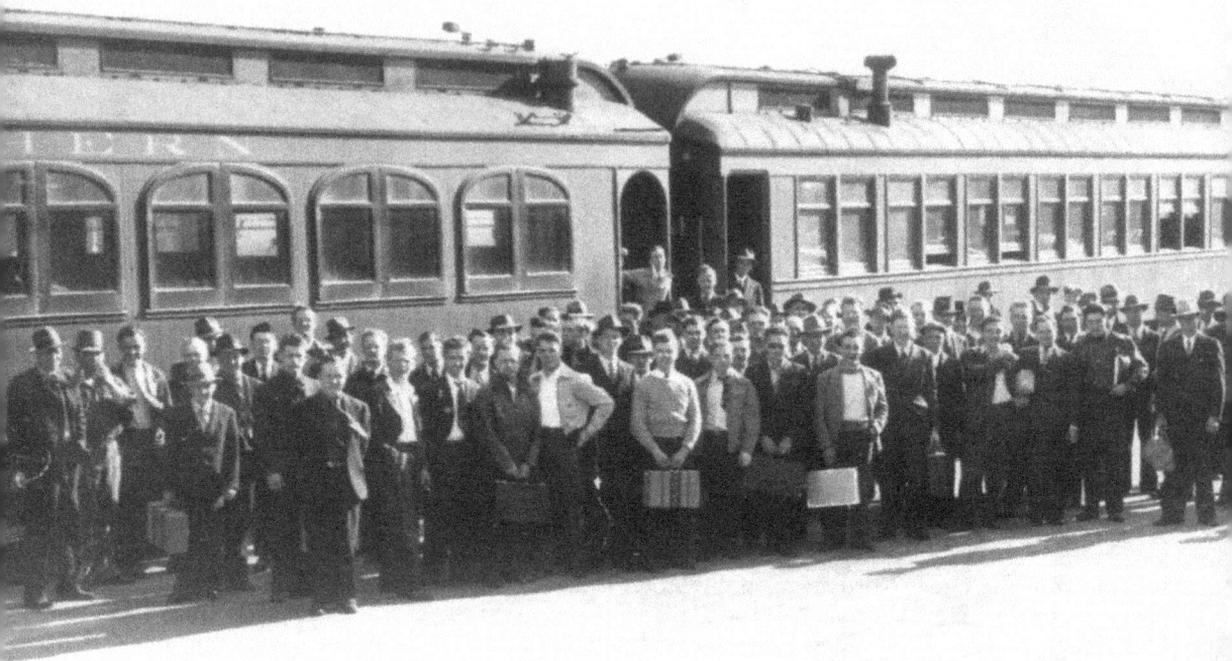

In January 1941, the Japanese fleet under Admiral Isoroku Yamamoto proposed an operation to destroy the U.S. fleet. The Pearl Harbor raid was only a part of planned operations to defeat British strongholds. Although there were signs of a possible Japanese action, no credence was placed in these rumors. Shortly after the bombing of Pearl Harbor, Hawaii, on December 7, 1941, the United States entered World War II. Young men were given a big send off when they left to serve their country. Here a troop train is seen boarding in 1942. Many were enlisted men that volunteered. Arthur A. Lewandowski fought in the Battle of Coral Sea, the first naval action fought entirely with aircraft. He served on the carrier *Lexington*. The United States shot down 43 Japanese planes and lost 33. Lewandowski was the first death reported from men in this area when the *Lexington* was sunk on May 8, 1942, when a motor overheated and ignited gasoline.

Three

SAUK RAPIDS
CYCLONE OF 1886

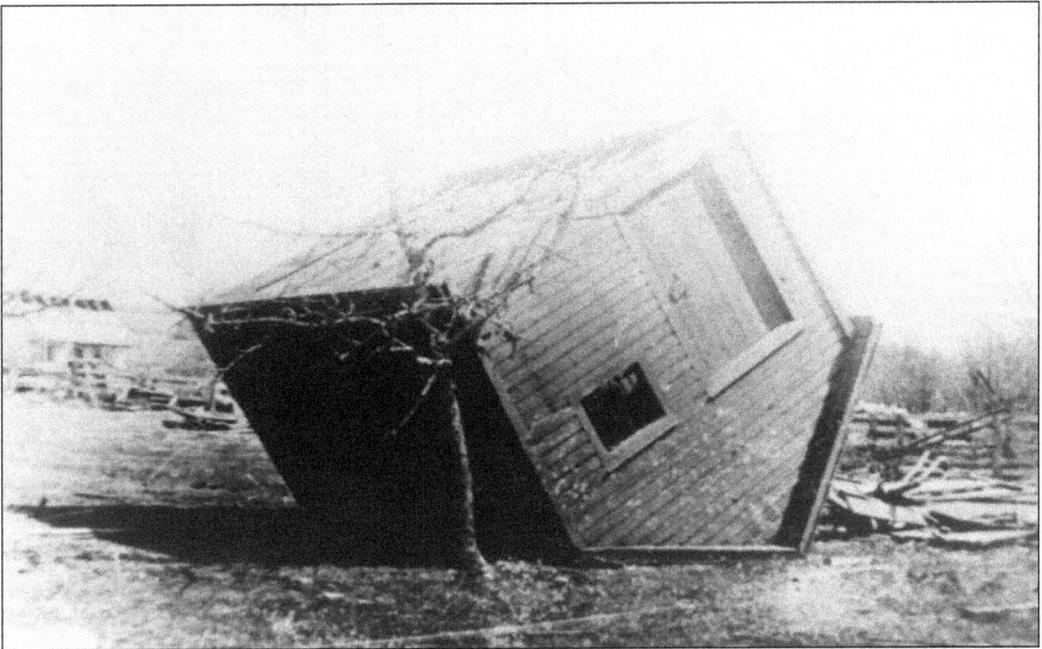

The cyclone began about 4:00 p.m. at the North Star Cemetery about one mile southwest of St. Cloud. As it crossed the Mississippi River destroying the bridge it headed to Sauk Rapids, where it did the most damage. It picked up this building and overturned it on its roof where it leaned against a single tree.

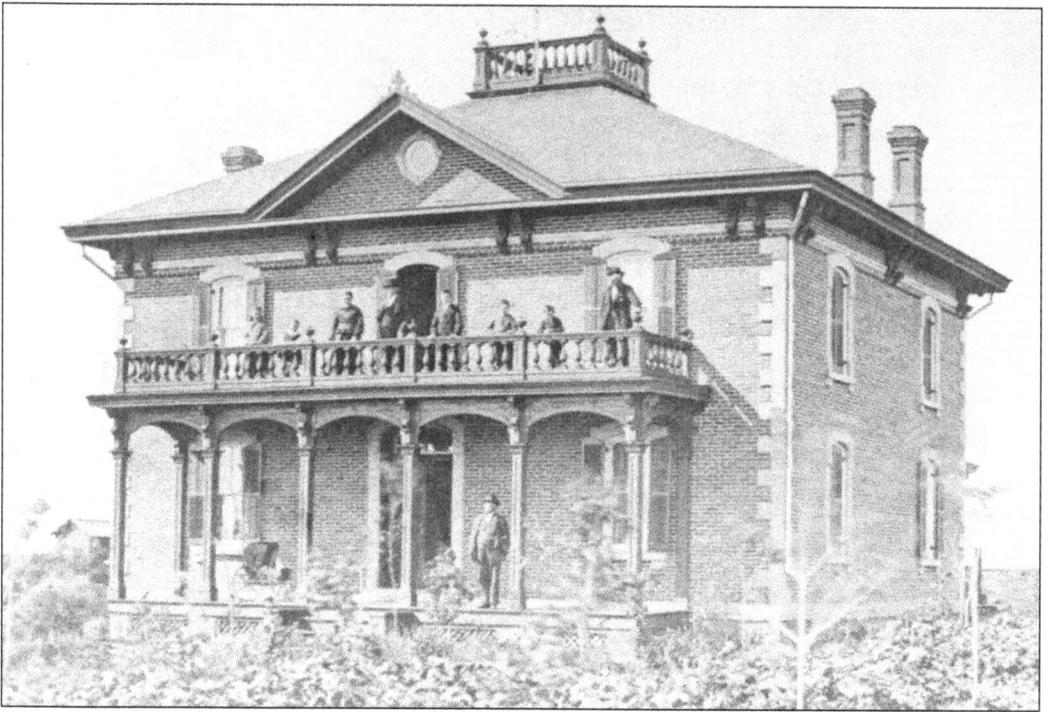

The cyclone came without warning. The air was filled with pieces of uprooted trees and wood from fences. John Schwartz's two-story brick dwelling house in St. Cloud was one of the first buildings hit by the cyclone, which was about 200 feet wide at the time.

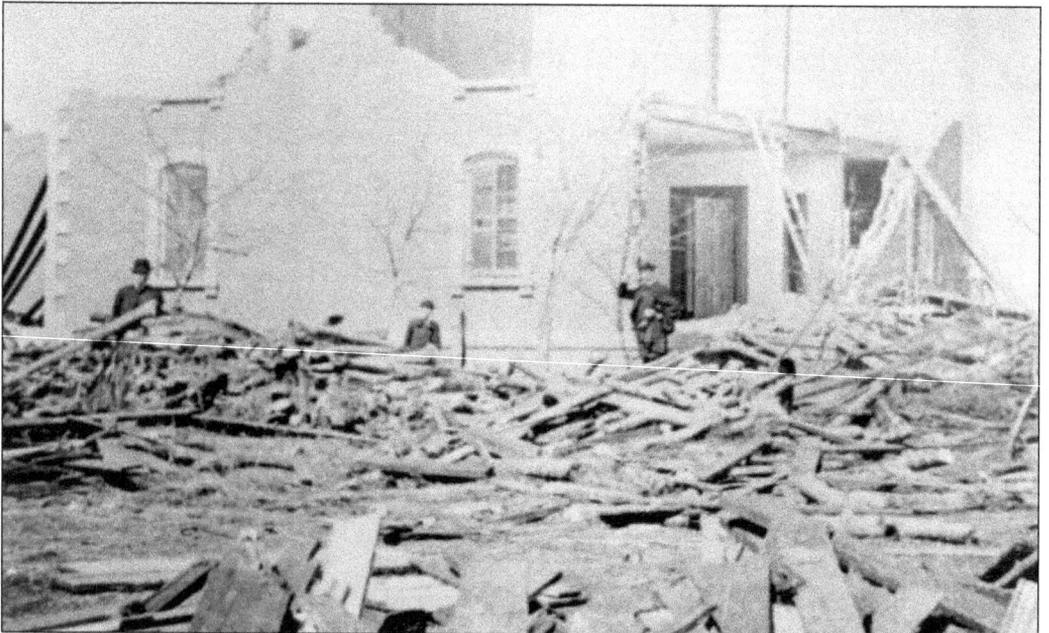

The home was crushed as people watched horrified. Room contents were seen as the cyclone tore off the front of the house. The sketch above from a postcard shows how it looked before the disaster; the photograph below shows the effects of the destruction.

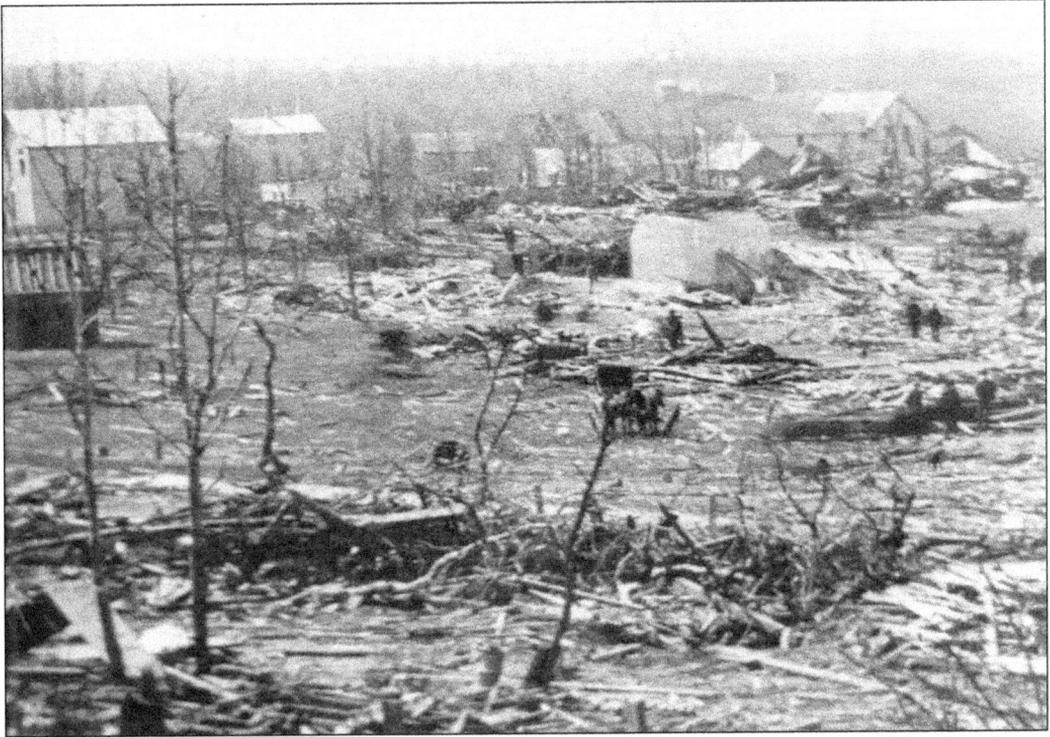

Streets were blocked with debris from the storm as to make them impassable. Residents that survived tried to salvage what they could to help rebuild their lives. In many instances, there was nothing left where a family's home once stood. Only the stories told of their terrifying experiences.

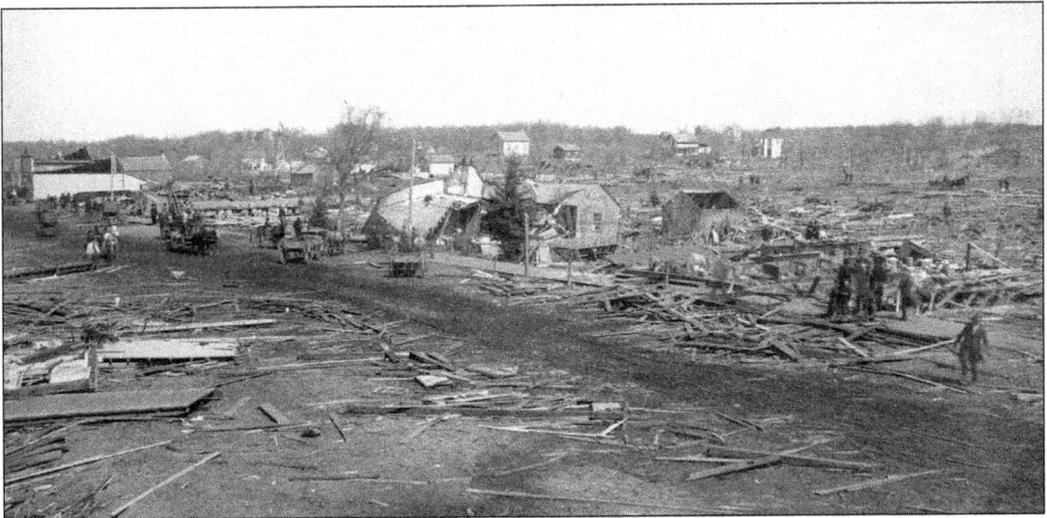

Private homes, hotels, schoolhouse, church, courthouse, post office, and newspaper office all disappeared as the storm came from the southwest. Some building were turned partly around, some fell from their foundations. The newspaper office in Sauk Rapids, which was painted a bright yellow, was lifted away in one piece never to be seen again.

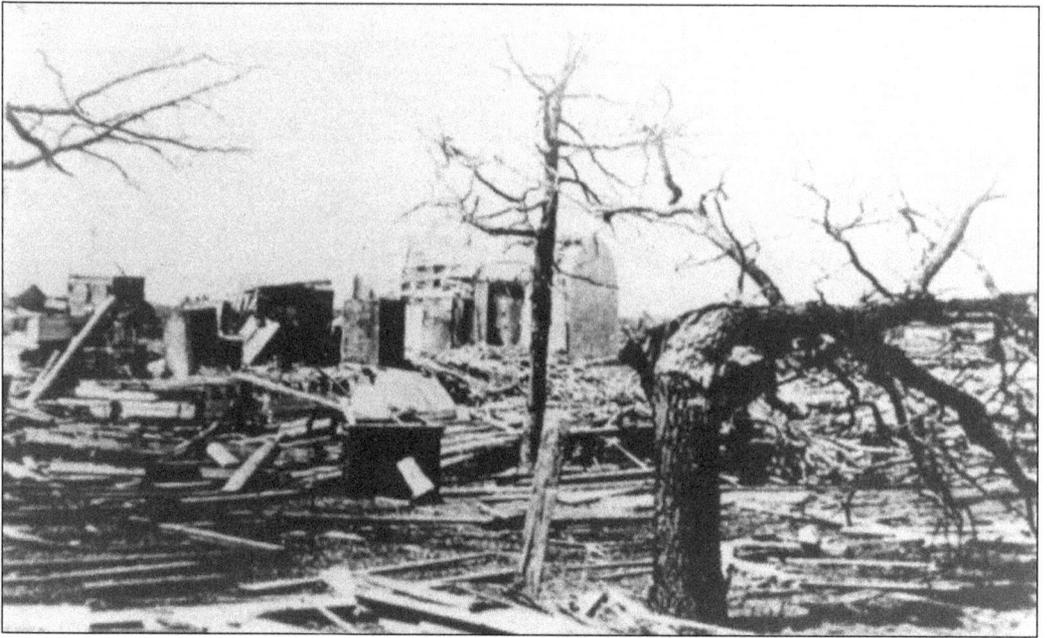

Benton County had seen windstorms in the past severe enough to overturn buildings and uproot trees, but nothing like this catastrophe. Trees were broken, twisted, and bent from the force of the relentless winds. Any leaves remaining on them before the cyclone were stripped from the branches.

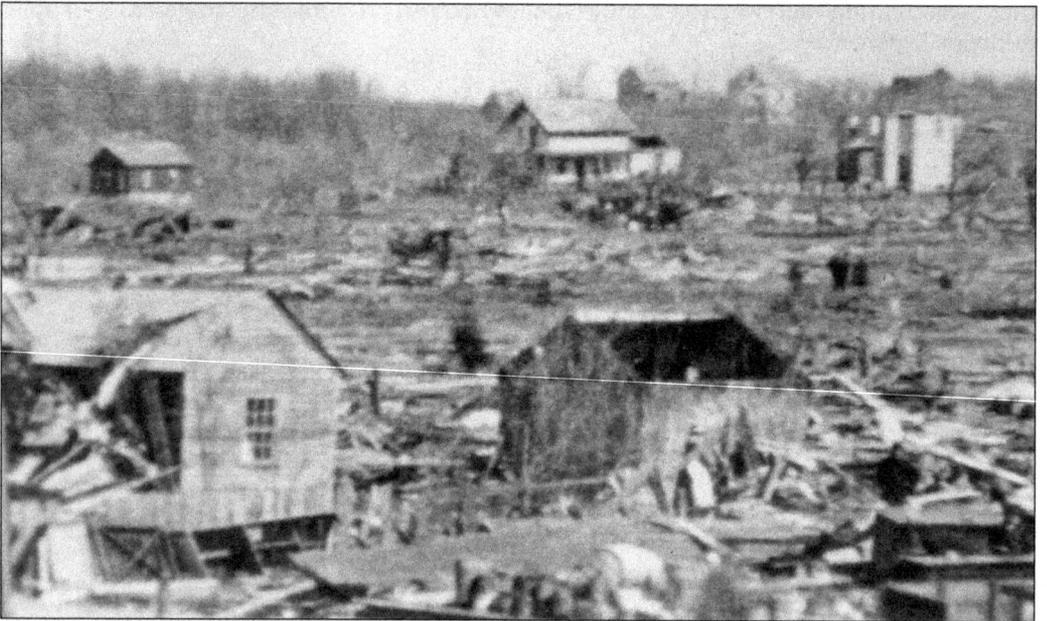

From a homeowner's upstairs window is a view of the residential area of Sauk Rapids. The ominous black cloud probably looked like the angel of death as it touched down with its mighty fury. Townspeople have nowhere to go; a businessman's daughter recalls the force of the wind as she clung with all her strength to a gate post, while the storm made its way through the area.

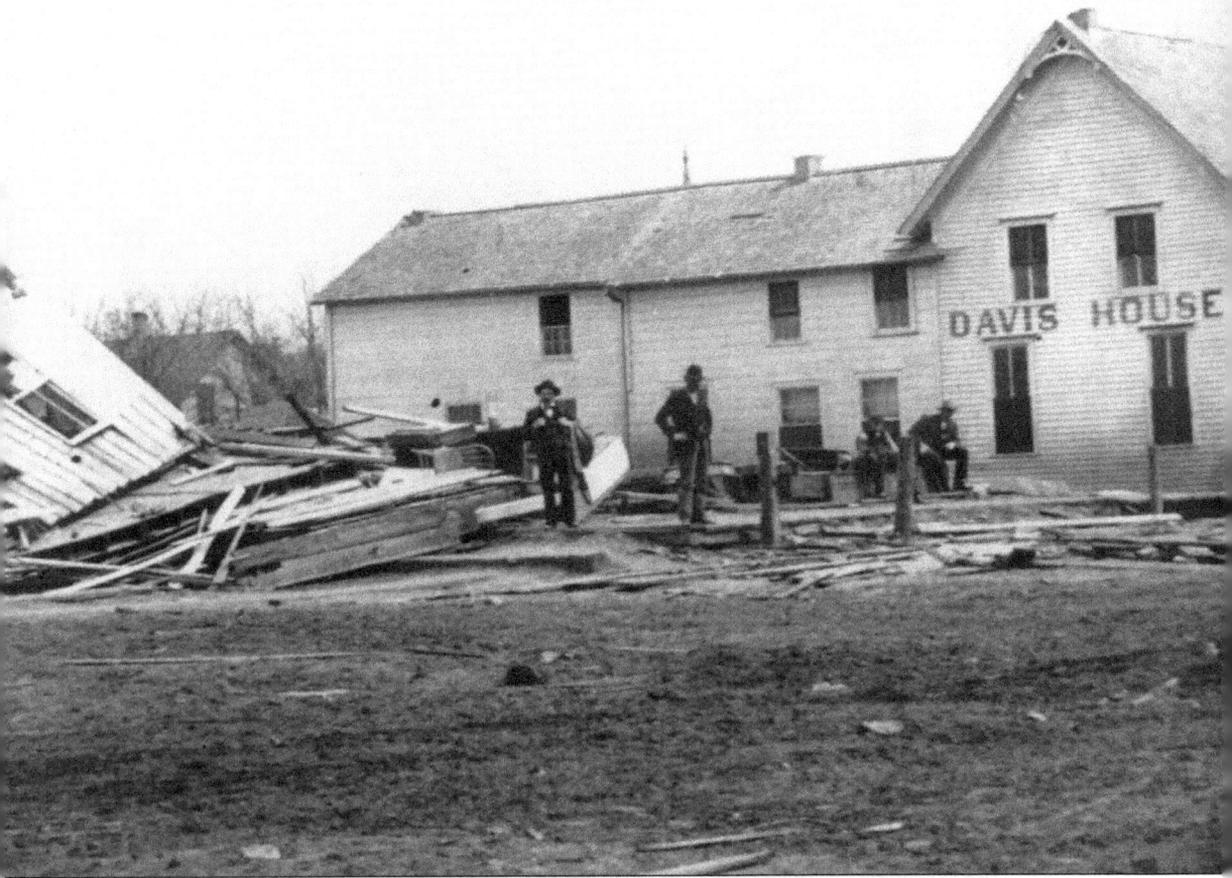

The building next to the Davis House in the background seemed to be selectively hit by the cyclone. A number of persons whose buildings were wrecked saved their lives by taking refuge in their cellars. In Sauk Rapids alone, 38 were known dead and 64 persons were seriously injured. Several hundred were wounded. The body of August Schuler was found about three miles from the village in the direction of Rice.

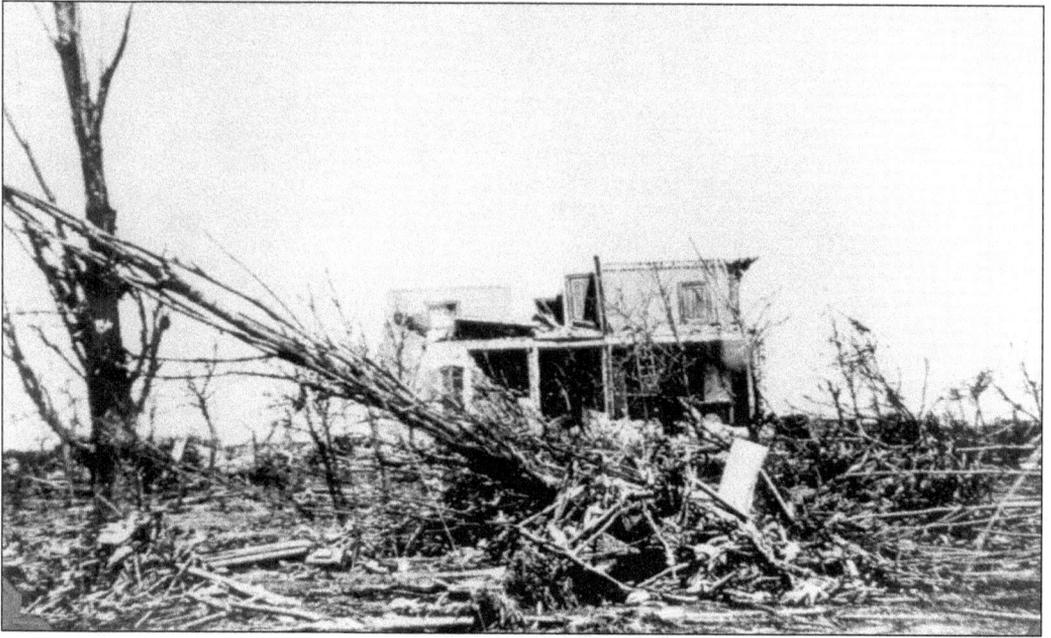

The remains of this building, once home to an early settler, is now destroyed. The number of new houses constructed after the cyclone were 66, costing $26,000; while the number repaired totaled 33, costing $4,000. Thirty-five homeowners bought material costing $11,000. Contributions were received from the surrounding cities and towns in Minnesota, including $560 from Chicago, $202 from New York, $200 from Indianapolis, and $25 from Boston. The largest individual contribution was from railroader James J. Hill at $5,000.

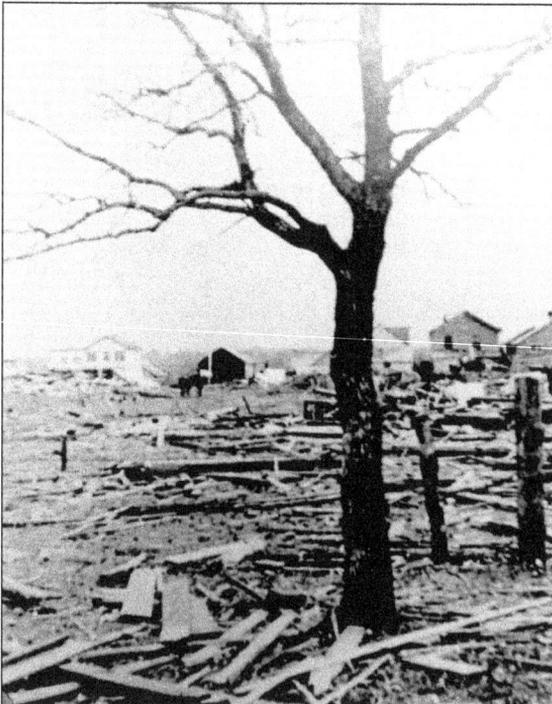

Resident A.E. Schueber, a druggist in the town, was found dead at the foot of this tree. Thomas Van Etten of Sauk Rapids, who reportedly weighed 300 pounds, was picked up and carried by the cyclone several hundred feet, splattered with mud, then released with only a few bruises from flying debris. Three days after the cyclone a man found the three-year-old son of Frank Zing, still alive in the brush.

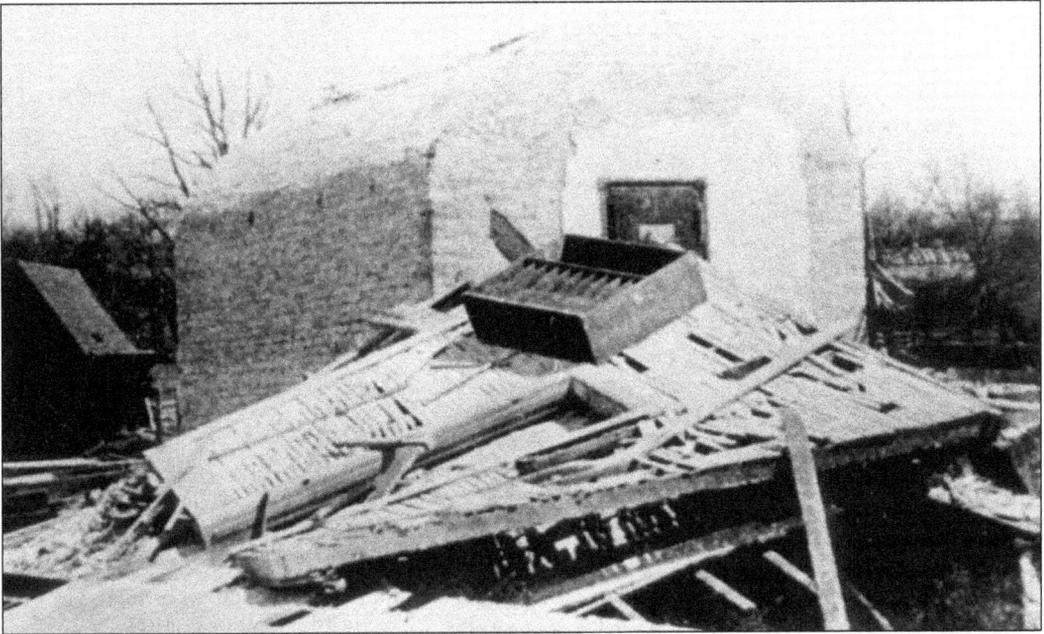

This photo shows damage to the Courthouse vault and jail in the background. The vault, weighing more than 2,000 pounds, was picked up and dropped across the street. The Sauk Rapids Depot sign was found near Rice Station, over 10 miles away. Nearby was a piece of heavy oak lumber about 15 feet long and 12 inches in diameter that earlier was on a freight car at the Manitoba yards in St. Cloud.

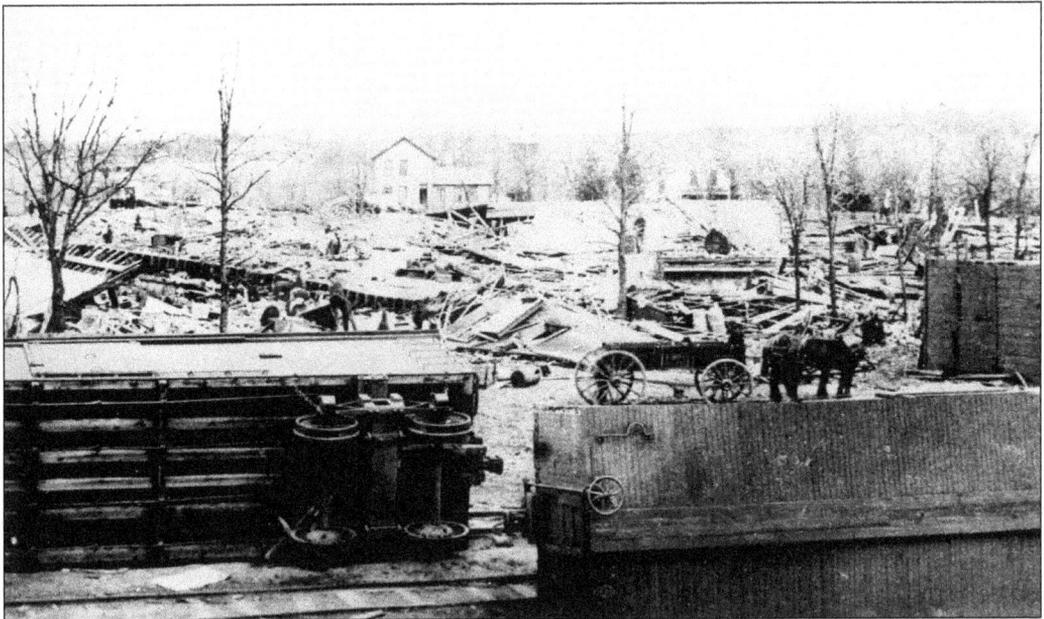

The survivors were rescued from what had been their homes. Viewing Sauk Rapids from the west, wagons converted into ambulances are seen taking the injured to the hospital or the dead to where the bodies were being gathered. The faces of the dead were so covered with blood and dirt as to be hardly recognizable.

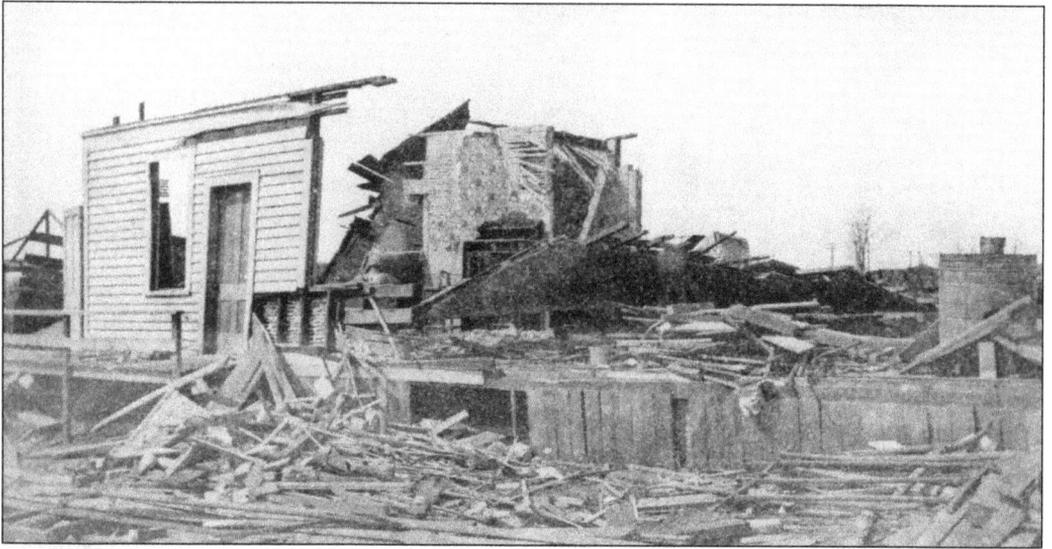

All that is left standing of this residence is part of a wall and fireplace. Families were torn apart as was this home in Sauk Rapids. A general committee composed of A. Barto of Sauk Centre, O.C. Merriman of Minneapolis, Channing Seabury of St. Paul, John Cooper of St. Cloud, and C.B. Buckman of Sauk Rapids was appointed to oversee building construction and repair.

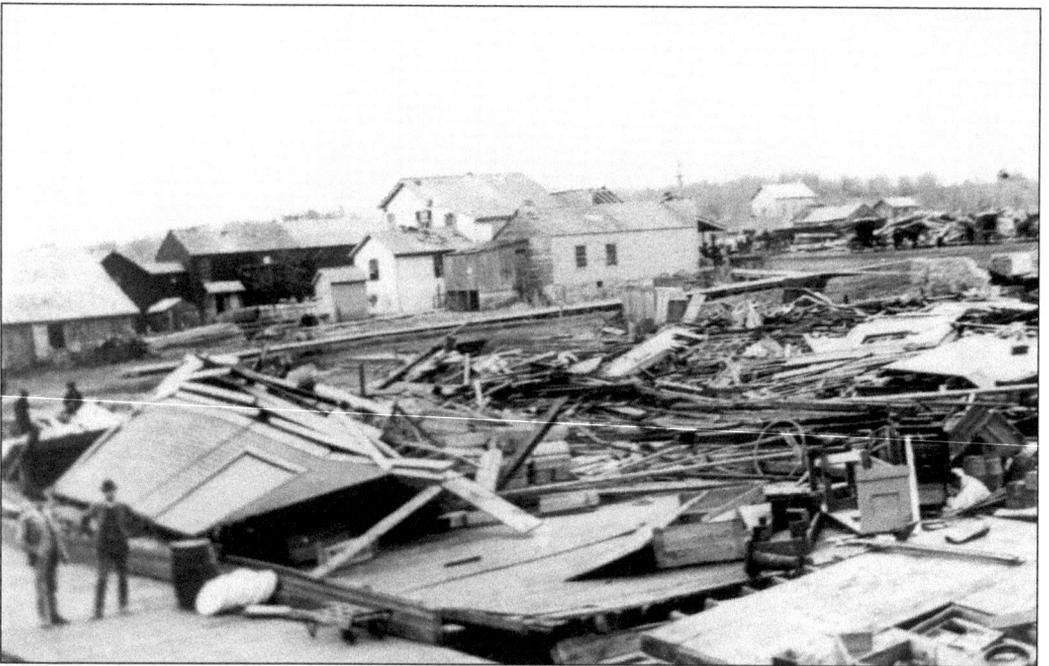

Residents were in shock as they surveyed the ruins in Sauk Rapids. Some hardly knew where to begin with the seemingly insurmountable task of rebuilding their town. Relief came in from surrounding communities. A special train from St. Paul brought a number of doctors and surgeons and another train brought help from communities between St. Cloud and Fergus Falls.

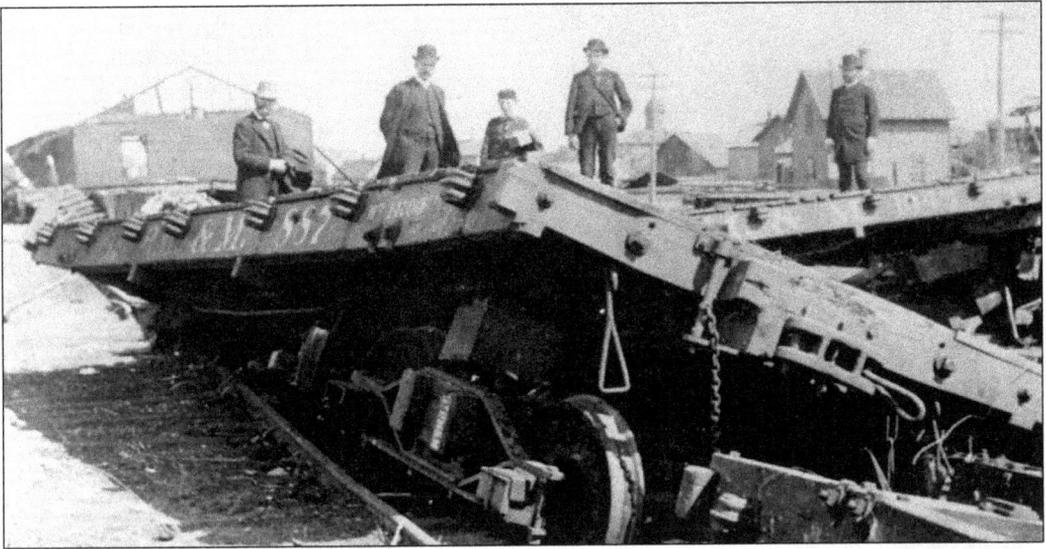

The St. Paul, Minneapolis & Manitoba freight depot in St. Cloud was almost totally destroyed. The carpenter shops and rail repair shops were unroofed. Sixty-two loaded freight cars were on the track, most were torn apart, and practically all the others were overturned.

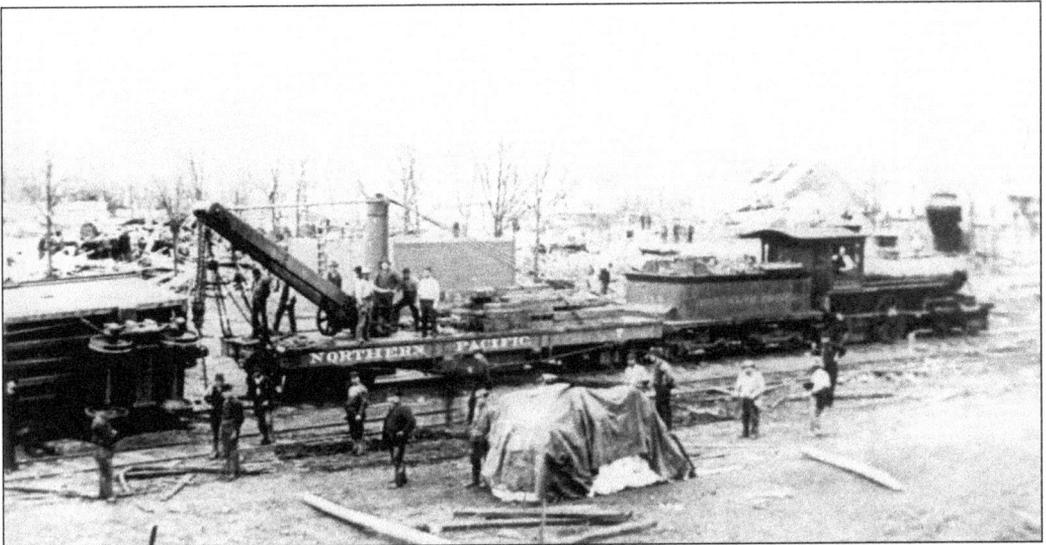

Shown here are the Northern Pacific tracks in Sauk Rapids where workers started the task of righting overturned freight cars. Freight loads were scattered everywhere, some dry goods were never found. Local committees of men and women formed to care for the injured and to distribute supplies. The work of restoration was quick to start, thanks to the general committee appointed to oversee the expenditure of money and supplies contributed.

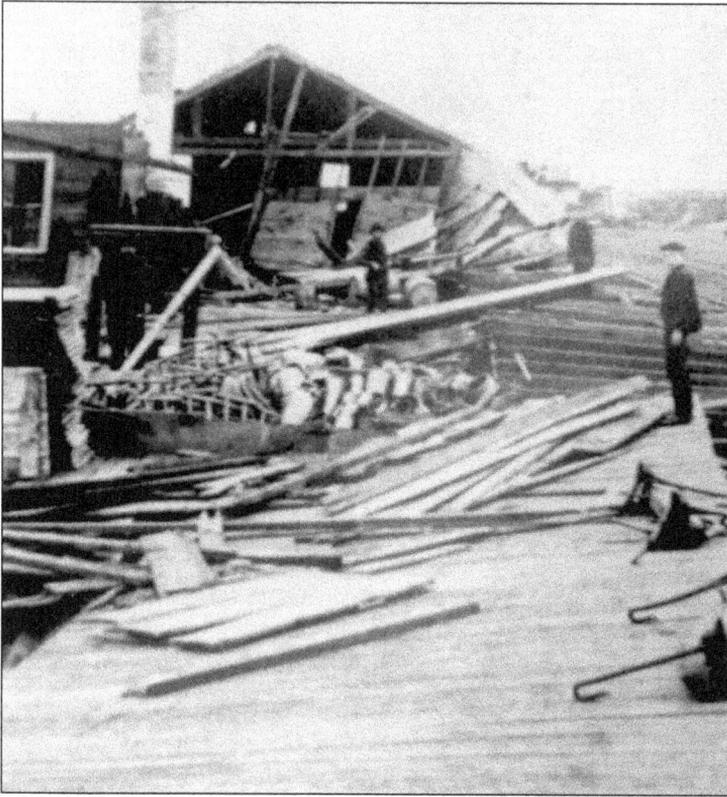

In all, over 100 buildings were destroyed, valued at almost $200,000 in 1886, along with contents of over $100,000, totaling about $300,000 in overall damages. This would be the equivalent of almost $6 million today. Total contributions received including lumber and supplies would approximate $2 million today.

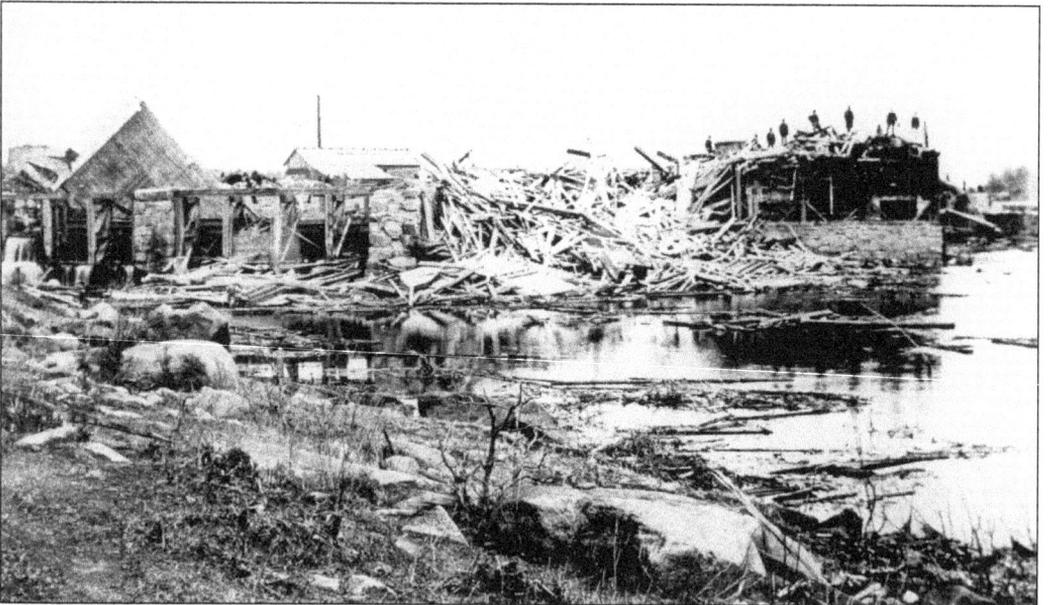

This is a view of the bridge across the Mississippi River where the cyclone paused over the water before continuing on its way to Sauk Rapids. After it flattened the wagon bridge and touched the banks of the river, it picked up speed and size, estimated at over 600 feet wide, the width of two football fields.

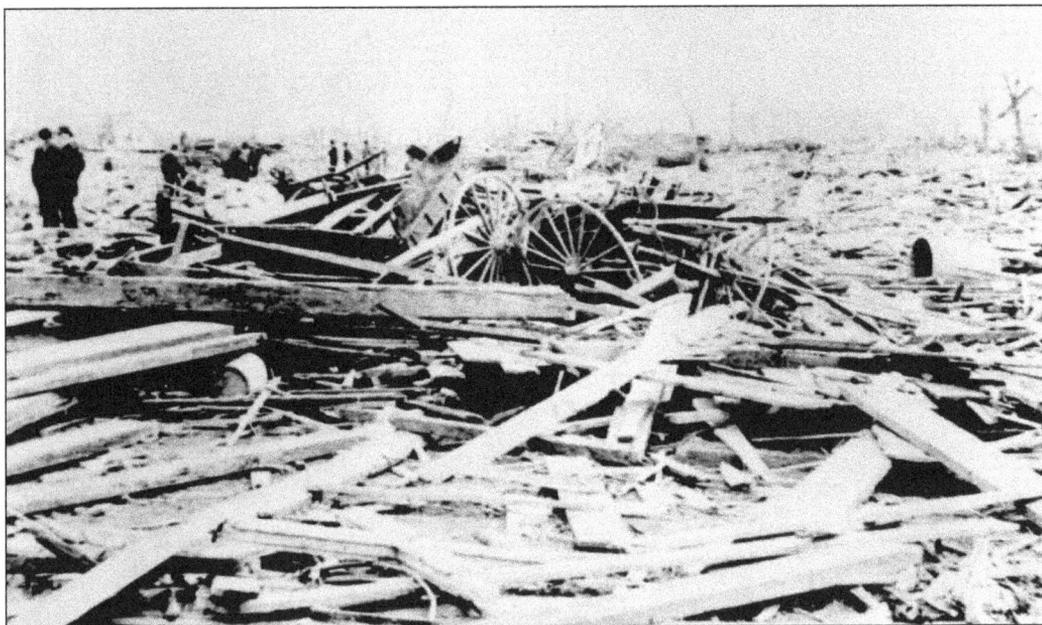

School was not in session, being closed five days earlier due to the school administration operating on a minimum budget and a seven-month instructional year. Shown are the remains of the Sauk Rapids School after the cyclone. Imagine the increased loss of young life if classes were being conducted.

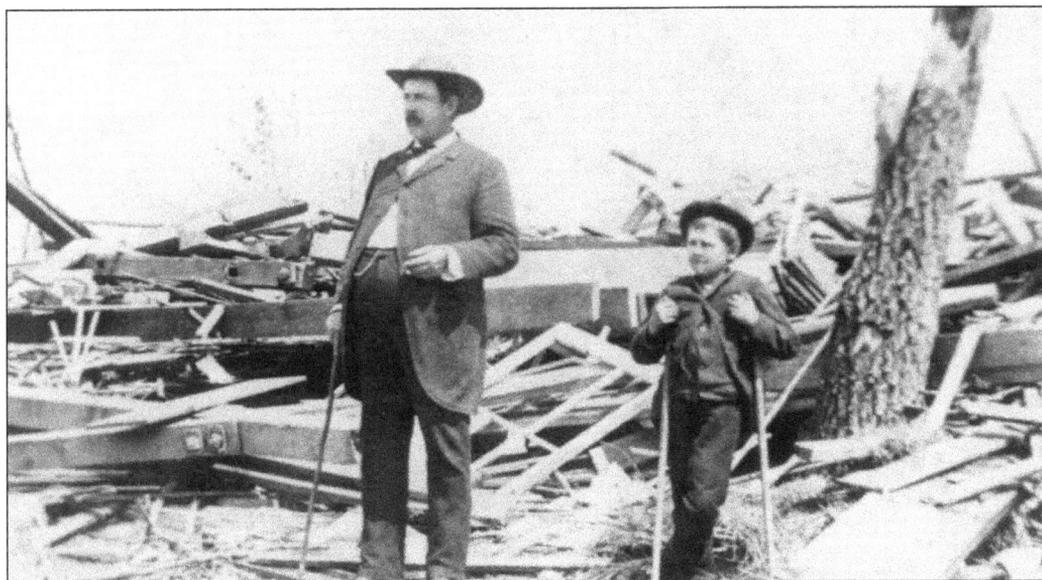

A local business owner and his son injured in the cyclone inspect what is left of their store in Sauk Rapids. Abner St. Cyr was another businessman in the village. He was not so lucky and was killed. Mr. Landre, a local resident, had gone to town with his son Louis that day for a load of lumber. The tornado caught them as they reentered the town turned back by the high winds, and picked up the box filled with lumber. The cyclone slammed it down so hard that Mr. Landre suffered from a concussion. His son was tragically killed, having both legs severed by flying debris.

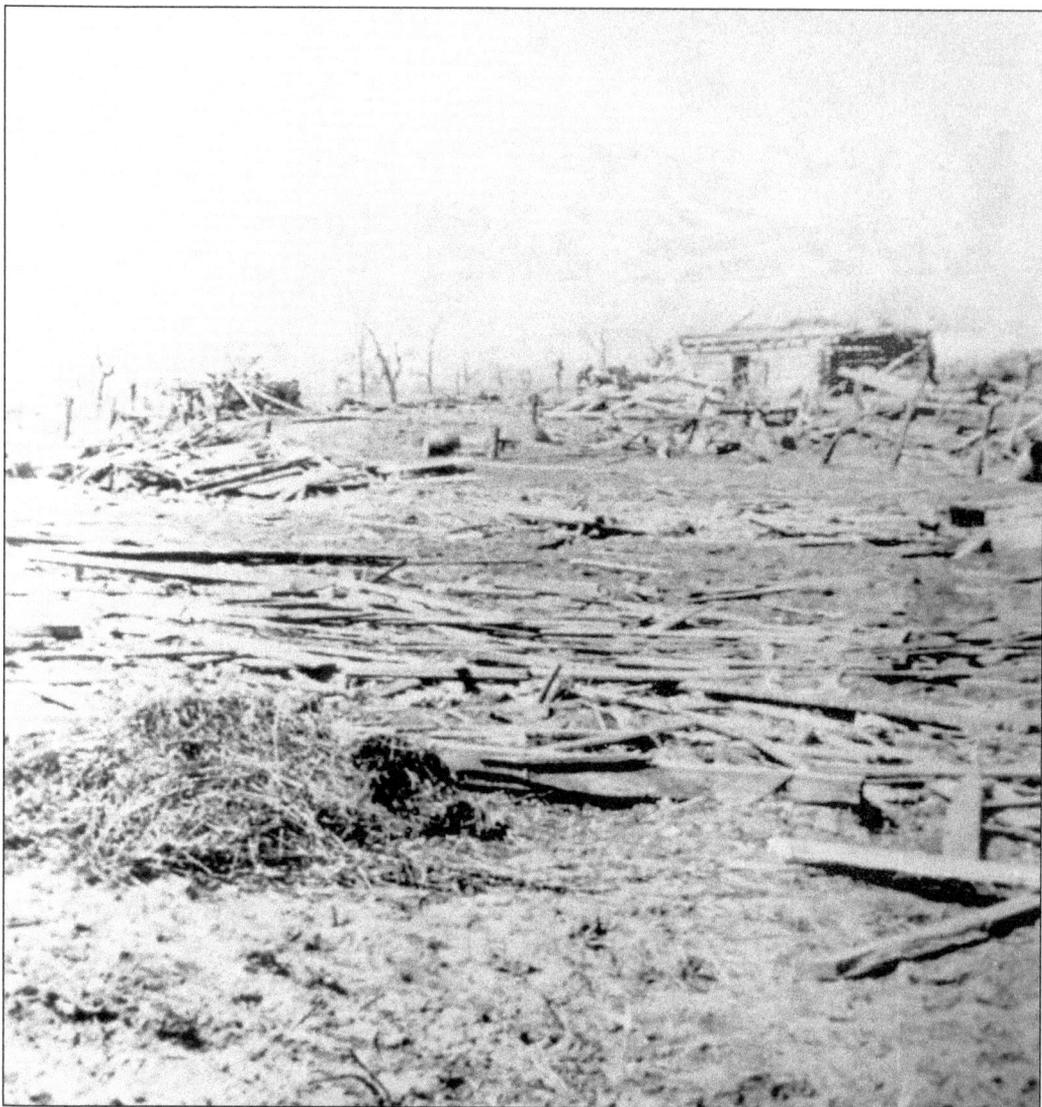

After the cyclone destroyed Sauk Rapids, it moved north to nearby Rice, Minnesota, killing seven members of a wedding party, along with the Reverend Gustav J. Schmidt, his wife, and the groom, Henry Friday, leaving the bride of only a few hours a widow. The railroad depot sign from Sauk Rapids was found at Rice, 13 miles away. Continuing north, the cyclone claimed the lives of two farmhands near Buckman and a young woman near Pierz. The singing book used by the Reverend Schmidt at the Friday/Schultz wedding was picked up near Buckman. The tornado extinguished itself at Sullivan Lake in Morrison County after having taken 73 lives total, the worst killer storm in Minnesota history.

Four

SETTLERS AND
THEIR DESCENDANTS

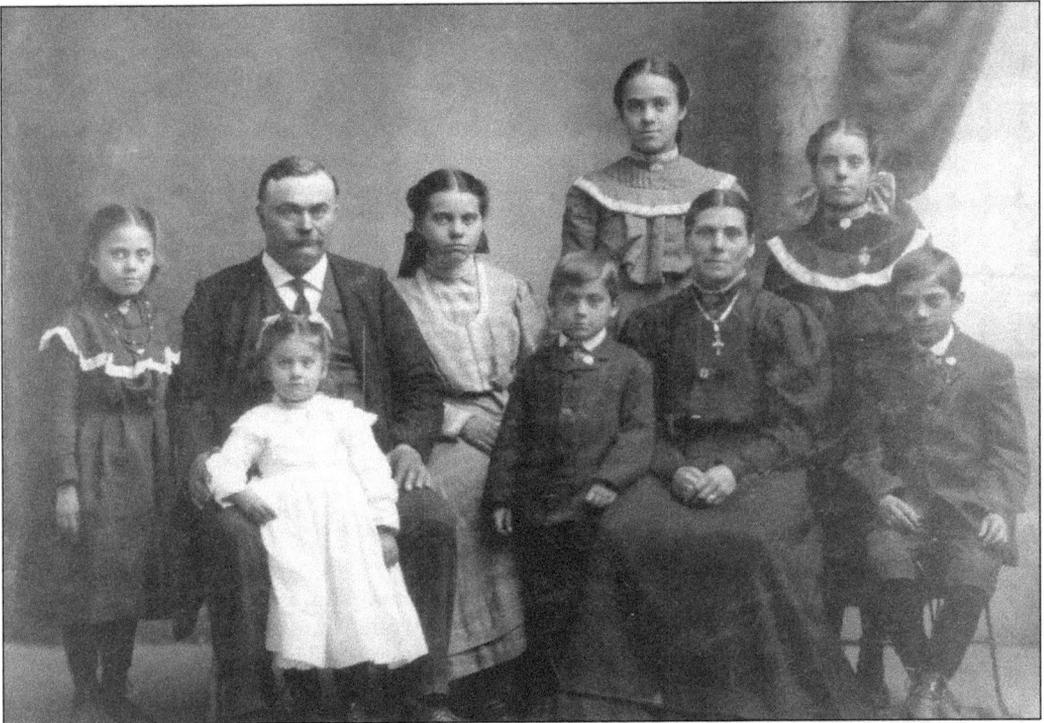

The James and Magdalena Misho Family, long time residents of Sauk Rapids, are pictured here, from left to right, as follows: (front row) Monica, James, Hildegard (front of James), Rose, Alphonse, Magdalena, and Rudy; (back row) Pauline and Cecelia. Their home was at 205 Seventh Avenue North, Sauk Rapids. James Misho was mayor of Sauk Rapids 11 times. He was one of the founders of Misho Granite Works.

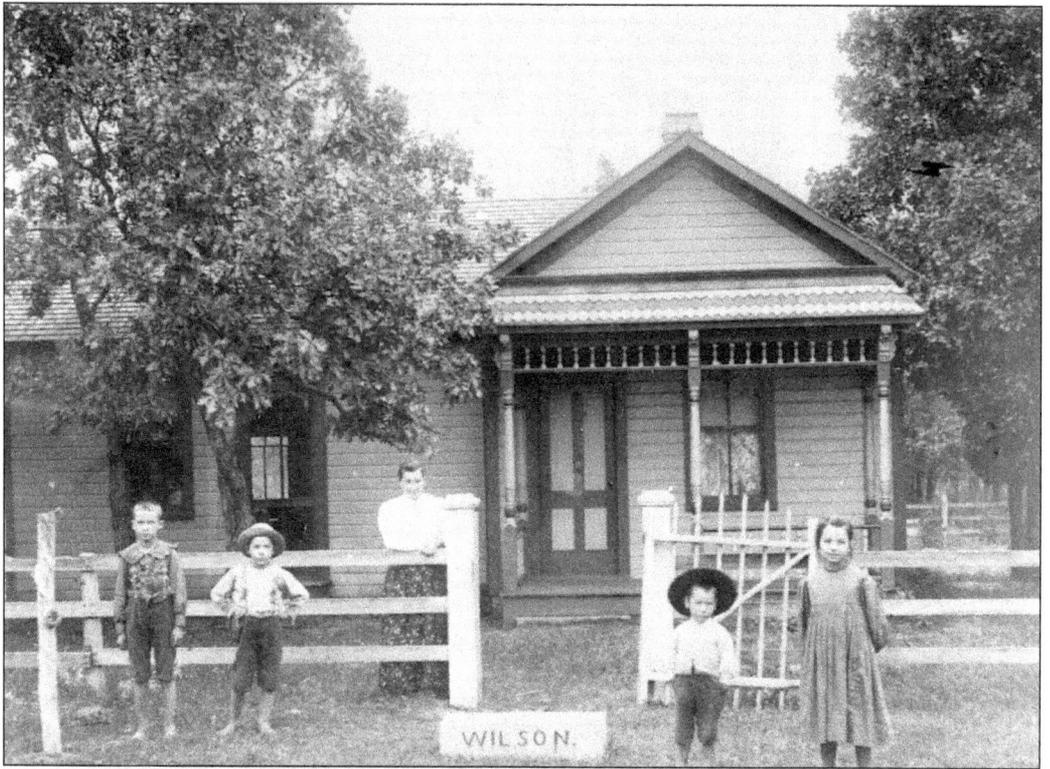

WILSON.

Mrs. G.M. Wilson is shown here standing behind the fence on the family farm during a summer day greeting her children, from left to right, Oscar, Willis, Gustave, and Ellen as they return from school. In the early days, school was in session only during the summer months due to sparse heating and floors of cold, hard-packed earth.

John Brennan was born in Ireland June 20, 1808, and died in St. Cloud November 23, 1899. Seneth (Hollister) Brennan was born in New York State March 20, 1827, and died in St. Cloud June 20, 1897. Both are buried in St. Patrick Cemetery beside their first grandchild, Hattie Patterson, who died March 17, 1888. Hattie is the daughter of Frank S. Patterson and Elizabeth (Brennan) Patterson.

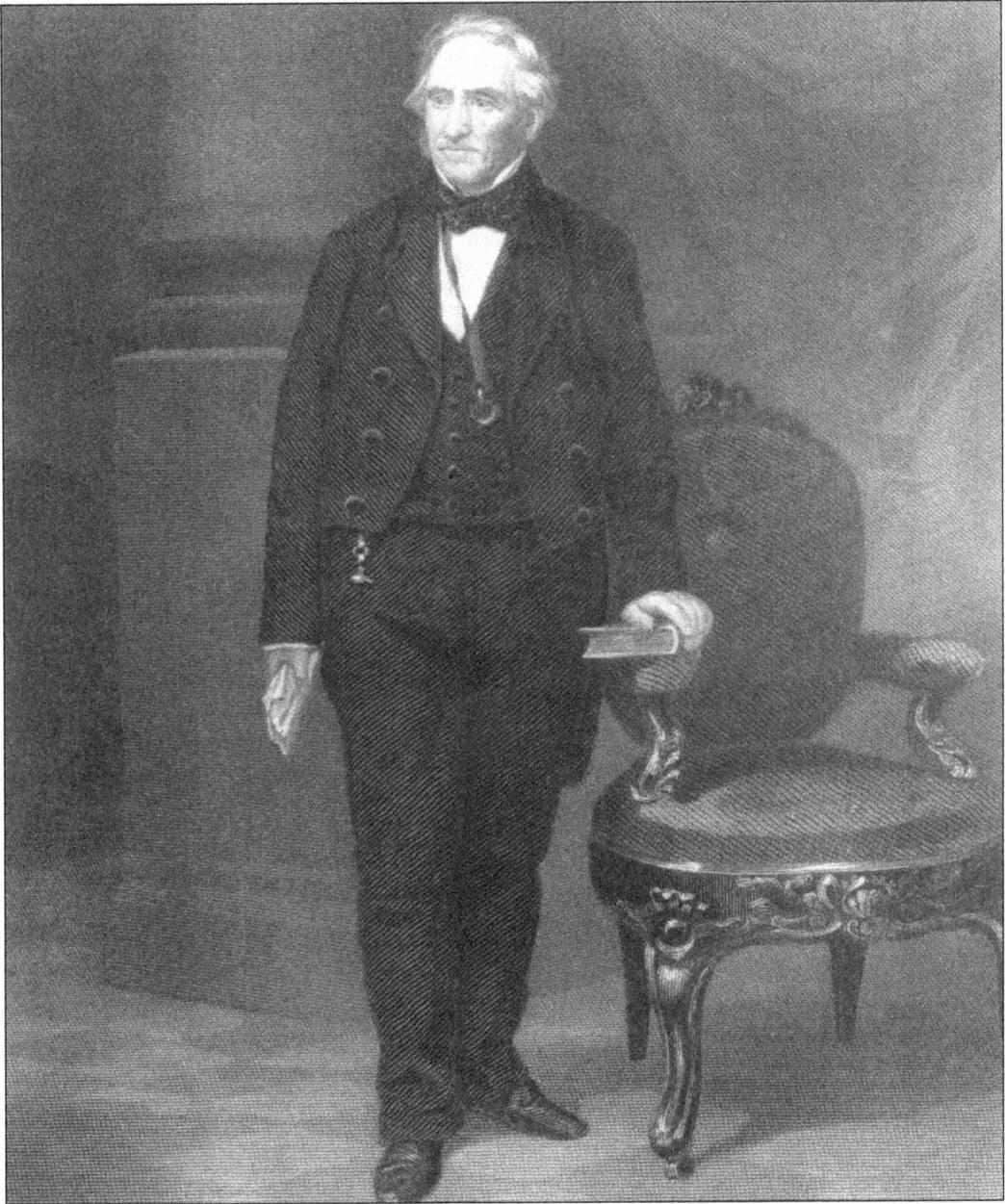

Benton County was named for Thomas Hart Benton, a Senator from Missouri, who was elected as a Democrat to the United States Senate in 1821 and served until 1851. In Congress, his work for the original enactment of Homestead Land Laws in 1824–1828 won the admiration and gratitude of the pioneer settlers throughout the West. He was born near Hillsborough, North Carolina, on March 14, 1792, attended Chapel Hill College (now the University of North Carolina) and the law department of William and Mary College in Williamsburg, Virginia. He was admitted to the bar at Nashville, Tennessee, in 1806, and commenced practice in Franklin, Tennessee. He died on April 10, 1858, in Washington D.C. He is buried in Bellefontaine Cemetery, St. Louis, Missouri. Benton counties in Arkansas, Indiana, Iowa, Oregon, and Washington are also named for him.

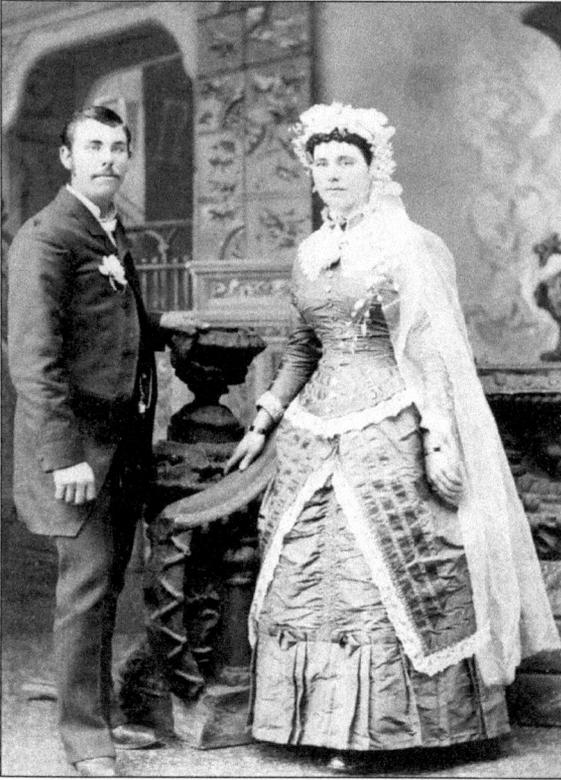

Entertainment was scarce in the rural communities of early Benton County, so weddings became a popular social event. Elmer John Troyer is pictured with his new bride, Sarah Elizabeth McNeeley, on August 22, 1883, wearing a white headdress and veil. The rest of the dress was not white as it is common in today's weddings. Dressy fabrics and trim were scarce in the early years, so it was not uncommon for the wife to wear her wedding dress for many years after the event.

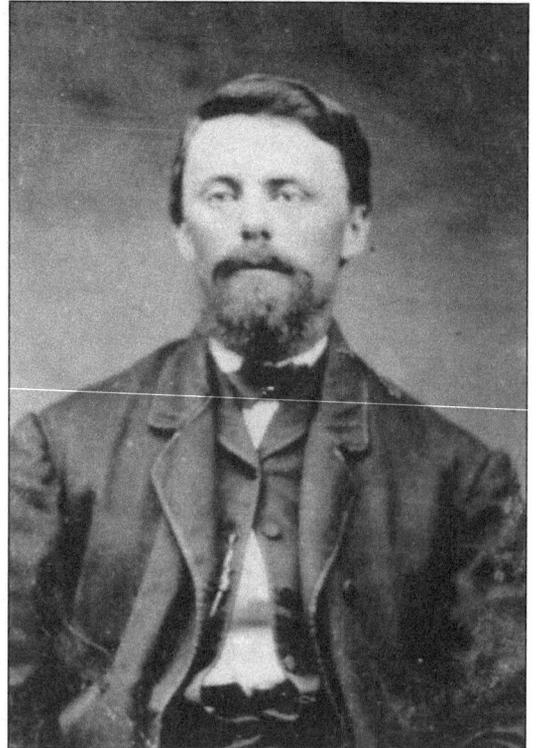

The first settlers began to arrive in Langola Township in 1853. They took up claims, starting farms and planting crops. O.D. Ellis settled on the fork of the Little Rock Creek in Langola Township after the Civil War. He was the son of Harris Ellis and a neighbor of Frank Flint.

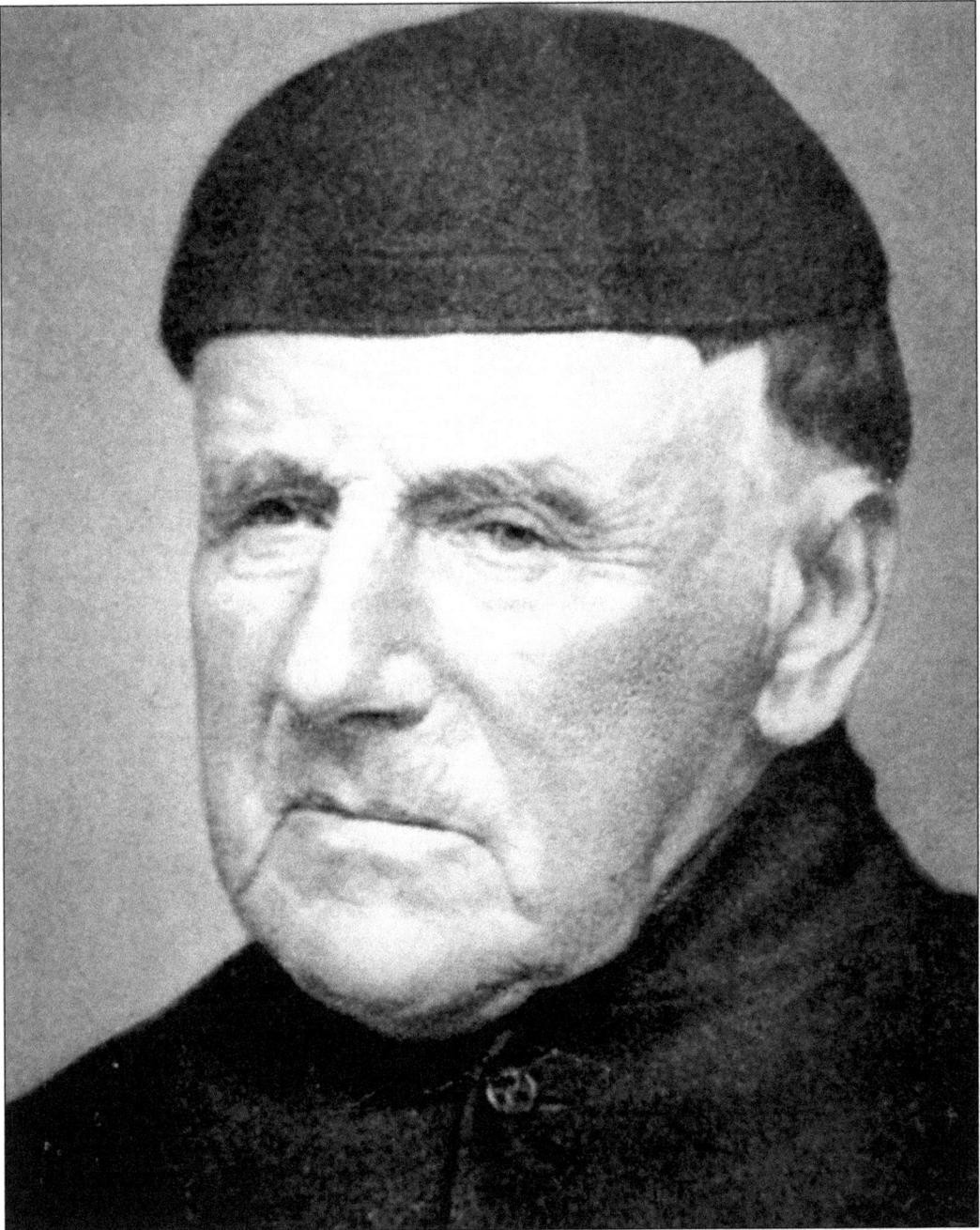

When this area was still a mission, the Reverend Francis X. Pierz, who was then residing at Fort Gaines (Ripley), visited Rice on several occasions. He is described as coming to the village on a little pony, his baggage consisting of a mess kit and a large sleeping bag made of animal skins. He held services at the Vincent Schindler home (the Agnes Schendzielos farm) and in the Henry Voerding home in Sauk Rapids. Fr. Pierz shortly later built a small log chapel at Sauk Rapids in 1854. From the services held in the Schindler and Voerding homes grew the St. Lawrence congregation at Duelm. It is the second Catholic Church to be built in Benton County, only the chapel at Sauk Rapids preceded it.

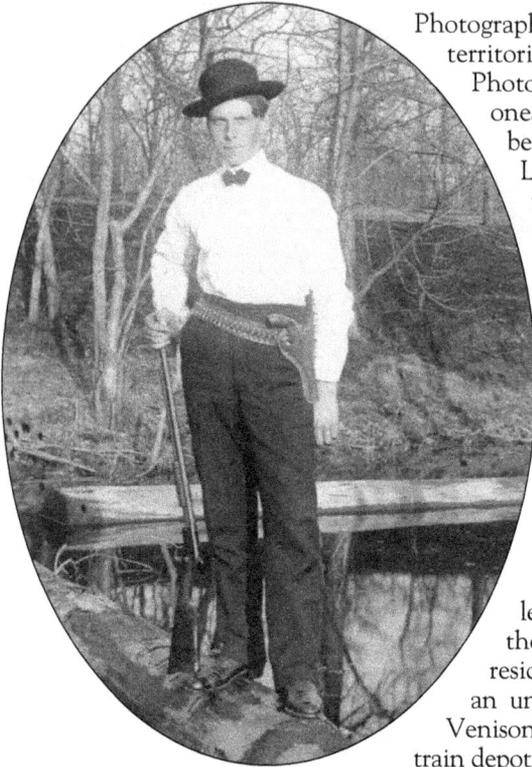

Photographers wandered throughout the newly settled territories catching portraits of the early settlers. Photography was still new and a photograph of oneself was rare. Subjects wanted to look their best, perhaps even show off a bit. Here Louis Lezer, husband of Anna Gratzek, poses ready for action, holding his hunting rifle and wearing his gun. Louis worked at the Watab Paper Mill, and was an active member of the Trinity Lutheran Church.

Wild game such as deer, prairie chicken, and pheasant were plentiful in the forests and throughout Benton County. Pictured here, from left to right, is Louis Lezer—an active member of the Sportsmen's Club—with fellow Sauk Rapids residents August Rogeschske, Dutch Kutzurik, and an unknown gentleman on a hunting expedition. Venison was frequently shipped from the Sauk Rapids train depot to markets in the East.

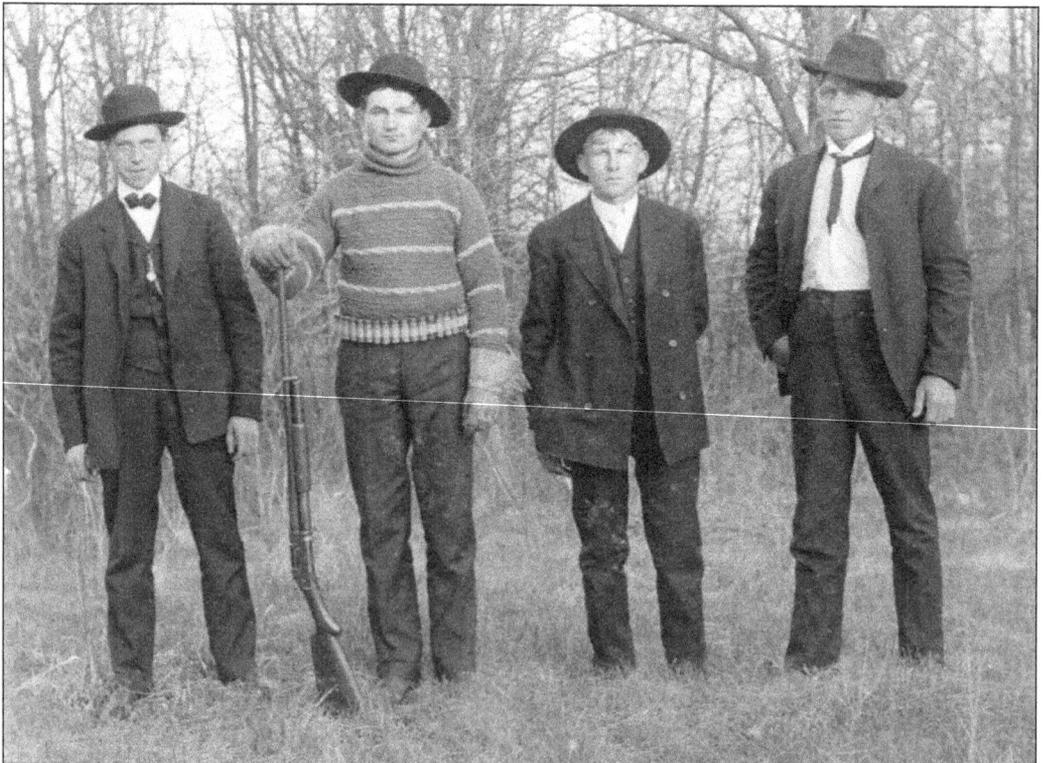

Joseph Kampa was born in 1850, in Prussia, and Theresa (Balder) Kampa was born in 1852. They were married in 1870 and settled on a farm in St. George Township. Mr. Kampa served in various official capacities in St. George Township. Joseph died in 1913 and Theresa in 1920.

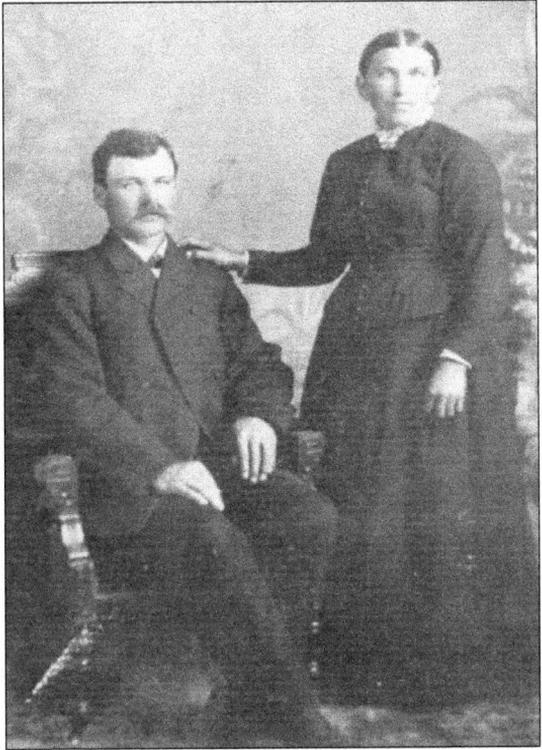

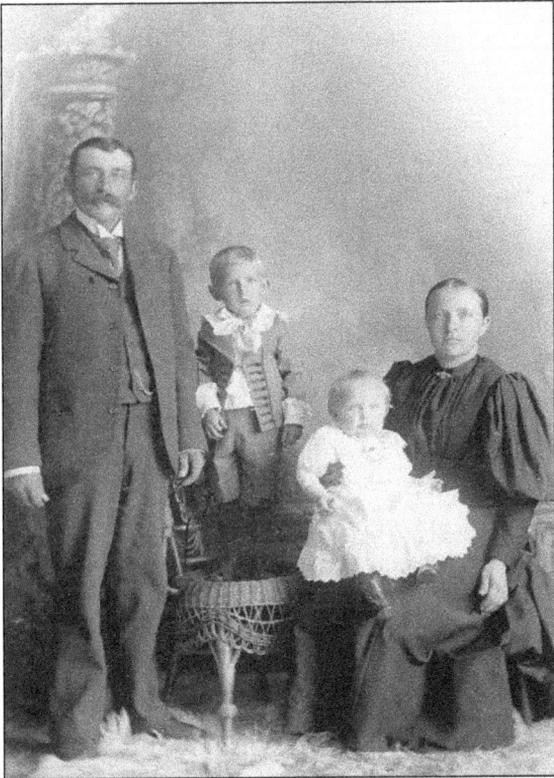

The pioneers of Benton County were frequently far away from their family and friends. Photographs showing the family in their new home would be sent back for relatives to admire. Fred Wippich and Augusta Bukowski, who emigrated from East Prussia in 1885 and married one year later, are shown with son Carl (standing on chair) and daughter Helen dressed in their Sunday best. The Wippich's farmed for about five years in rural Sauk Rapids and raised seven more children. Fred owned and operated the Wippich Shoe Store most of his life, until he died in 1927.

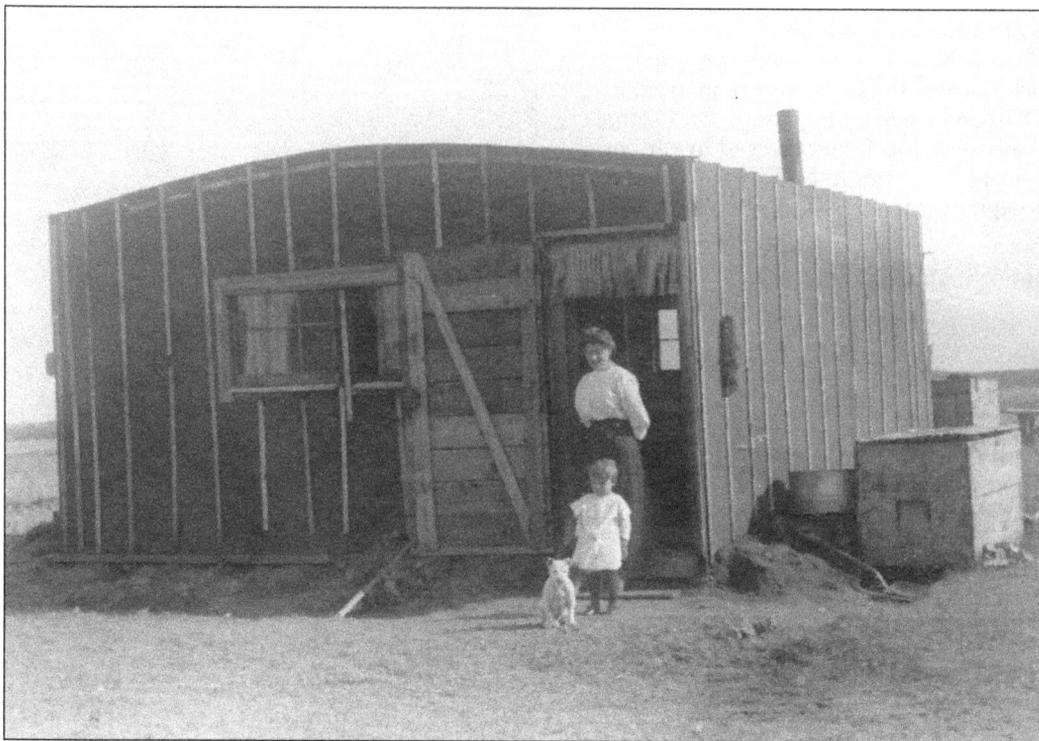

The Homestead Act allowed anyone to file for a quarter section of free land (160 acres), which was yours at the end of five years if you had built a house on it and actually lived there. Mary McGregor, who married Erwin Walstedt of Sauk Rapids, her child and dog are shown in front of this simple structure built to meet the Act's requirements and shelter the family from winter.

George Rice was born in Hampshire County, Massachusetts, on January 26, 1832. In 1856, he left his home state to come to Washington County, Minnesota. About two years later, he came to Little Falls' Village, where he carried on a meat and cattle trade until 1862. Here he initiated his trade with the Government, selling meat and provisions destined for the northwest chain of forts. In 1864, he came to the farm on the Little Rock River in Section 28. Here he built his home and the grist and flourmill, which was situated a mile and one-half east of the station on the trail, now the village of Rice.

School District No. 3 in Sauk Rapids organized as an independent district in 1885. J.A. Senn was the first superintendent at a salary of $20 per year. Hattie A. Rockwell, pictured here, taught school in 1890 after marrying Edward W. Mayman in 1886. Other teachers on the staff were Sonnie Denton, Clara Richards, Annie Getchel, and Lucy Hammonds. In 1892, Hattie Rockwell became school superintendent for District No. 3.

Early pioneers James Sparrow (right) and his niece Vernie Daggett are shown here. In July 1889, J.A. Sparrow presented an affidavit to the County Commissioner. Voters wanted to form a new township called "Eureka." The name was quickly changed to "Graham" in honor of Mr. Graham's daughter, whose name was Beautiful Graham. Twenty-six voters signed the petition and the township was organized.

Dr. William Friesleben was born in Illinois in 1878, and married Anna Kremer. In 1907, they came to Sauk Rapids, where Dr. Friesleben practiced medicine for 45 years. On June 30, 1946, this area honored the doctor with "Dr. Friesleben Day" to pay special tribute for his long and faithful service to the community. Dr. Friesleben served on the school board for many years. He was a member of the Benton County Fair Board, Village Board of Health, and was County Coroner. He was past president of the Stearns-Benton Medical Association. He was a charter member of the Sauk Rapids Lions Club. Dr. Friesleben died May 20, 1952.

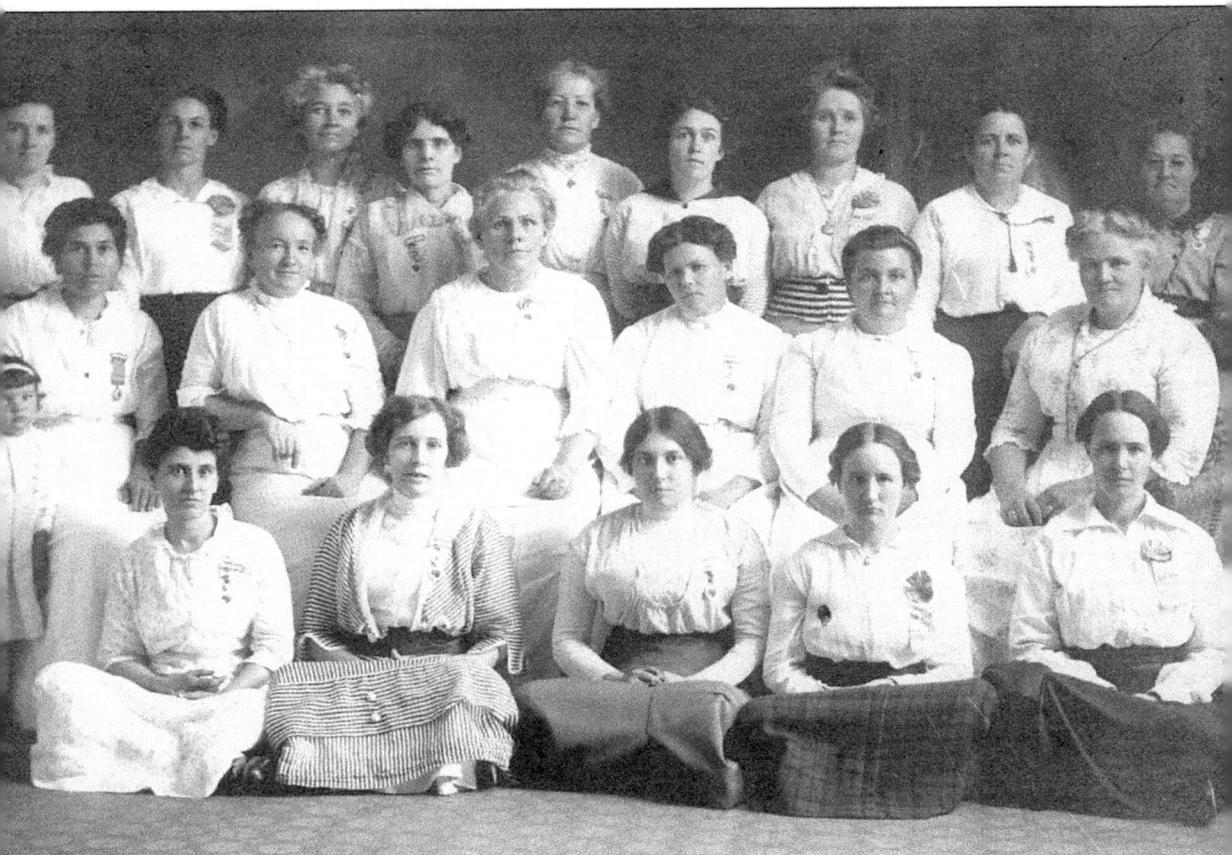

A group of Foley ladies gathering for a photo are shown, from left to right, as follows: (front row) Liz Barthelemy, Mrs. Kate Murphy, Belle Broding, Lonetta Latterell Crathy, Claudia Latterell Dziuk; (middle row) Alice Latterell, Mrs. Clark, Mrs. McNulty, Mrs. Lena Linn (Alice's sister), Mrs. Orcutt, unidentified; (back row) Mrs. Riley, unidentified, Mrs. Peterman, Mrs. Jim Murray, Mrs. Odegard, Mrs. Miller, Mrs. Harmon Becker, Mrs. McGuire, unidentified. The child is Ms. Peterman's daughter.

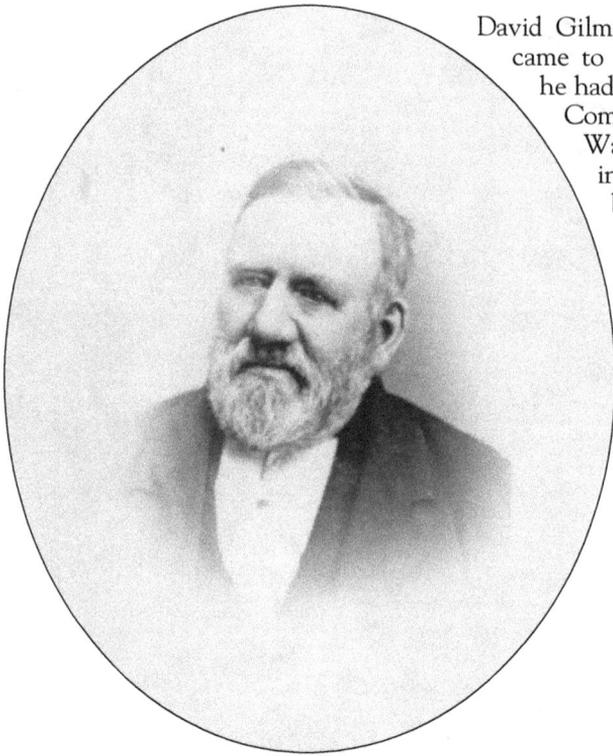

David Gilman and Nancy Lamb Gilman (below) came to Benton County from Mendota, where he had been associated with the American Fur Company. In the fall of 1849, they moved to Watab and bought out Asa White's interest in a trading post there. He immediately built a hotel and opened a farm, probably the first farm to be operated in this county. Later, Governor Alexander Ramsey appointed him Sheriff of Benton County.

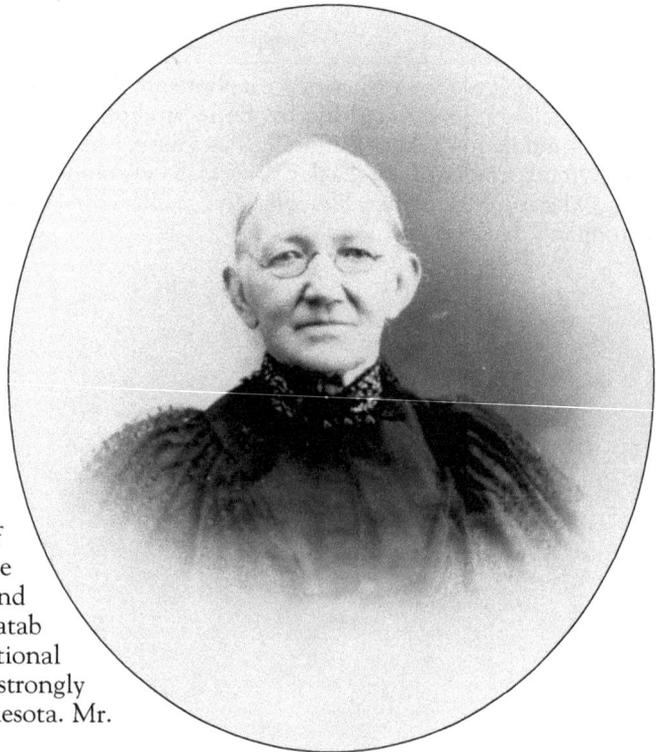

Mr. Gilman also served as County Commissioner for a number of years. He was a member of the Territorial Legislature in 1850, and was appointed postmaster at Watab in 1854. He sat on the Constitutional Convention in 1857, where he strongly advocated school interests in Minnesota. Mr. Gilman died May 9, 1885.

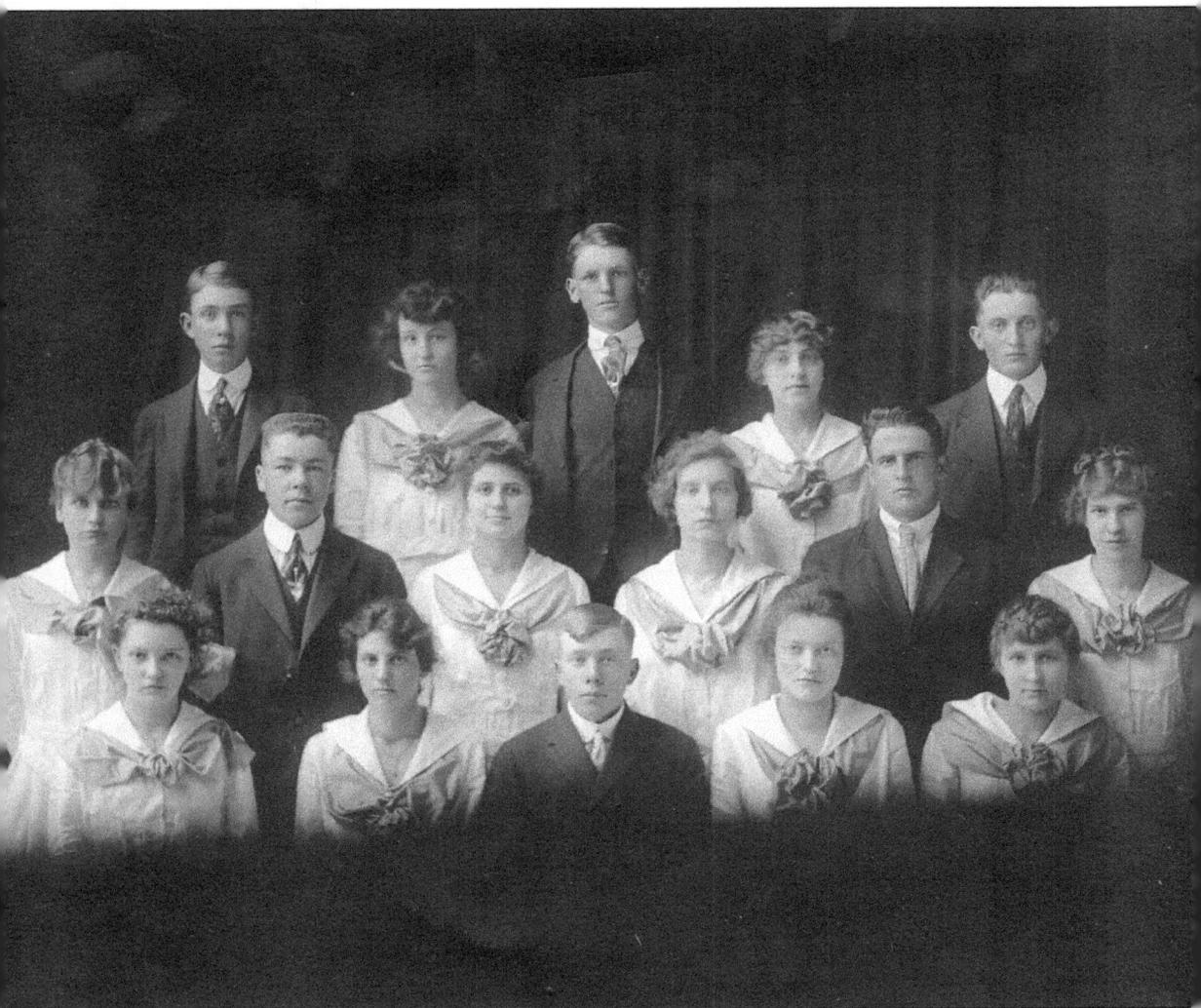

The first high school studies to be offered in Benton County were introduced in Sauk Rapids in 1899. However, a fully accredited high school was not established until 1903. Classes offered were English, Latin, Civics, and Elementary Algebra. Teachers' salaries at the time ranged from $30 to $40 per month. Pictured here, from left to right, the Sauk Rapids High School Class of 1917 is as follows: (front row) Miss Cedarstrom, Charlotte Clifton, Ernest Larson, Marion Campbell, and Elsie Sleizer; (middle row) Uena Orcutt, George Hagguist, Mabel Grunnewald, Marian Keller, Page Sartell, and Vesta Potter; (back row) Norb Bergguist, Irene Pelton, Harry Burns, Bertha Blaske, and Pierre Hoskins.

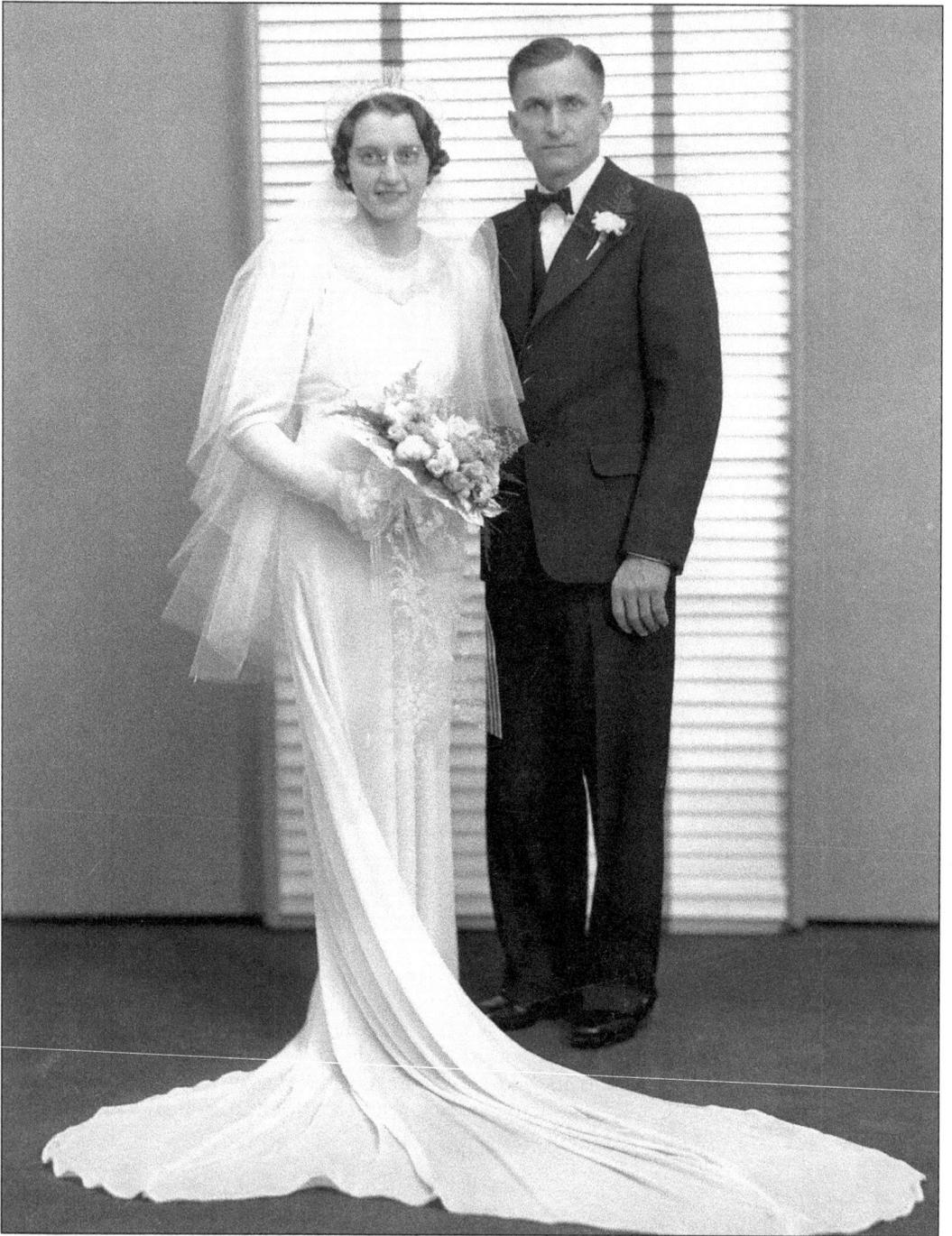

Trinity Lutheran Church in Sauk Rapids began through the missionary efforts of Pastor John von Brandt. Services were first held in the old courthouse building, but in the summer of 1886 a church was built and dedicated that fall. A new church was built in 1936-1937. Pictured are John Wasilowski and Louise Schibonski, the first to be married in the new Trinity Lutheran Church, on October 18, 1937. John and Louise owned the Sauk Rapids Plumbing and Heating from 1935 through 1973. The Wasilowski family has been residents of Sauk Rapids since 1903.

Richard Berge, with brothers Harry (left) and Stanley (right), with syrup pails in hand and ready for the walk to school. The pails kept their lunch for the day. Snow was on the ground from November until late March or April. There were no snowplows so the roads were kept open by shoveling. The spring thaw left the road trails a muddy mess. (Courtesy of Richard Berge.)

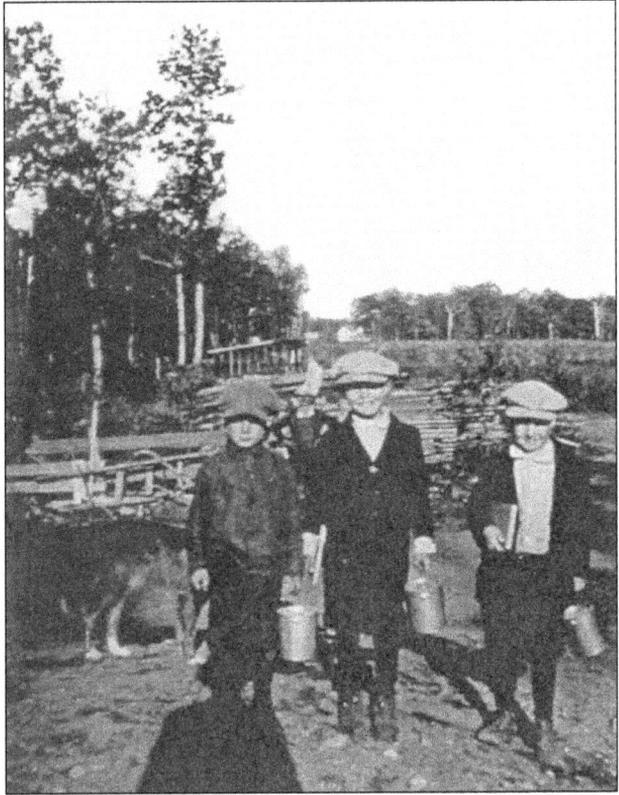

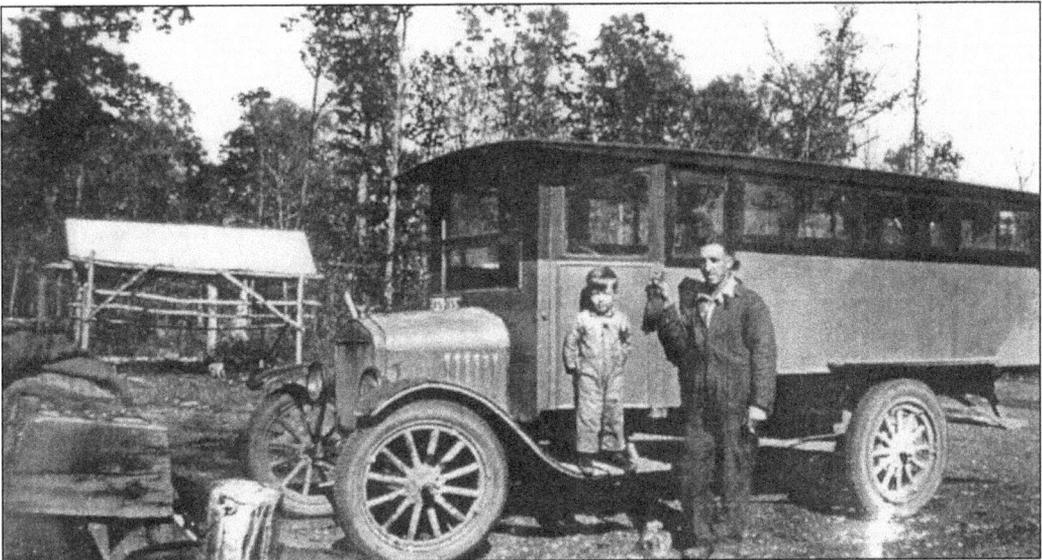

Gene Berge drove the school bus that was made from a Ford Model T truck. Gene was thankfully a mechanic, as the bus needed the transmission bands tightened regularly. The school bus commenced service in 1929, when Gene's niece Violet Berge started school. Gene's nephew Kenneth Berge, pictured here on the running board at age three, made the daily trip just to be with his sister Violet. (Courtesy of Richard Berge.)

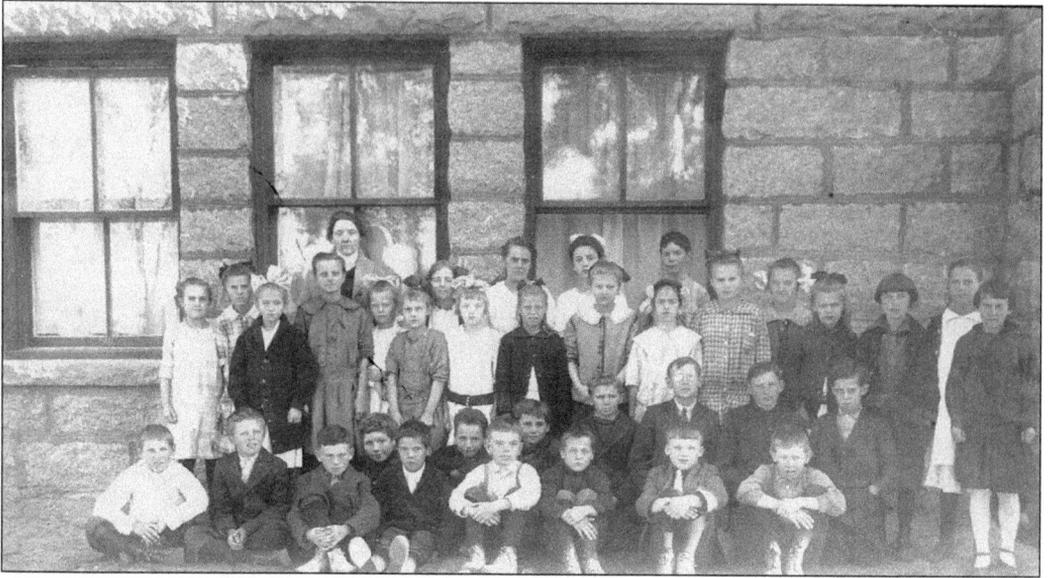

Mrs. Amelia Gerber's fifth grade class is shown outside the Russell School, Sauk Rapids, c. 1904. During the earlier years, there were many operational differences among the school districts in the County. For example, the Foley School Board voted against free textbooks for children. It was feared that the residents would look at this unfavorably, as the only way to pay for books would be to increase taxes.

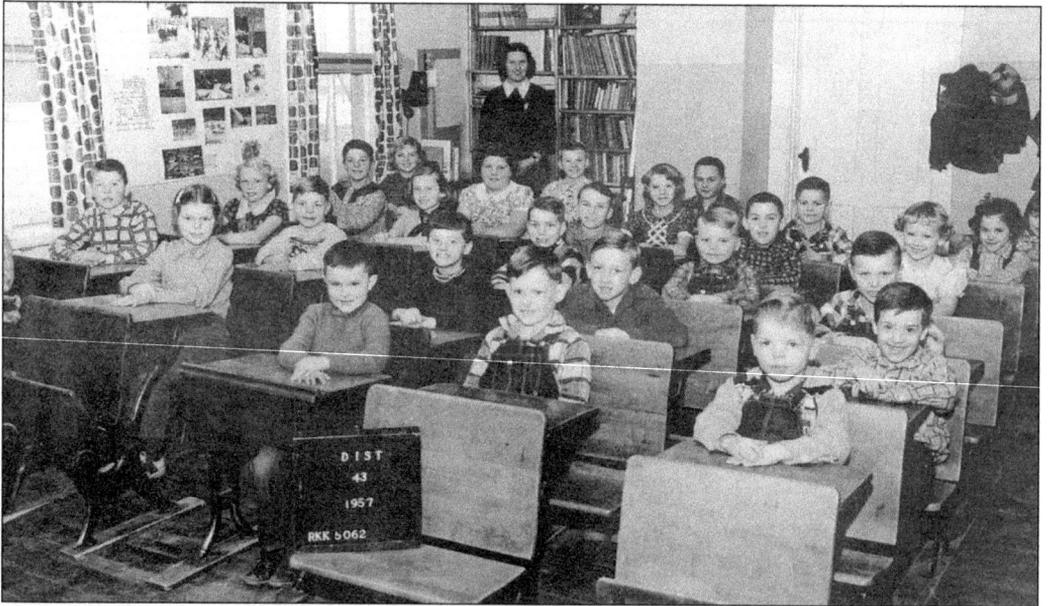

School districts in Benton County received new identification numbers in the late 1950s and were classified as common, independent, special, or associated districts. A group of students of the "baby-boomer" generation assemble for a photo with their teacher M. Selander in 1957. School District No. 43 was a "common" school district located in the Granite Ledge Township.

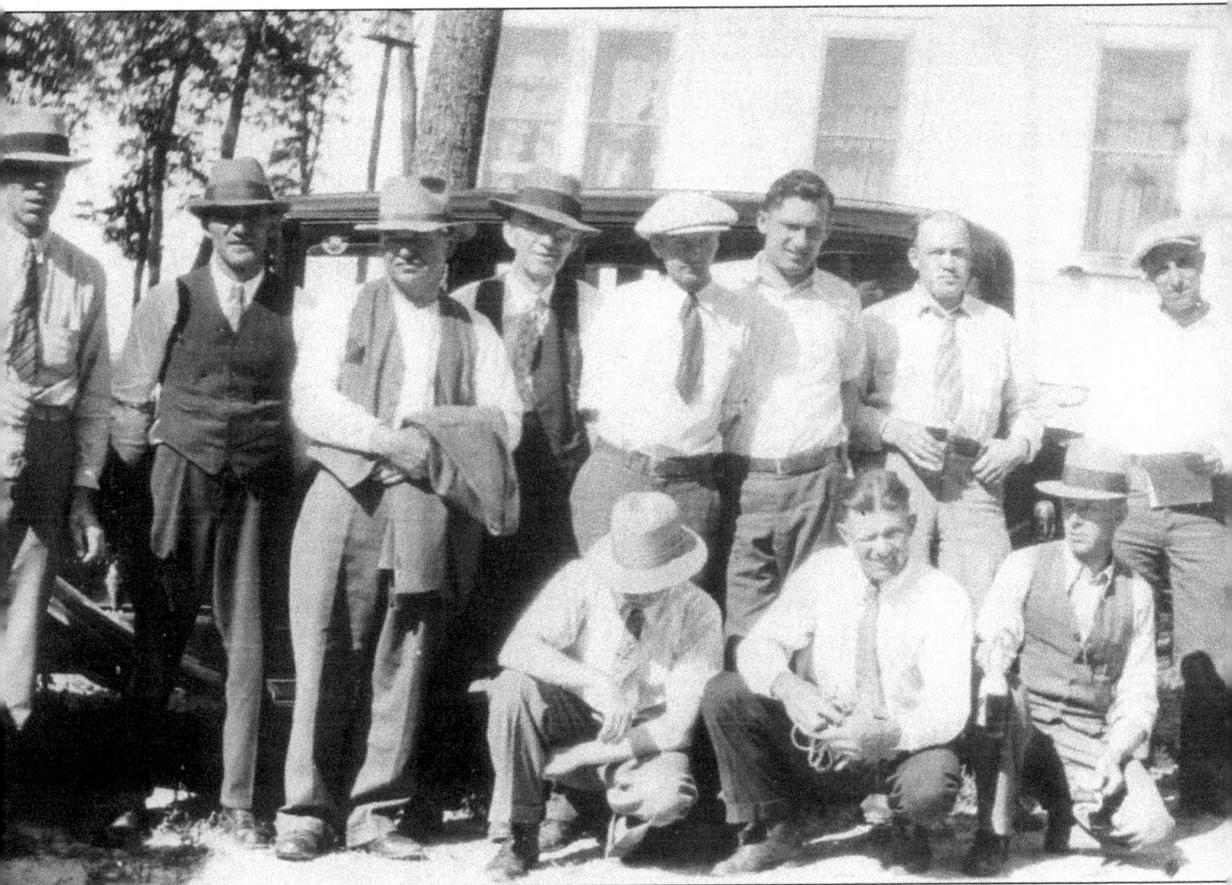

Members of the Sauk Rapids Lions Club on a fishing trip at Leech Lake in the early 1930s, are pictured, from left to right, as follows: (kneeling) Ernie Benson, Elmer Youngberg, and William Soder; (standing) Emil Czarnetzki, Henry Bolinski, William Hohn, Orville Gifford, T.E. Olson, E.L. Bell, Otto Heinzel, and Joe DeLair (resort owner).

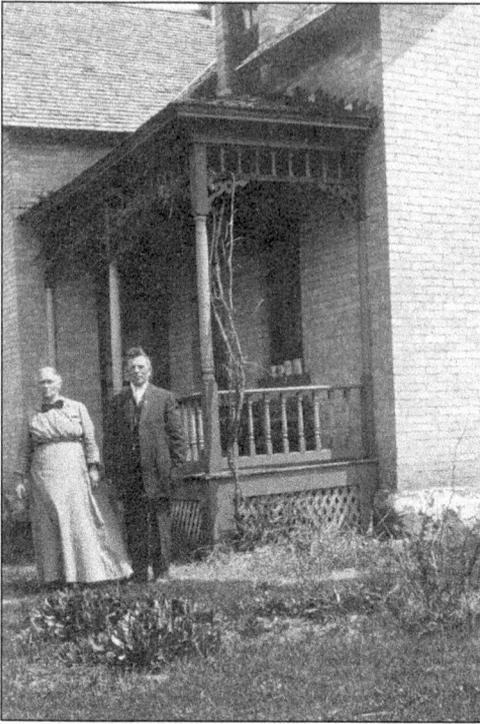

Edmund Mark Zawacki and Maryanna (Frost) Zawacki are shown here in front of their home in Gilmanton Township. Edmund emigrated from Danzig (now Gdansk), Poland, as a German citizen in 1880. He worked for the Government and was in charge of the wood lots. Edmund saved his money for five years then returned to Danzig to bring his family back to the United States in 1885. On April 16, 1897, he was naturalized as a United States citizen. (Courtesy of Joyce Kitzmiller Gelle.)

The Bronder Family is shown here in front of their home in Foley in 1908. From left to right are Martha (Zawacki) Bronder (standing next to the tree), Apolonia ("Pearl") (standing on porch), child Martha, John Jacob Bronder holding his son John Edmund Bronder, Adella ("Della"), and Martha's brothers John Zawacki and Joseph Zawacki. John, who married Mary Markowski, was Frances Mary Zawacki's father. Joseph, who married Annie Kuszma, was an uncle and godfather of Frances. (Courtesy of Joyce Kitzmiller Gelle.)

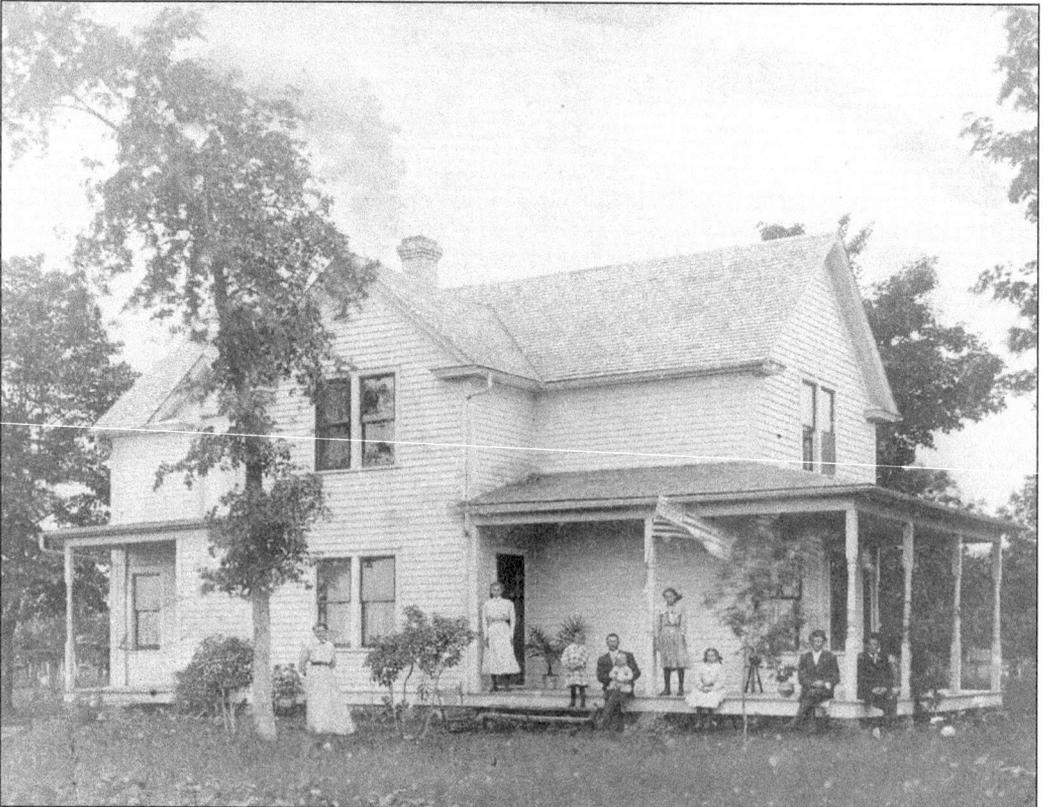

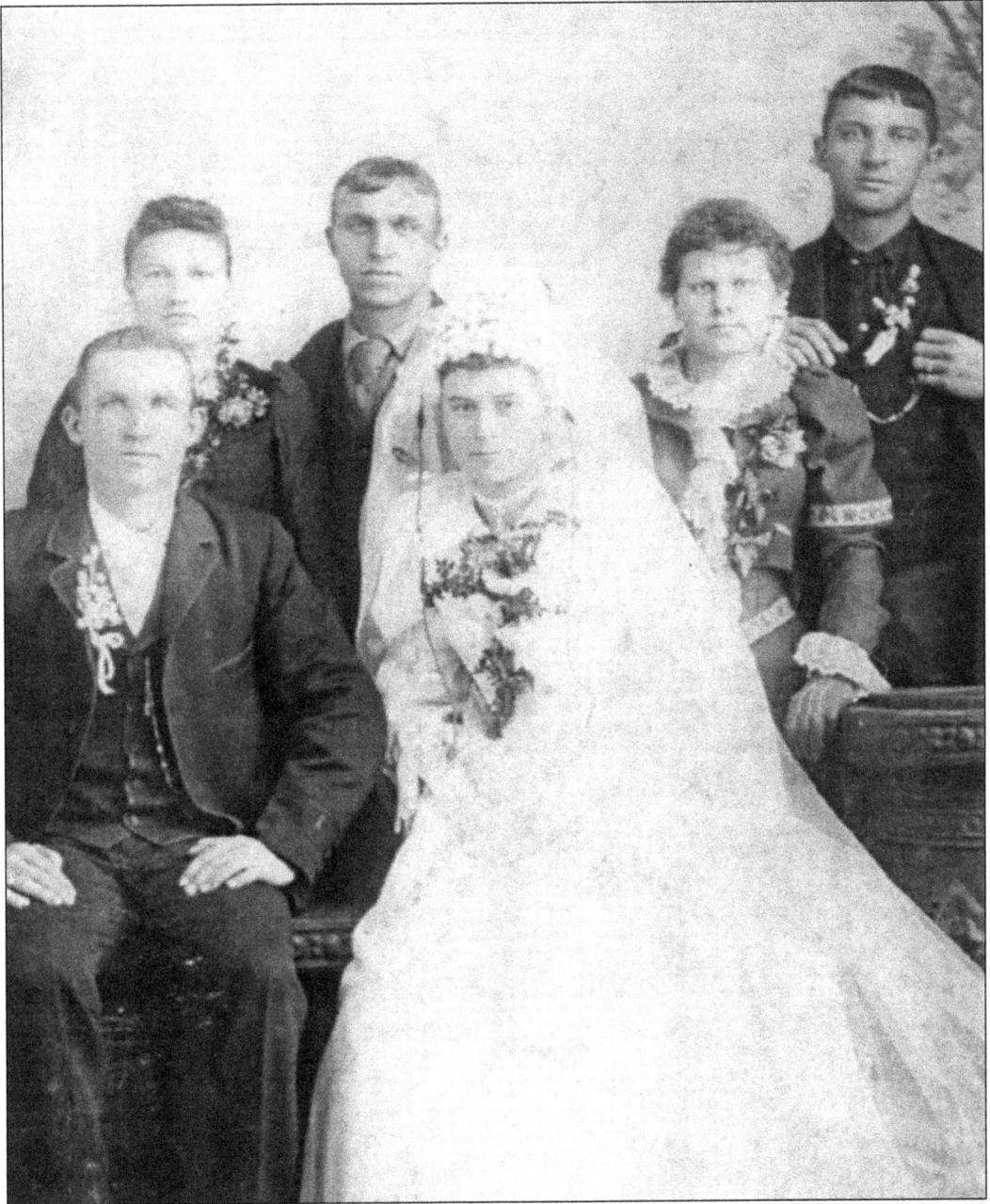

The wedding of John Jacob Bronder and Martha (Zawacki) Bronder on October 21, 1893, was held at St. Casimir's Catholic Church in St. Paul. The wedding party members are unidentified. John was born in Opole, Poland, on May 10, 1871, the second son of Jacob Bronder and Franciska (Kolic) Bronder. John worked as a foreman of a railroad section crew, laying tracks in Montana and in North Dakota where their first two daughters were born. Together John and Martha had ten children—Apolonia, Adella Frances, Frances, Augusta Mary ("Gustie"), Martha, John Edmund, Mary Josephine, Paul Anthony, Benedict Titus, and Dorothy. Martha was born in Danzig, Poland, on June 10, 1873, the first born of Edmund Mark Zawacki and Maryanna (Frost) Zawacki. John and Martha lived with their family in Foley after the turn of the century.

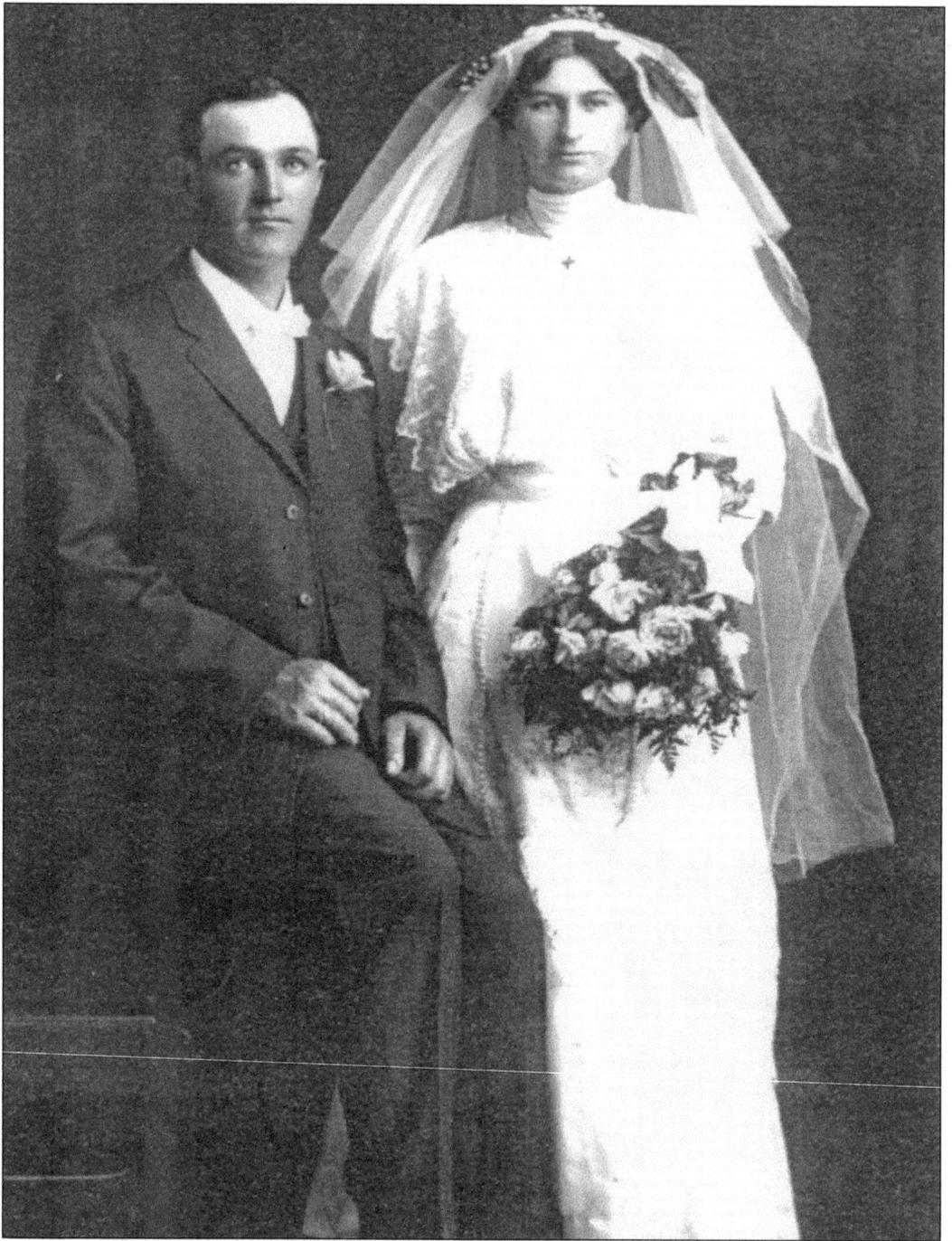

Francis ("Frank") Kipka and Apolonia ("Polly") Zawacki are shown here on their wedding day June 2, 1914, at Saints Peter and Paul Catholic Church in Gilman. Frank was born October 31, 1884, in Gilman, the son of Joseph Kipka and Mary Patock. Polly was born January 7, 1889, in St. Paul. Polly was one of eight children, her parents being Edmund Mark Zawacki and Maryanna (Frost) Zawacki. Frank and Polly together had six children of their own—Eleanor, Irene, Clara, Dorothy, John, and Leonard.

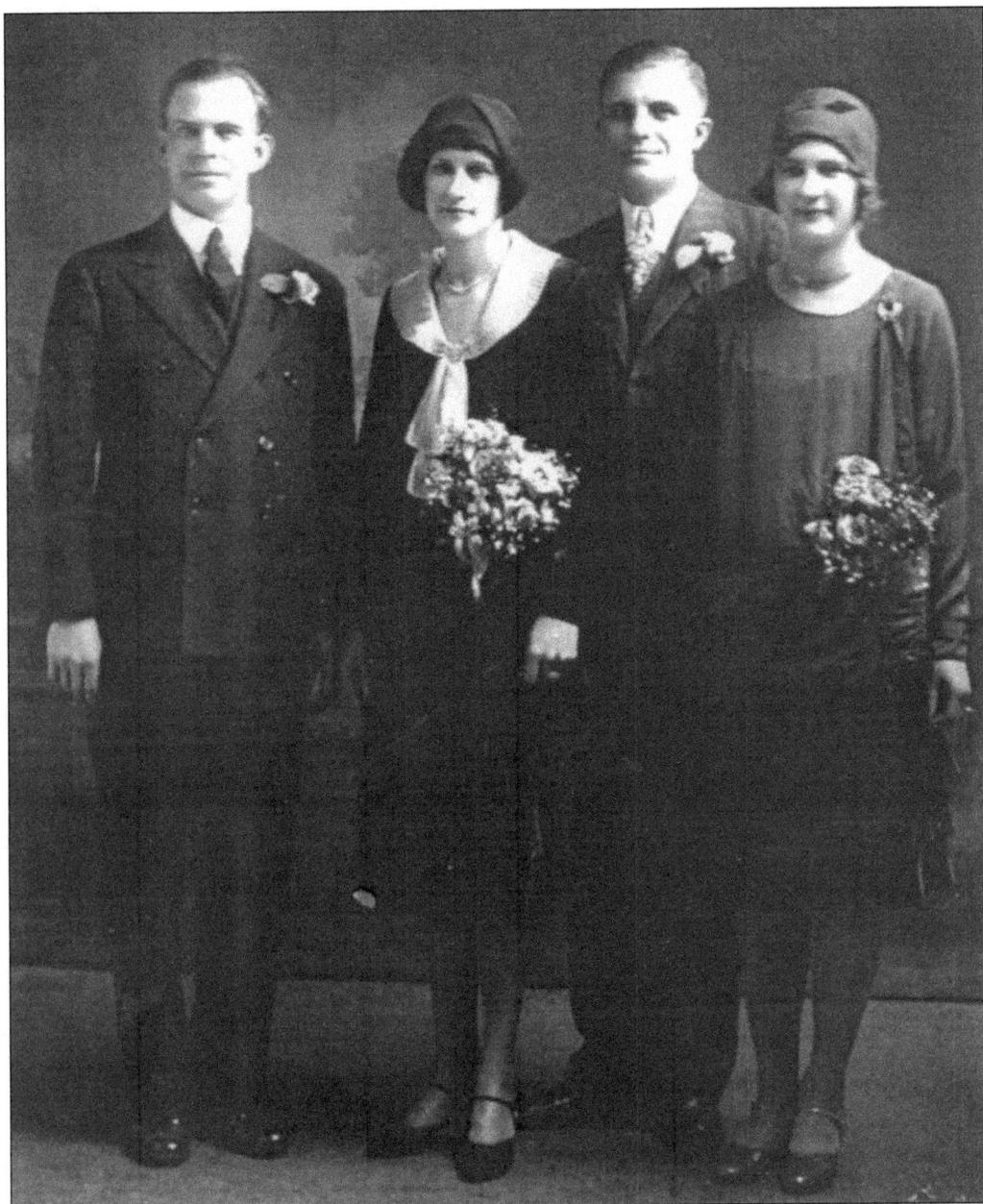

George Ward Kitzmiller and Augusta "Gustie" Mary Bronder, married in Foley on August 26, 1929, are shown here with their attendants Gus's younger sister Mary Bronder (far right) and cousin Ed Zawacki. Ed Zawacki was the first-born son of Edmund Mark Zawacki and Maryanna (Frost) Zawacki. George was born in Roanoke, Virginia, on February 13, 1897, and Gustie was born on August 9, 1899. Gustie attended St. Mary's Hospital School of Nursing and graduated as a registered nurse in 1926. In early 1940, the government re-activated men in the Army Reserve and George went back to active duty. George preceded Gustie in death on January 3, 1963. Gustie died at the age of 101 on November 5, 2000, in Sartell. Survivors include her children, Joyce Gelle and John Sr. of Sartell; three grandsons; four great-grandchildren; thirteen foster grandchildren; seven foster great-grandchildren; and brother Benedict of Sartell.

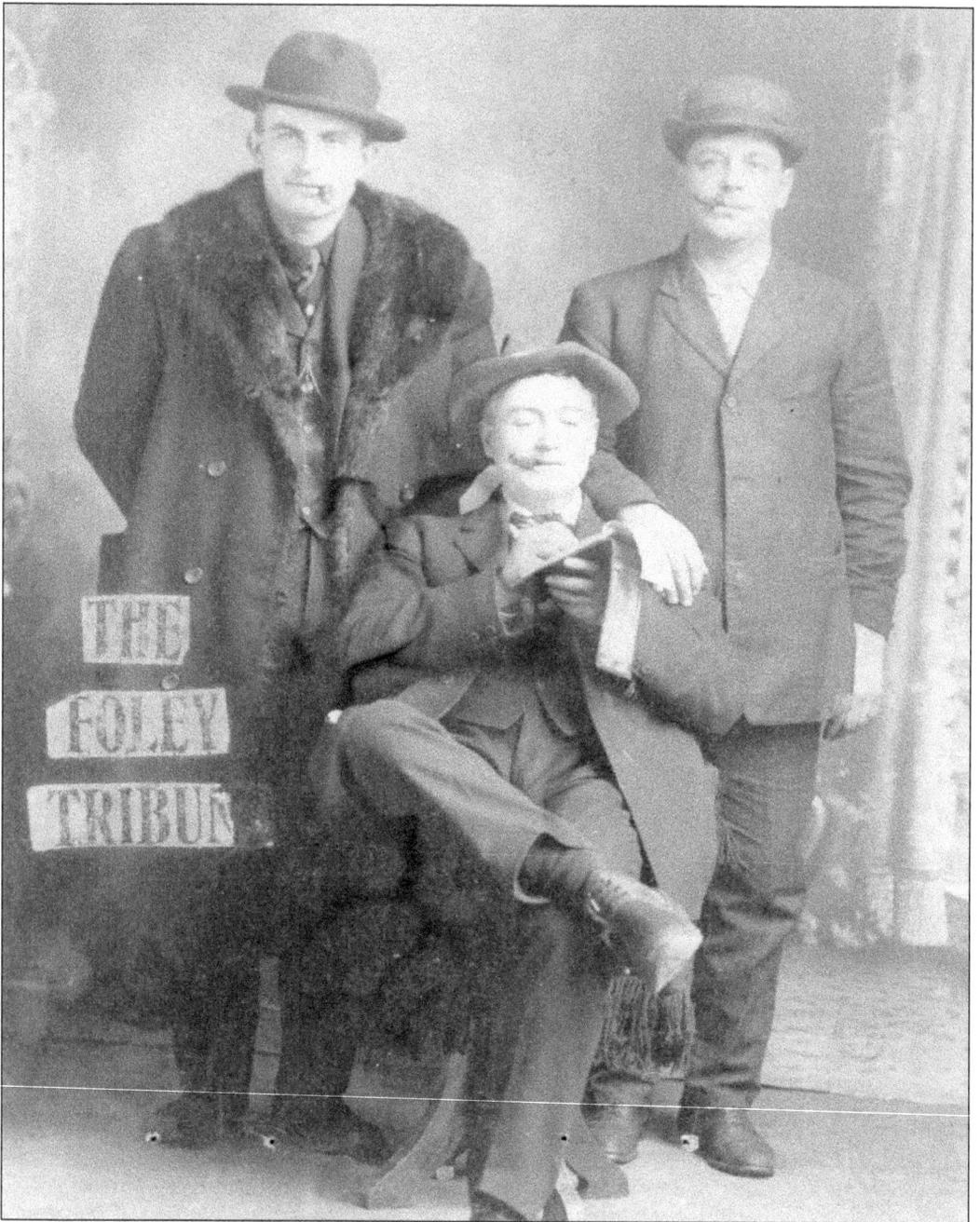

W.A. Farrington (center), his company once the publisher of the *Foley Independent* and now the founder of the competing *Foley Tribune*, enjoys a cigar with loyal backers John Zawacki (left), who worked on the Great Northern Railroad section crew, and Ben Latterell (right), one of the noted musicians of the Latterell Brothers Orchestra. The *Independent* became the official newspaper of Benton County in 1908, and the *Tribune* enjoyed a contract printing for the County one year later. The papers eventually merged. John Zawacki is wearing a full length, fur lined coat so popular in the early days. John is the maternal grandfather of author Ronald Christopher Zurek. (Courtesy of Helen M. Latterell photo, "Benton County News.")

All dressed up in their Sunday best ready for church, from left to right, are John "Jack" Zawacki, Helen Zawacki, and Edward Zawacki, c. 1914. Parents John Zawacki and Mary (Markowski) Zawacki went on to have six more children—Leonard, Mark, Frances Mary, Roman Gregory, Mary, and Tony. Today Frances lives in Downey, California; Mary in Chicago, Illinois; and Tony still lives near the family home in Foley. (Courtesy of Frances Zawacki Zurek.)

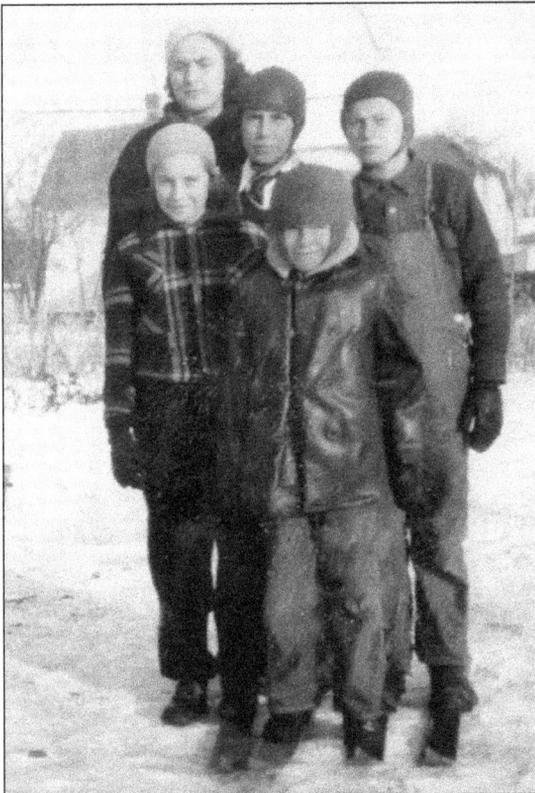

The children of John Zawacki and Mary Markowski bundled up on a cold morning in the winter of 1936. On their way to school, from left to right, are Mary Zawacki, Frances Zawacki (behind Mary), Len Kipka (cousin), Tony Zawacki, and Rome Zawacki. Heavy wool suits, long underwear and skis were used in their journey during the winter trekking through the snow. (Courtesy of Frances Zawacki Zurek.)

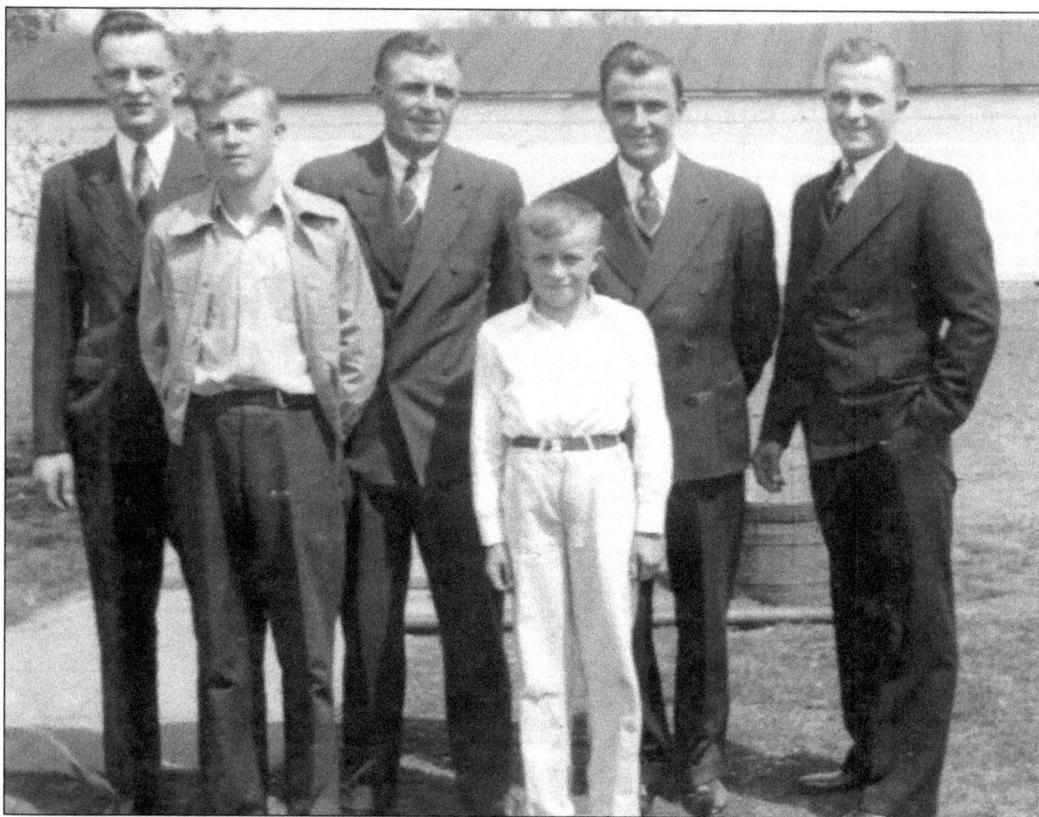

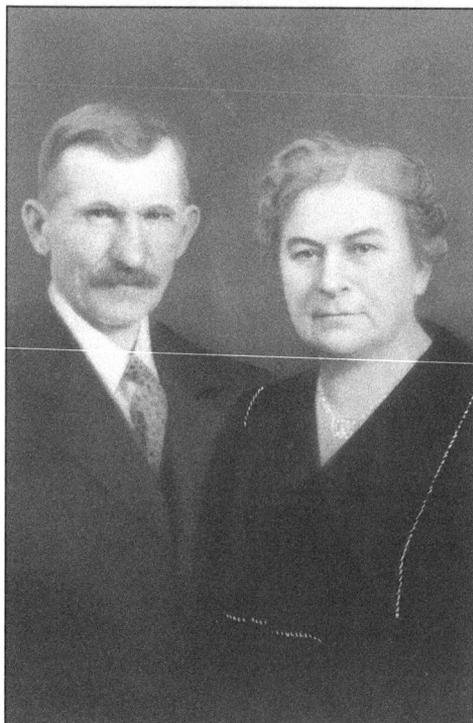

Gathered together are the sons of John Zawacki and Mary Markowski of Foley. Their first-born brother, Victor, died as an infant in 1909. The Zawacki boys pose here for a photograph taken in 1939. From left to right are Mark, Rome, Edward, Tony, John "Jack," and Leonard. (Courtesy of Frances Zawacki Zurek.)

On October 21, 1943, John Bronder and Martha Zawacki celebrated their 50th wedding anniversary. John was remembered as a quiet man, a hard worker, and very active in the community. Martha was a homemaker, also active in the community, and both brought their children up in the Catholic faith. John was a member and an officer of the Livestock Shipping Association and elected as a director of the Foley Cooperative Creamery. Martha was a member of the Royal Neighbors, an organization that supported financial security and independence for women. She frequently accompanied physicians as a mid-wife when friends were having a child. (Courtesy of Joyce Kitzmiller Gelle.)

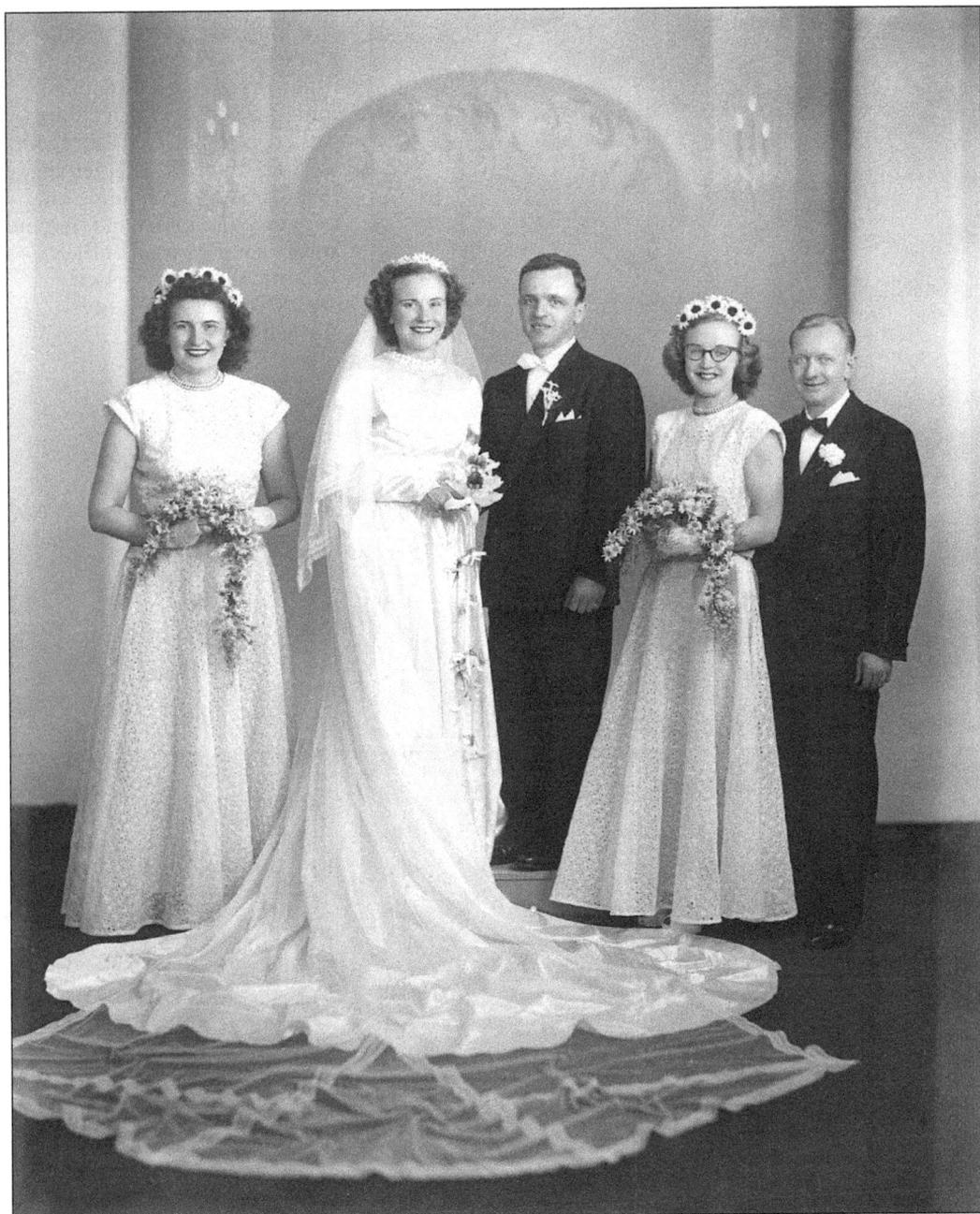

Mary Zawacki and Theodore ("Ted") Kmiecik are shown here on their wedding day June 25, 1949, in Chicago, Illinois. Members of the wedding party pictured, from left to right, are Matron of Honor Frances Zawacki Zurek (the sister of the bride), Mary, Ted, bridesmaid Doris Sraga, and her husband Matthew Sraga. Ted was born June 13, 1919, and died April 5, 2000. Mary was born March 30, 1926. Mary was one of ten children, her parents being John Zawacki and Mary Markowski Zawacki of Foley. Ted and Mary had three children of their own—Linda, Daniel, and Janet. (Courtesy of Frances Zawacki Zurek.)

The children of Rome Gregory Zawacki and Eulala Ethel Rodgers pose with Grandpa John Zawacki during a family gathering in March 1953. From left to right are Diane, Jerome, James, and Linda holding on tight to Grandpa's hand. Jerome and James are proud of their Atlantic City, New Jersey, caps. (Courtesy of Frances Zawacki Zurek.)

Here is a photograph of Mark Zawacki and Harriet May Winkelman Zawacki's six children taken in 1954. They are, from left to right, as follows: (front row) Mary Ellen, and Jean Marie (sitting on Mary Ellen's lap); (back row) Steven Charles, Robert John, Mark Frank, and Richard Joseph. (Courtesy of Frances Zawacki Zurek.)

Five

BUSINESSES AND THE LOCAL ECONOMY

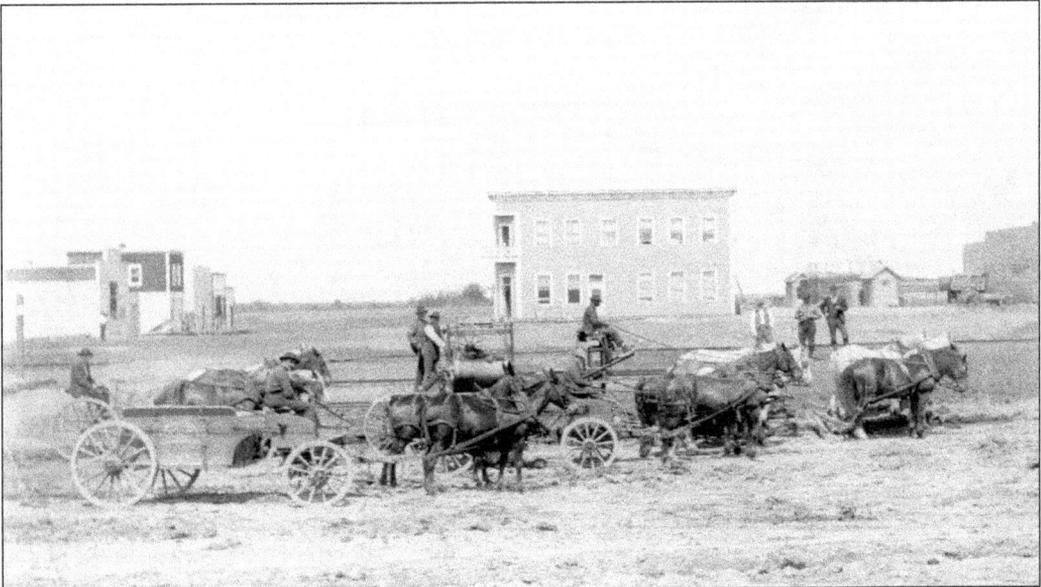

Provisions were brought to local merchants by way of the railroad. At the railroad depot supplies were loaded and placed on wagons drawn by horses and transported to proprietorships in the towns. Residents watch in the background as dray operators made their daily runs.

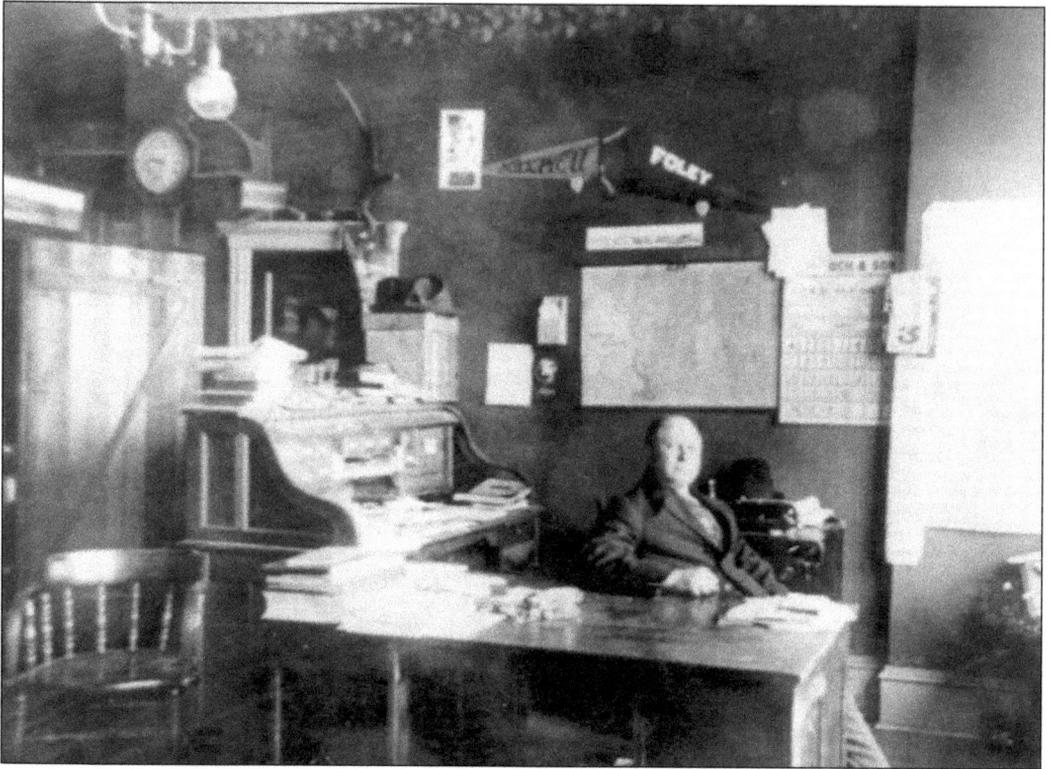

The land office business of 85 years ago was the forerunner of the modern real estate business. In 1916, Frank Kotsmith took out an auctioneer's license and for over 20 years was the main auctioneer in the Foley area. Shown here is the interior of the Kotsmith Land Office with the owner seated at his desk. The W.C. Murphy Land Office was on the east side of Fourth Avenue. Business was good enough for two such land offices. The bank vault can be seen at the left in the background.

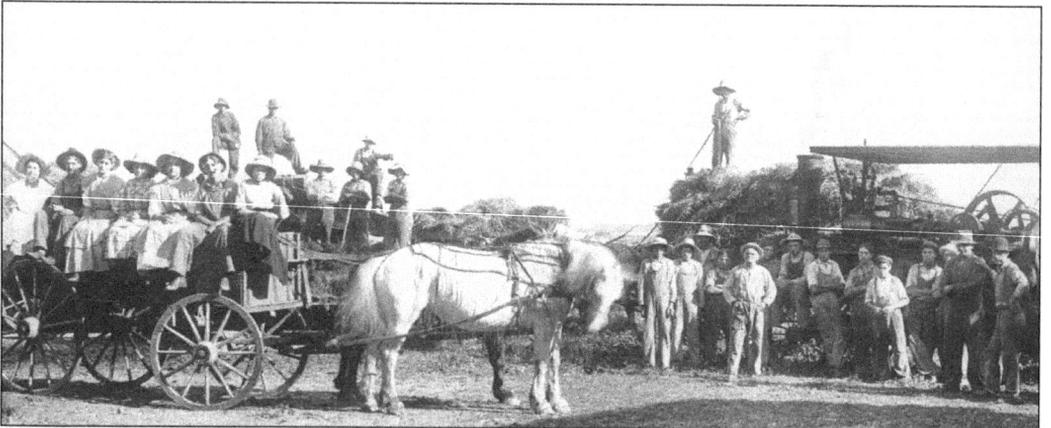

The first Case steam engine was produced in 1869, and by 1882 Jerome Case began supplying steam power for sawmills. By 1886, Case was the largest worldwide manufacturer of steam engines. The McNeal Brothers, Marsh and Norman, are shown threshing down on the farm c. 1910, using an old Case steamer that separated grain from straw. Marsh is standing in the center with hands in his pockets and Norman is in the engineer's cab.

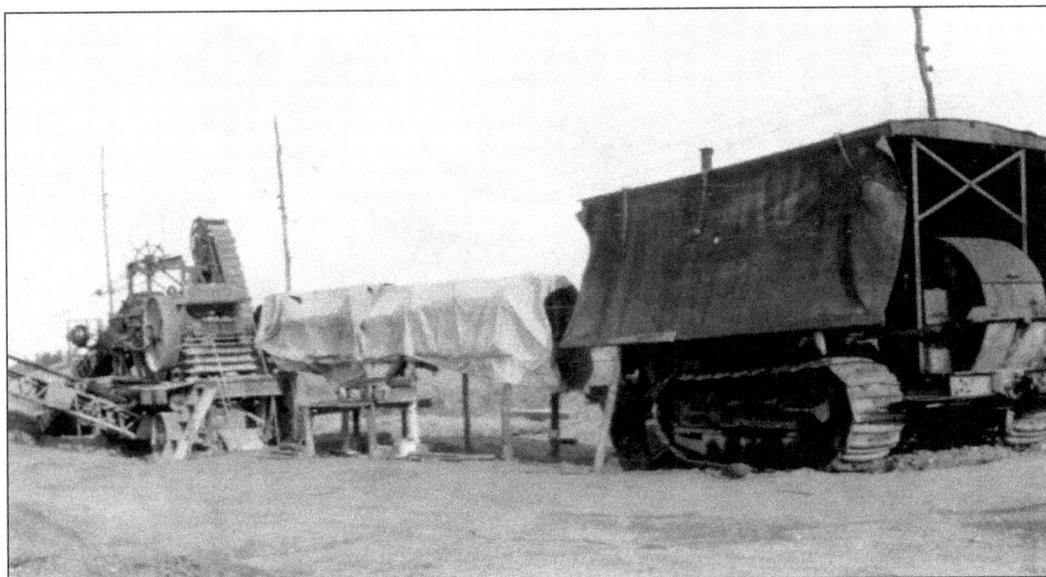

Clemens A. Hunck operated a farm in Benton County that employed the most up-to-date equipment and methods available. His farm buildings were well built and in excellent shape. His combined store, residence, saloon, and post office were on well-manicured landscaped grounds. Some of the farm implements used during the era are shown here.

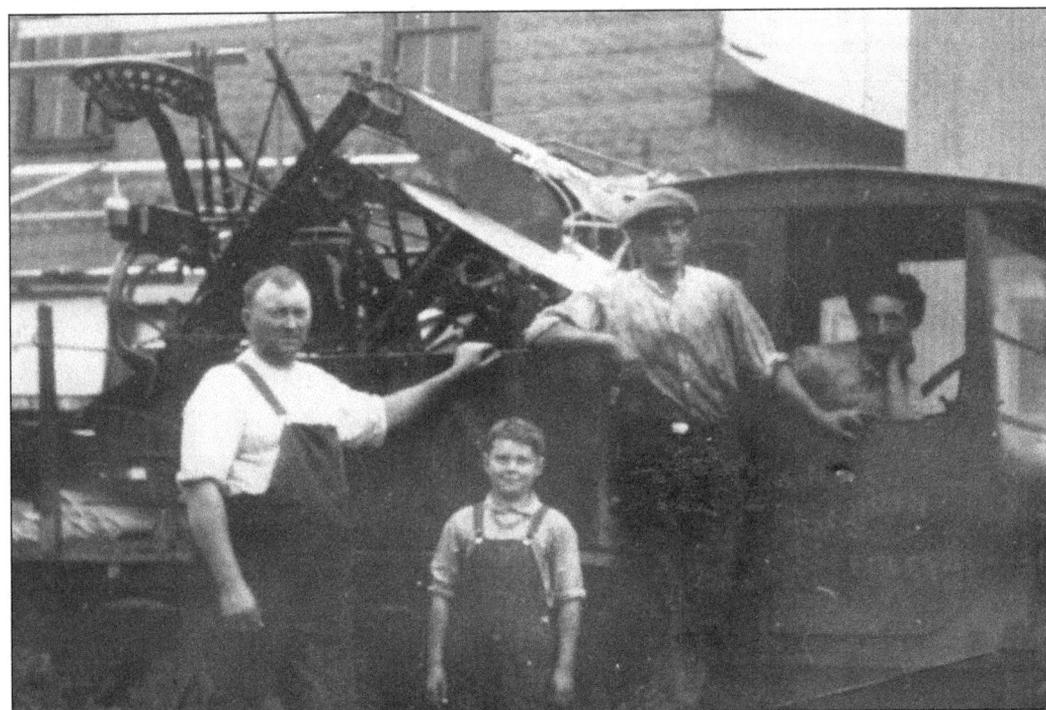

Kotsmith Implement was based in Foley. Pictured here, from left to right, are Jim Kotsmith, Sonny Kotsmith, and Emil Henry Kotsmith delivering supplies and equipment to the area's farmers. They also gave demonstrations of their products. A popular implement was the cream separator, used to skim the cream from the cow's milk. The boy in the photo is unidentified.

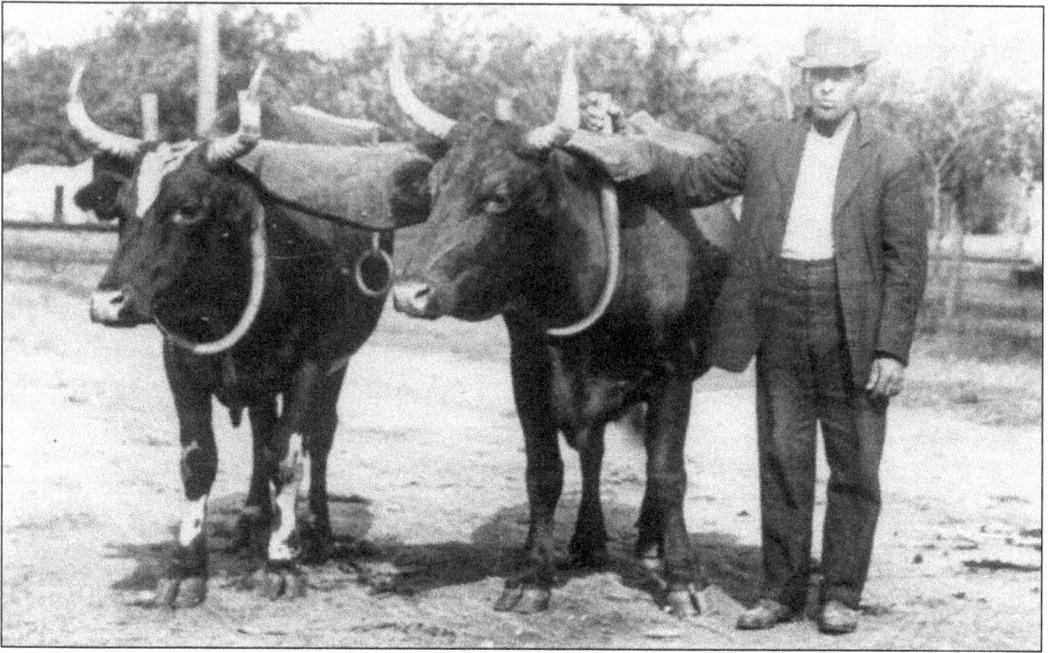

Oxen were used to cultivate the soil, pull stumps, and to haul lumber, supplies, and men in and out of the hardwood forests. Only in the last one-hundred years has the workhorse and finally the tractor replaced oxen in most of the modern western world. John Miller was the last to sell oxen in this area. He is pictured with his oxen team of "Belle" and "Star," taken in Royalton in 1910.

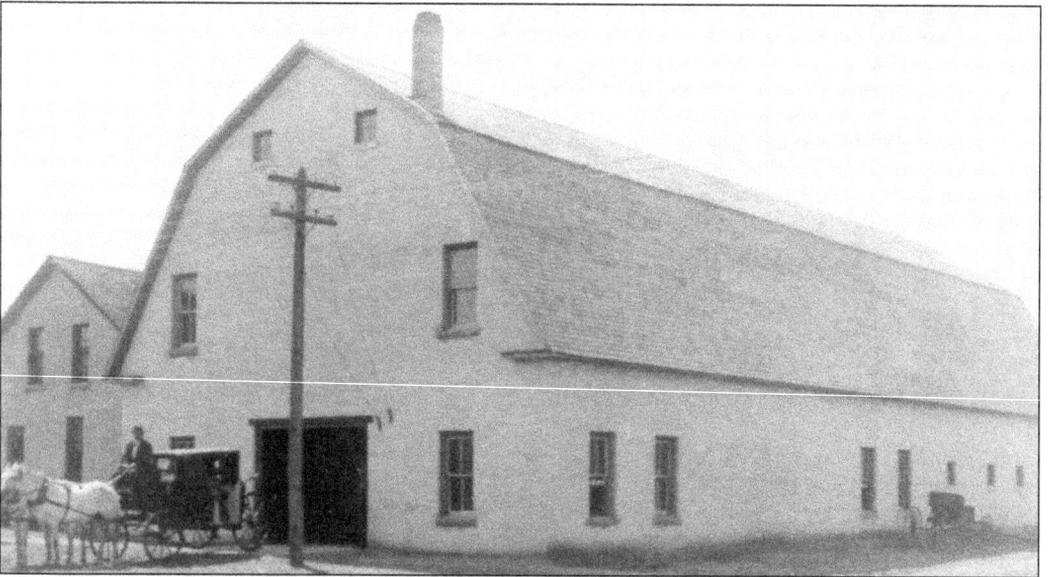

The William Jochum Livery Barn stood on the southwest corner of Second Avenue and First Street North in Sauk Rapids. In addition to renting out horses, wagons, and sleighs, the livery barn also provided a place for boarding horses, whether the farmer was just in town running errands for a few hours or departing for a few weeks by train. The barn burnt down in the 1930s in one of the worse fires in Sauk Rapids history. The fire was started by two boys playing with matches, and the livery barn was never rebuilt.

In May of 1903, Mr. Avery, a representative of the Maple Leaf Telephone Company, made a proposal before the Foley town council to start a local phone exchange. In July, Northwestern Bell began setting up poles between Foley and St. Cloud. There was quite a demand for the service as 43 subscribers were listed in early 1904. Here unidentified operators were ready to take calls in the telephone office over the State Bank in Foley.

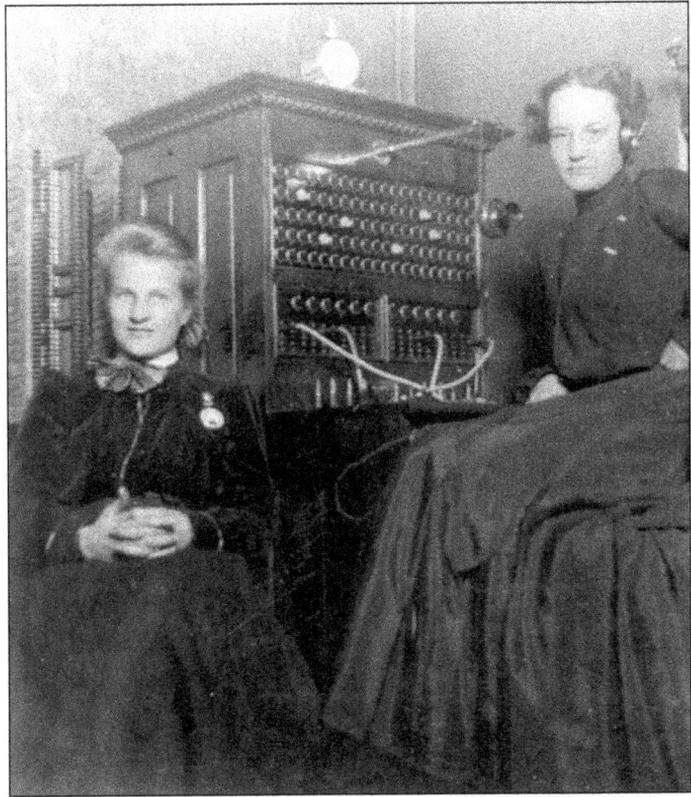

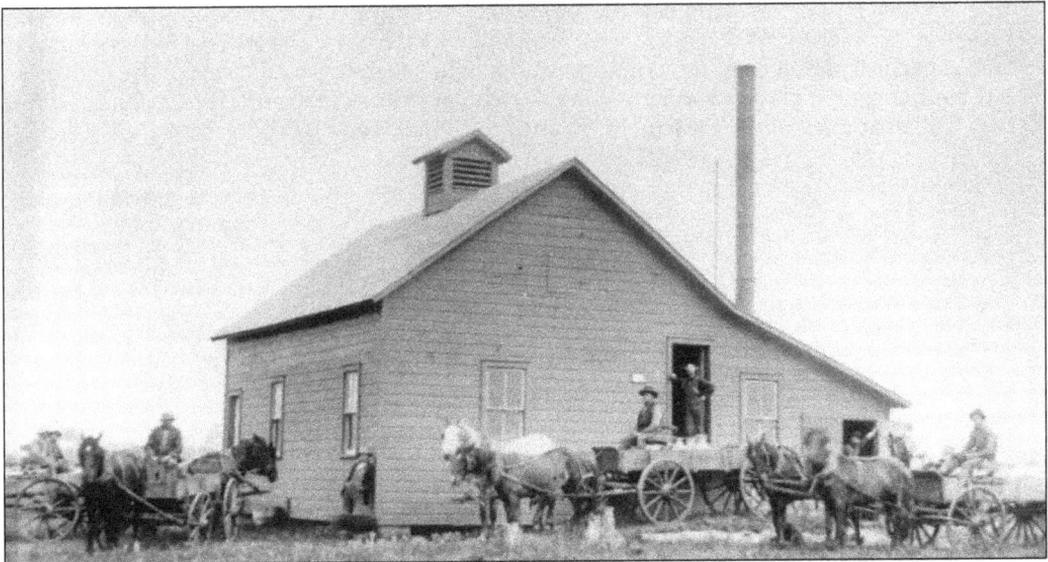

Seen here are horses and wagons next to Foley's first creamery building. Sweet cream was unheard of in those days. Much of the cream sold was already sour as cans stood in the hot sun waiting to be loaded. The sour cream would percolate from the top of the cans and dribble down the sides. Sour cream butter was considered good and buttermilk from such cream was the best.

The one-horse light freight wagon was used to deliver grocery orders twice a day and was part of the dray business. Boyd Lloyd, father of Jack and Jim Lloyd, operated the dray line when this picture was taken. The morning delivery was made at ten o'clock and the afternoon delivery was made at four o'clock. Wood boxes were used and reused to pack the grocery orders instead of today's paper and plastic bags. In winter months, a light sleigh was used to make the deliveries. The three young men in the wagon, from left to right, are Henry O'Konek, Joe Callahan (son of Barney Callahan the County Probate Judge until the 1930s), and Jack Lloyd.

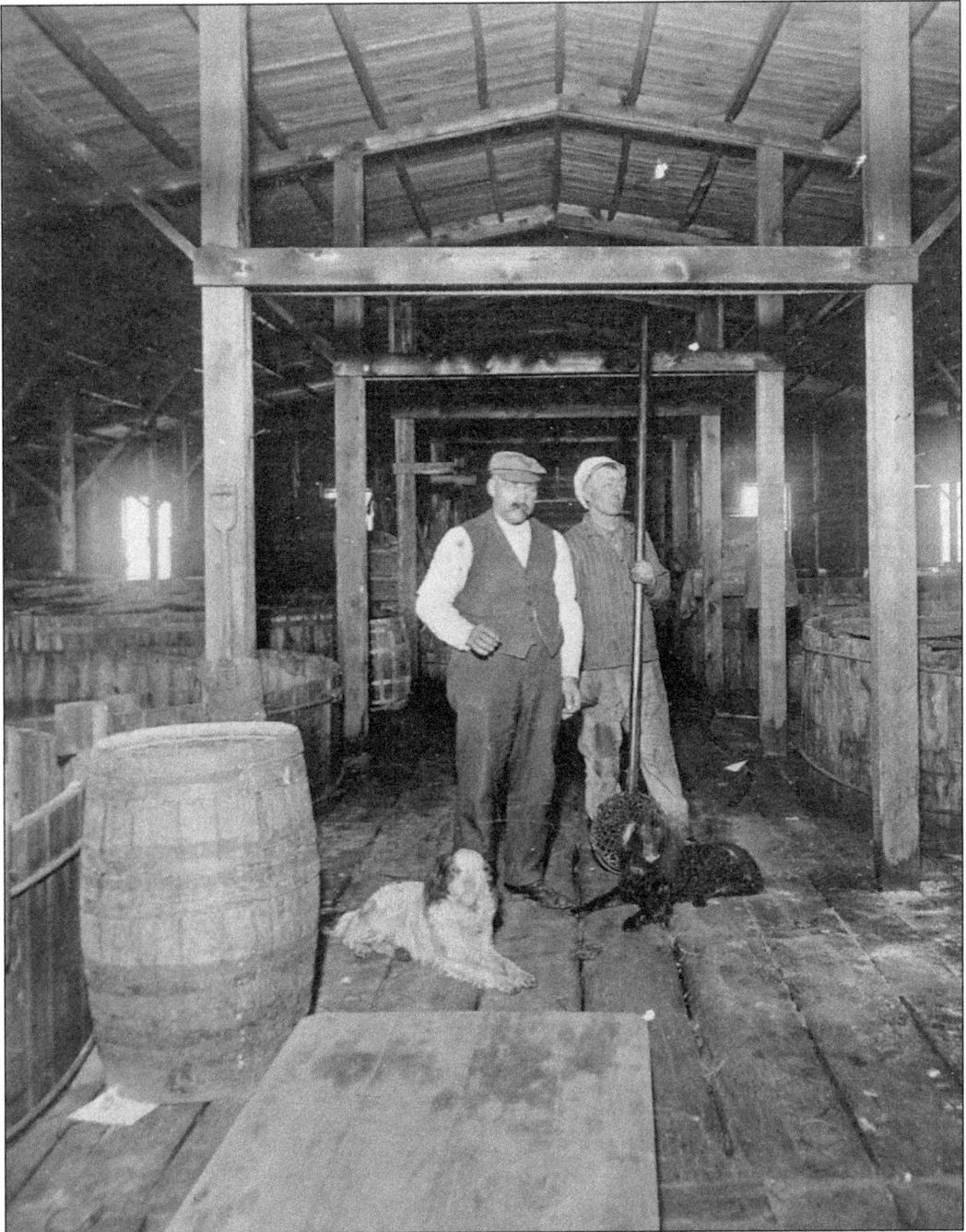

Frank and Jim Kotsmith took over the Foley pickle factory in 1911. The building pictured here held big wooden vats for making sauerkraut. The vats were about 10 feet deep and can be seen on both side of the raised center aisle. Cabbage was cut and placed in the vats with salt for curing. The plant contracted with farmers for acres of pickles and cabbage. Standing in the picture on the left is Bartley Klein, one of the partners of Klein and O'Donnell Hardware, later becoming the Foley Hardware Company. Mr. Johnson, an employee, holds a long handled scoop used for scooping sauerkraut and pickles from the deep vats.

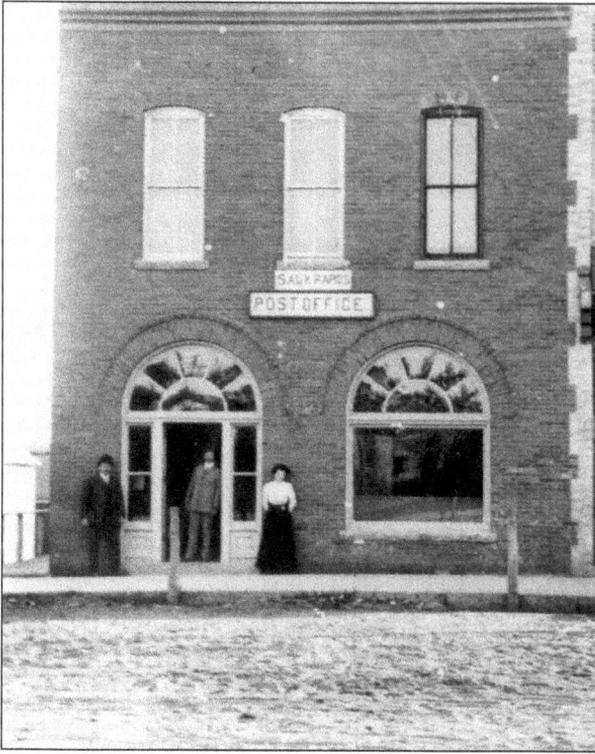

The first post office to be opened in Benton County was in Sauk Rapids in 1850, one year after Minnesota became a territory. Jeremiah Russell was Sauk Rapids' first postmaster. The post office was a popular daily meeting place to discuss current events. Peter Jansen, father of Mildred (Mrs. Fred) Benner, is pictured here standing in the doorway, c. 1910.

The well-dressed John Burski was postmaster of Sauk Rapids, and the uncle of Fred Burski. In the post office was a large bulletin board where notices of meetings, items for sale or wanted, auctions, legal notices, and other general information was posted. The board served to give area farmers timely notice of the activities in the community.

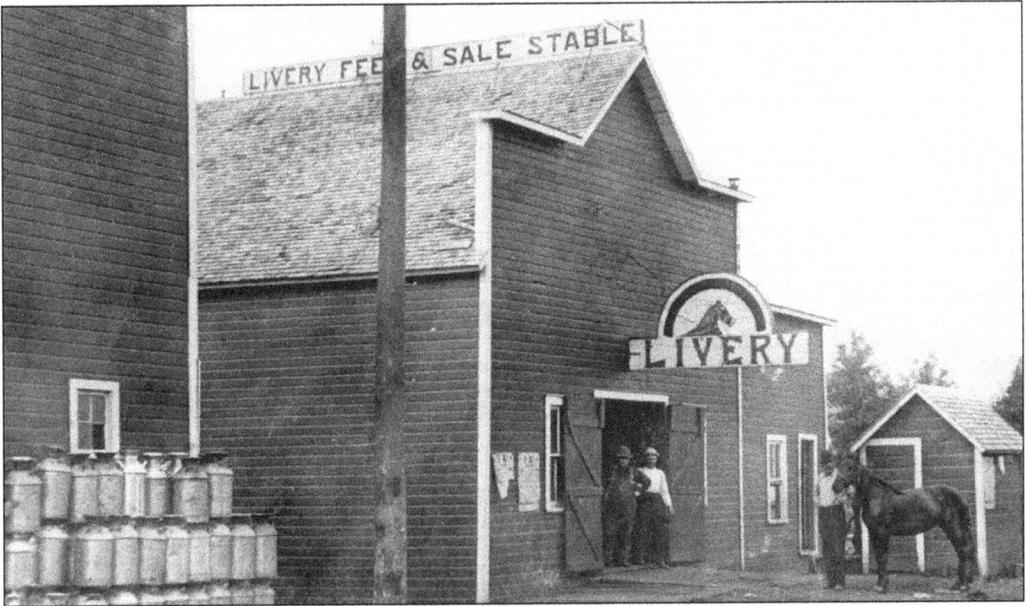

The Lloyd and Callahan Livery and Dray business was housed in this building on the south side of Dewey Street during 1912. The livery and dray business was good in the days before automobiles appeared and horses were the main means of transportation. Lloyd and Callahan did have one of the early horseless carriages, looking like a buggy but driven by a gasoline engine. Standing in the white shirt at the doorway is co-owner Barney Callahan, next to him on the left is Bill Howe buying cream for North American Storage Company. Notice the creamery cans stacked on the left. The man holding the horse on the right is Mike O'Rourke.

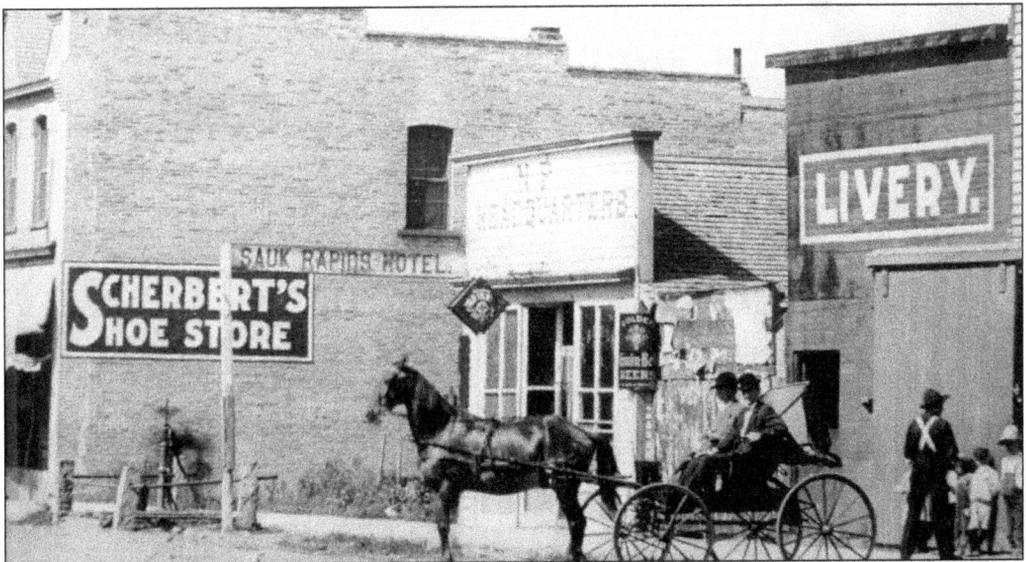

This photo of Broadway Avenue in Sauk Rapids is believed to been taken between 1896 and 1902. The building in the center of the photo (NP Headquarters) was Emiel Kurr's saloon, later to become Coborn's grocery store. The building to the right was William Jochern's livery stable that was later sold to Mansfield & Son, then Leas & Son. Scherbert's shoe store was destroyed by fire in 1919. Notice the water pump with handle next to the shoe store.

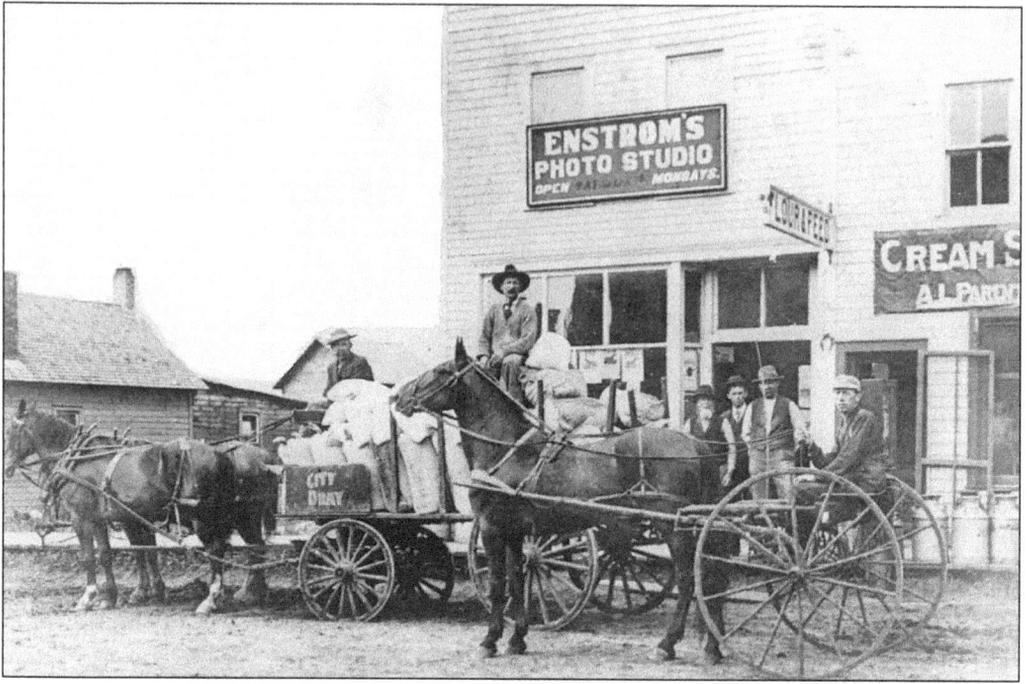

This early 1906 Foley street scene shows Archilles Parent's Flour & Feed and Cream Station right next to Enstrom's Photo Studio. When the City Dray service made daily deliveries to stores, local farmers made the trip into town to buy what they had ordered.

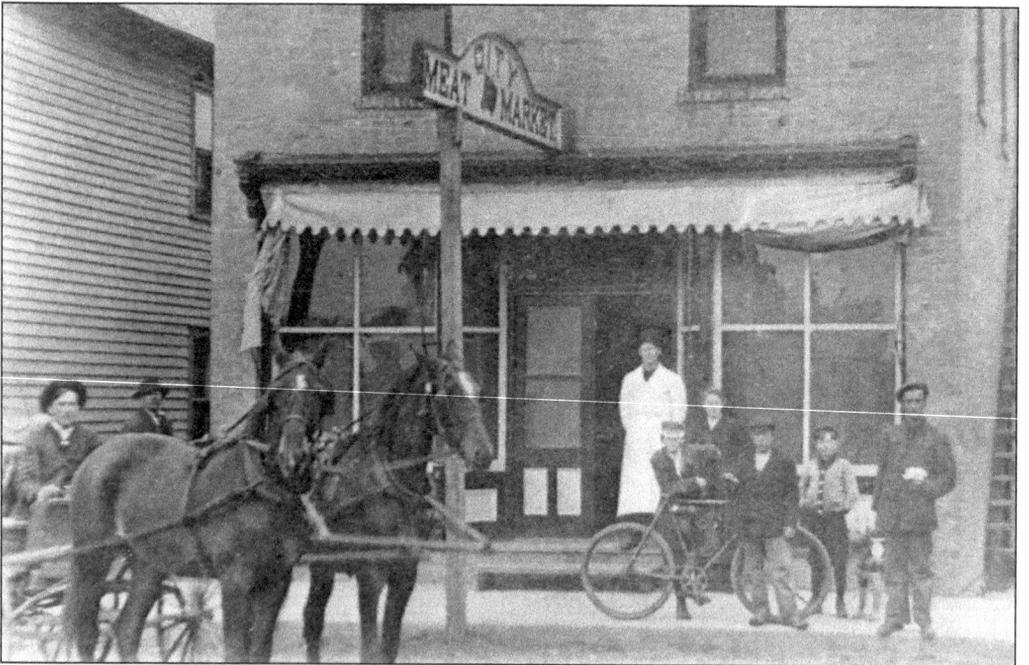

N.R. Lewis was the proprietor of Foley's City Meat Market in 1901. Inside, behind the butcher's counter, was an icebox with glass doors allowing customers to see the meat. Big blocks of ice were used to keep the meat fresh, the only refrigeration system used in the early days.

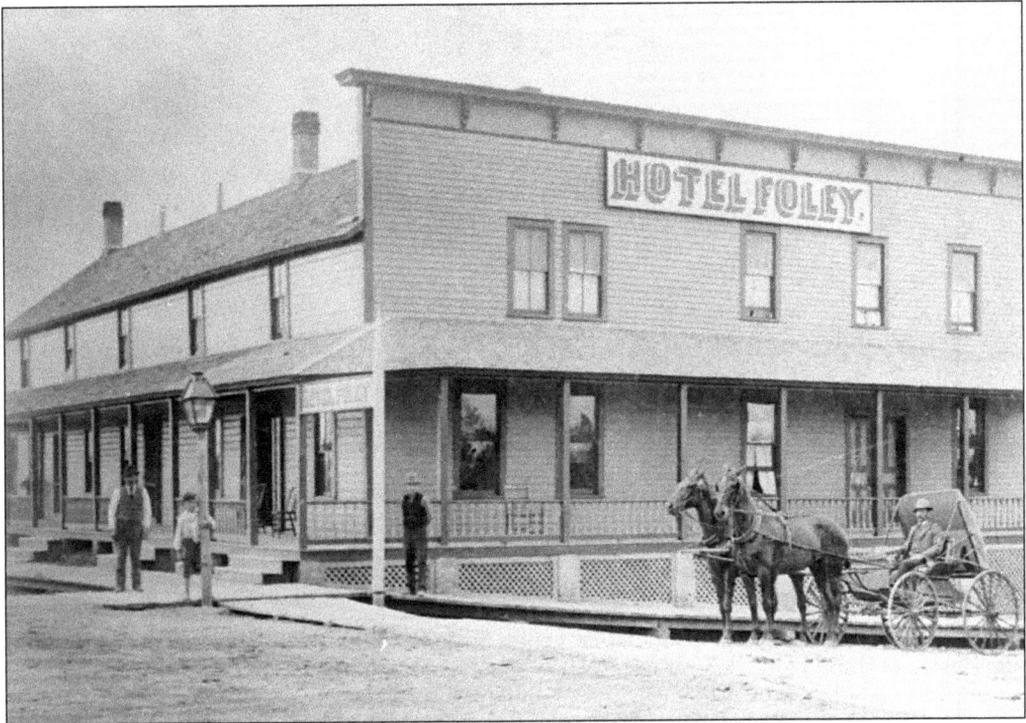

This is the Foley Hotel, built in the early 1890s by the Foley Brothers. When this photo was taken in 1902, Frank Leffingwell owned the hotel. He is sitting in the buggy in front of the hotel. Frank was also the County Sheriff at one time. Notice the wood sidewalks leading to the hotel building.

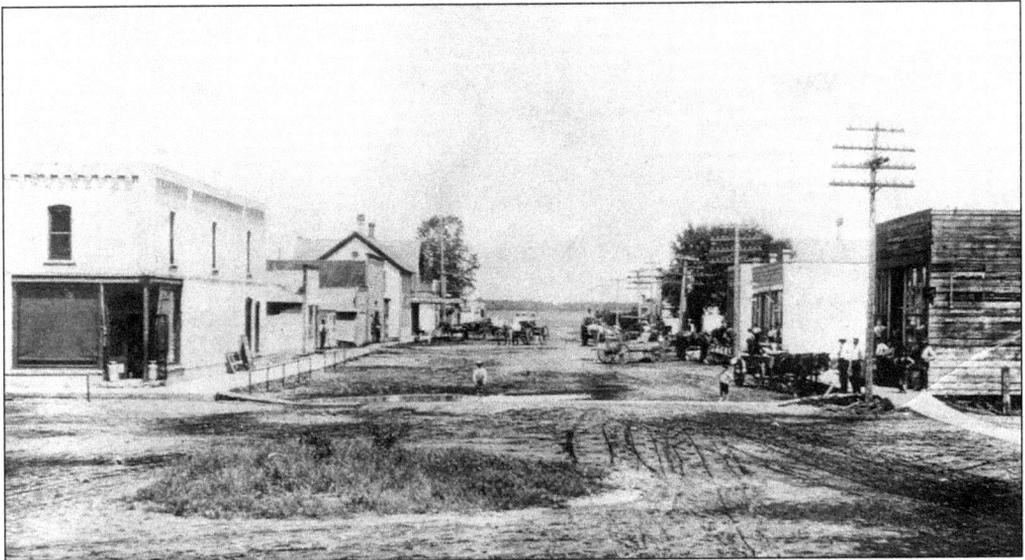

Although the center of City Government for St. Cloud was in neighboring Stearns County, East St. Cloud across the Mississippi River contributed much to early Benton County history. East St. Cloud was originally known as Benton City, and eventually was incorporated into the City of St. Cloud in 1888. Shown here is Front Street in 1905.

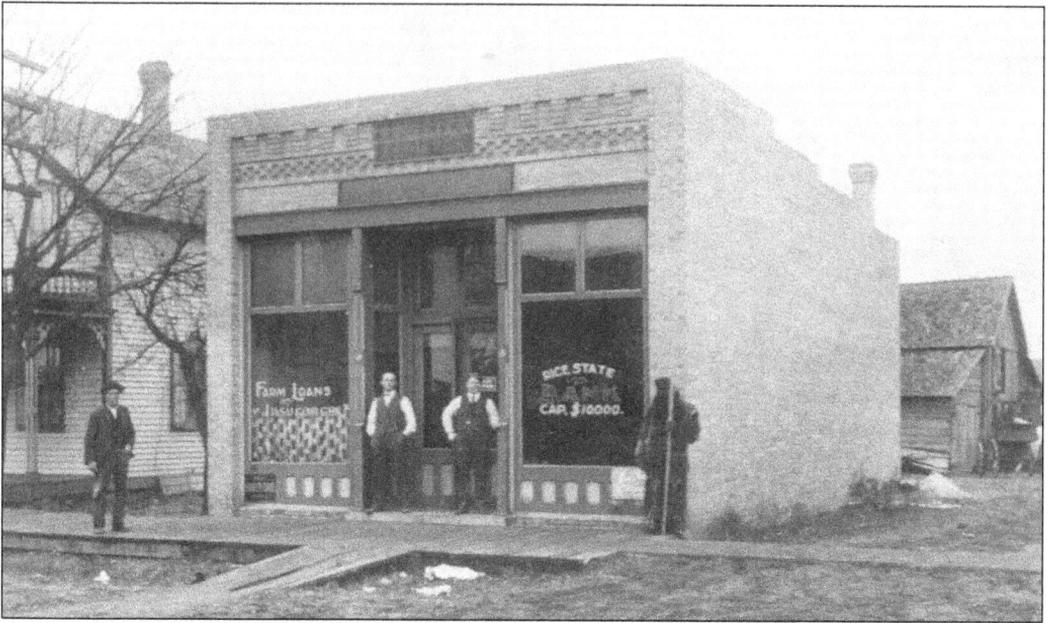

Farm loans were granted and insurance was sold at the Rice State Bank. The bank had capital of only $10,000 and FDIC deposit insurance was nonexistent until 1933. Today it is common to see consumer credit card limits exceeding what previously were monies used to start and operate a local bank in the early days.

Shown here is the interior of the Scherbert's Shoe Store in Sauk Rapids, 1909. Customer Anthony Kurr (left) is being helped by owner William ("Bill") Scherbert. The building has since been torn down after a devastating fire. Bill was very active in the local community and was the Sauk Rapids City Band leader from 1906.

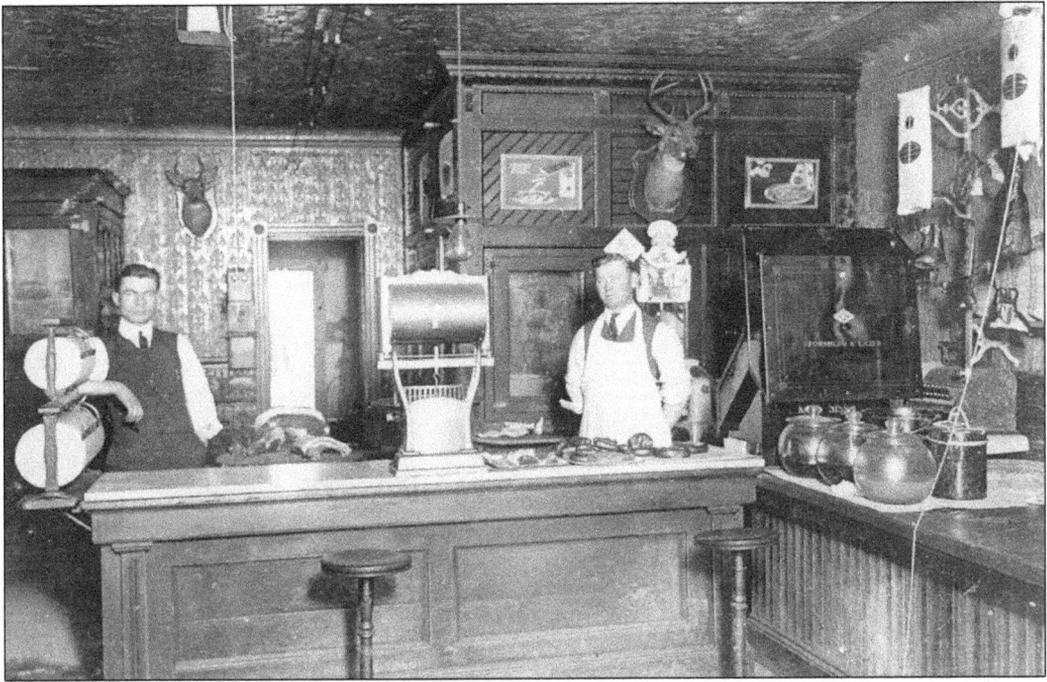

Forsberg and Lezer Meat Market was once located in the building now owned by Annie's Hotel. Pictured here are Earl Walters (left) and Forsberg (right). Notice the butcher paper wrap in rolls on the left and the scale in the foreground. Stools were furnished at the counter so the customer could watch while the meat was cut, weighed, and wrapped to order.

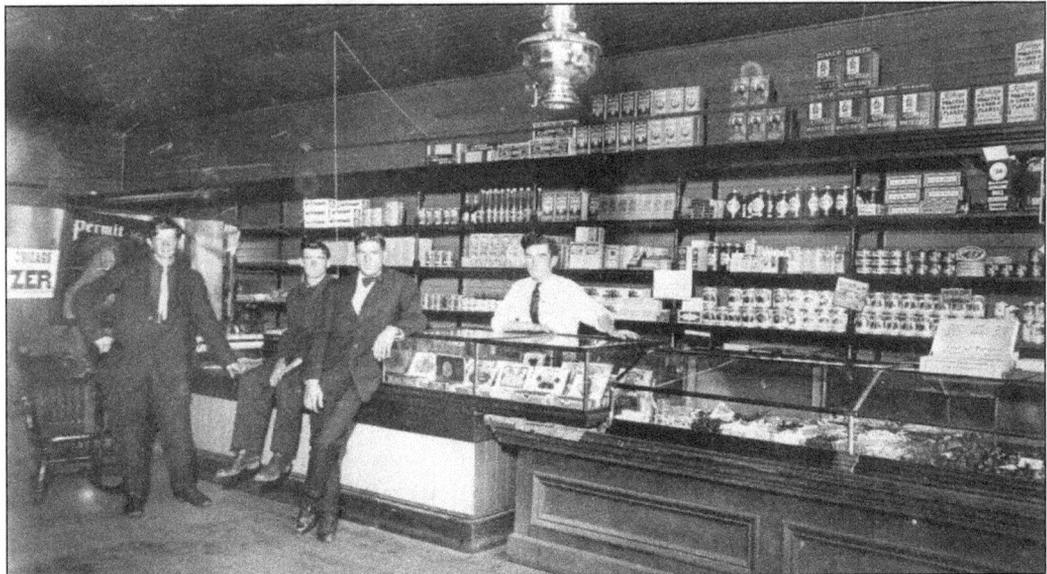

This photograph of the Ed Murray store was taken in 1911. Pictured, from left to right, are Francis Forquette (who after leaving Foley, served on the St. Cloud Police force until retiring, then made his home on the old Forquette farm north of Highway 23), Jay Murray, Rick Smith (a barber in Foley), and proprietor Ed Murray (behind the counter displaying his fine selection of cigars).

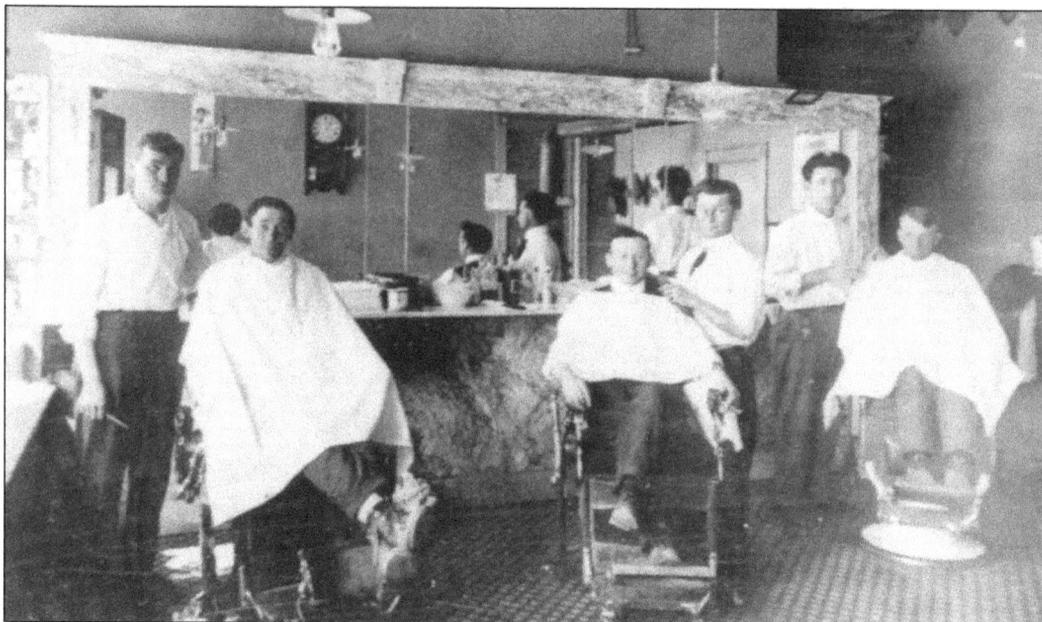

In 1916, Joe Kasner moved his barbershop next to the Foley Feed Store. The barbering trade was good then with haircuts costing 25¢. People would keep their hair well trimmed, visiting the shop often, sometimes as often as weekly. A shoeshine boy at the shop would charge 10¢ for his services.

On July 5, 1901, Drs. Hoyt (left) and J. E. Doheny (right) advertised their dental services for one week at the Foley Hotel in the local newspaper. Soon after, they became regular visitors, and then opened a permanent office. Dr. Hoyt practiced a short time in Foley before opening a practice in St. Cloud. This picture shows the dentists at their Foley location. After Dr. Doheny settled here, he married Ida Hall, a niece of John Foley. He had one ambition in life, to achieve a record of 50 years of service, which he accomplished in 1943 when the Minnesota Dentist Society honored him by awarding a life membership to him in the state organization.

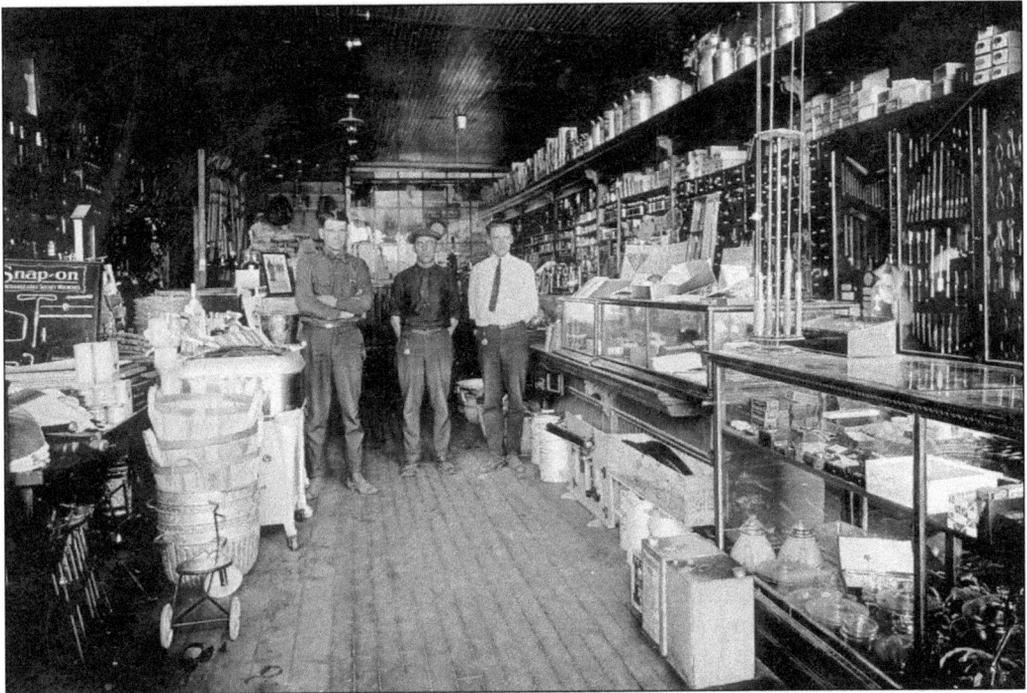

Shown here surveying the merchandise in the Sauk Rapids Hardware store during the early 1920s, from left to right, are Joseph Neron, Marcel Steinbach, and Dominic Hennen. The building located on the corner of Benton Drive and First Street North was later destroyed by fire in February 1979.

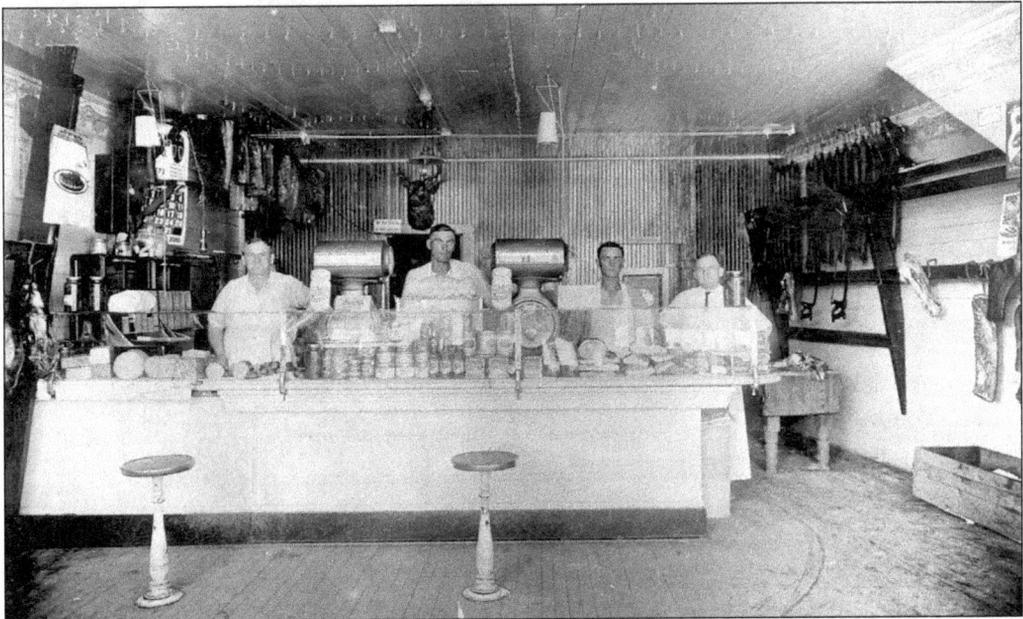

Ready to serve you at the Heinzel Meat Market in 1924 were, from left to right, Chas Heinzel, Paul Wickman, Eddie Jahn, and Aug. Heinzel. The market was located at the corner of South Broadway and west side of Van Ness Street. The building was later destroyed by fire.

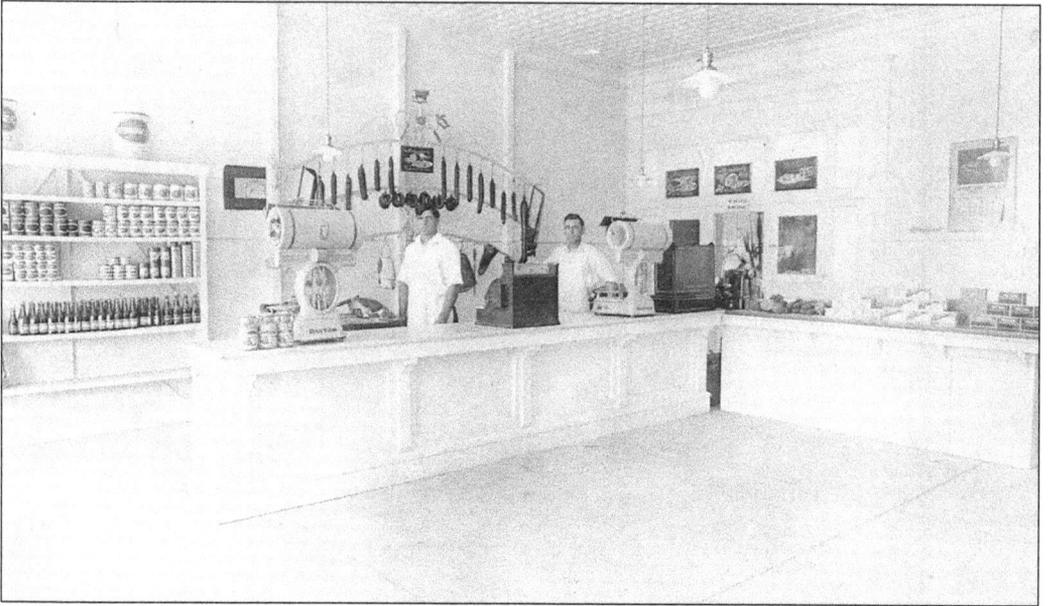

The White Food Market in 1920 was both pristine and spotless, with Mike Cziok (left) at your service, assisted by Charles Reedstrom (right). The building was believed to be located in the parking lot of the Ben Franklin store.

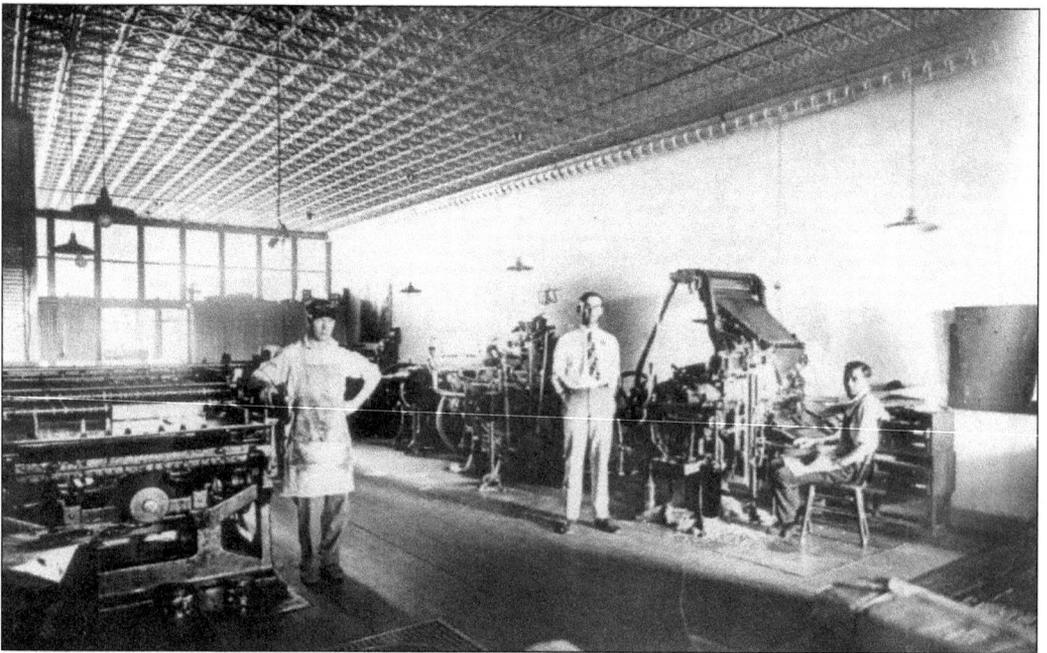

In 1873, George Benedict started *The Sauk Rapids Sentinel* newspaper. It was the only newspaper in Benton County for many years. Shown is the *Sauk Rapids Sentinel* plant as it looked in the 1930s. Ed Vandersluis, owner and publisher, is pictured in the center, with pressman James Nolden (left) and Al Tofting (right).

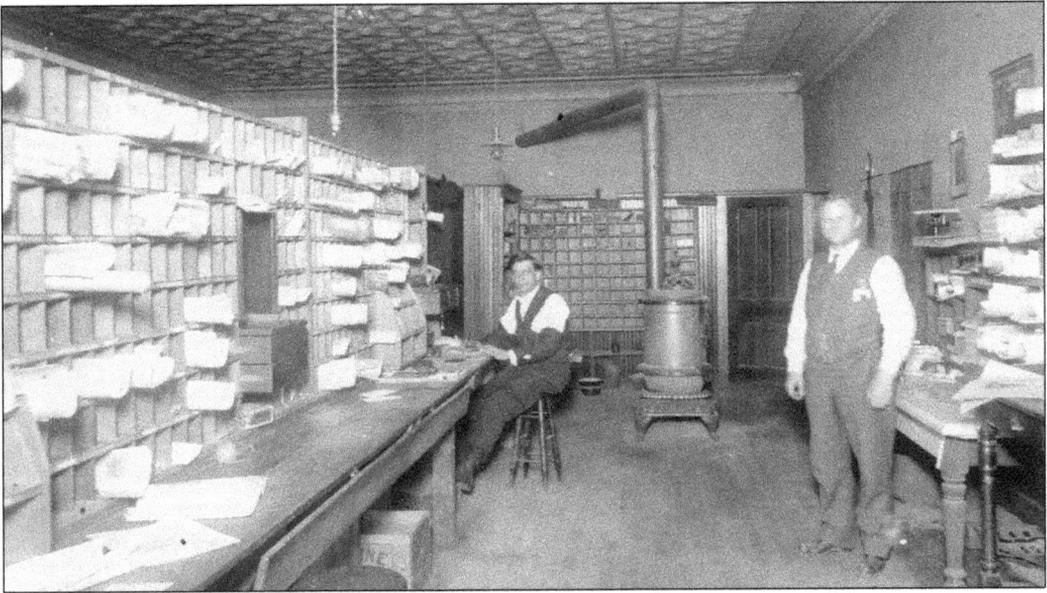

The postal system played an important part in public information, along with the newspapers. Sorting mail took place in the Sauk Rapids post office, which was located on Broadway after 1929. William Baron is sitting on the left and postmaster Emiel Kurr is standing. The pot-bellied stove kept the room warm in the winter.

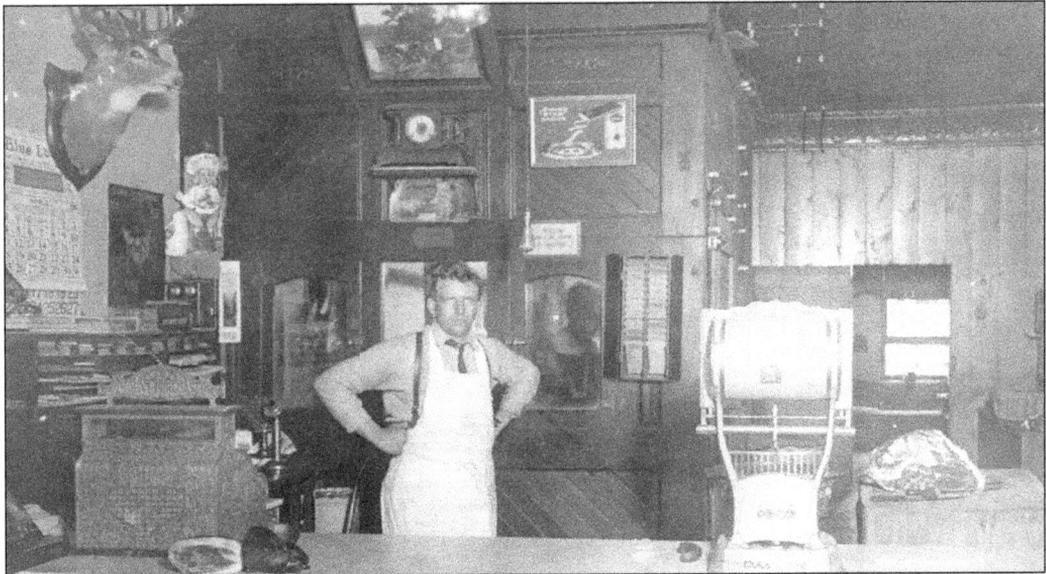

Ernest Stauffenecker was the head butcher and a partner in the Stauffenecker Meat Market during early 1915. The counter in the market had a solid marble top with a Dayton scale on one end and the cash register at the left. Part of a beef slab is shown on the wood cutting block near the scale. At the left, back of the cash register was a desk where some of the account books were kept.

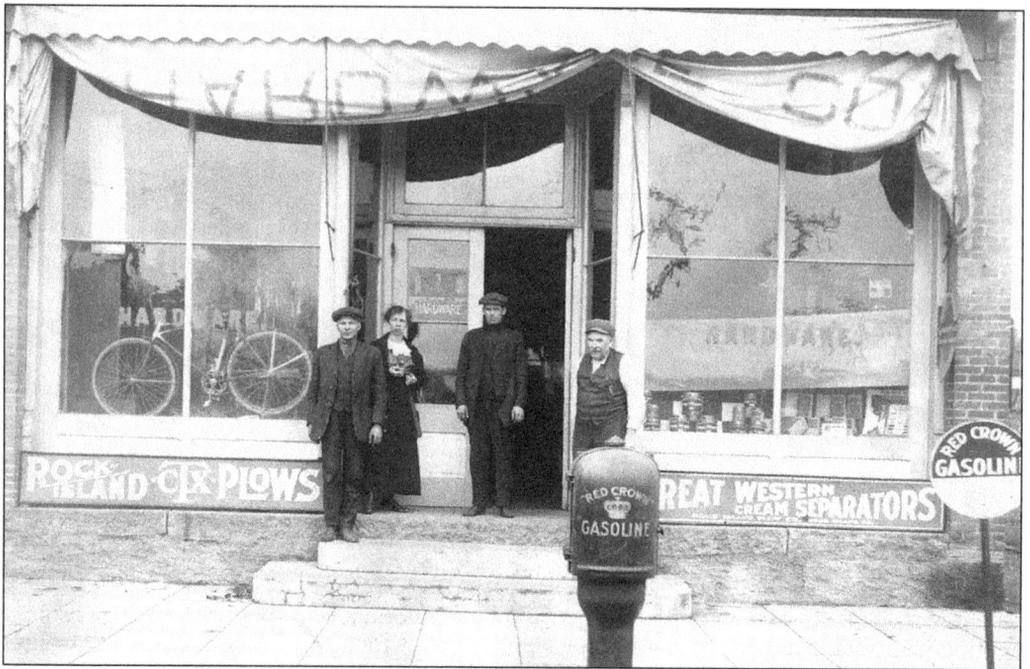

Shown here is an early photo of the exterior of the Sauk Rapids Hardware store where farmers could trade money and goods for implements. Believed identified to be in the doorway is J.C. Niesen, other residents are unidentified.

In 1909, there were 9,000 theaters operating in the United States. That number had jumped to more than 20,000 by World War I. Movies, considered by some at the end of the 19th century to be a passing fad, had become prominent in early-20th-century life. In 1910, Robert Morrison and John McElroy bought M.V. Leonard's opera house in Foley, and the new owners showed moving pictures throughout the winter.

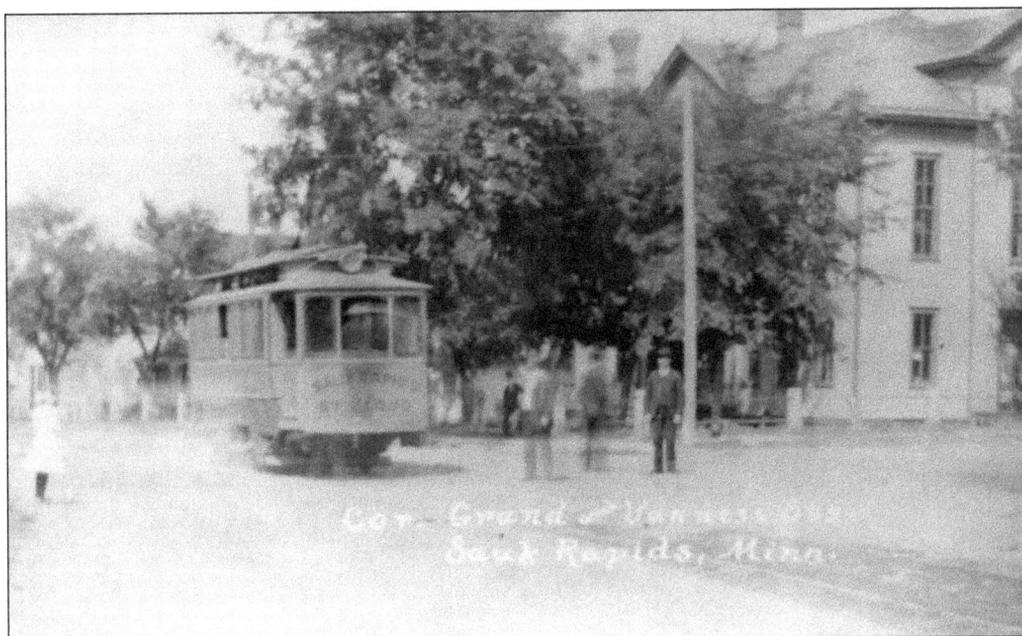

The electric railway system was completed from St. Cloud to Sauk Rapids about 1892. The tracks extended across the St. Germain bridge in St. Cloud to Wilson Avenue NE and to Sauk Rapids on Grand Avenue. The tracks ran to Eighth Street North and then back to St. Cloud. Pictured here is the streetcar on Grand Avenue (presently Second Avenue) and Van Ness Street (Division Street). The courthouse is on the right side of the photo.

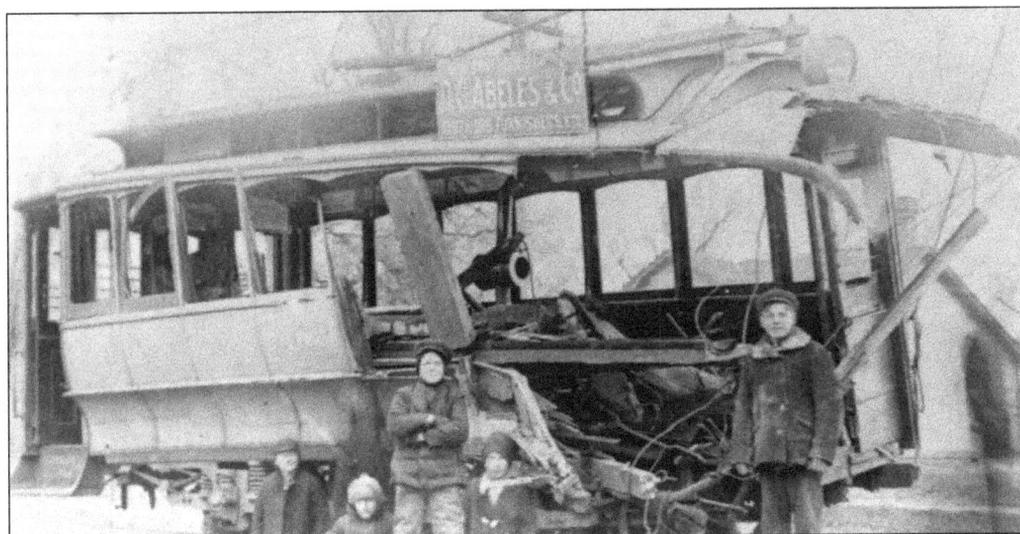

The streetcar used a hand brake and each had a motorman and a conductor. Sometimes accidents would happen, as depicted in this photo. On April 29, 1936, the last run from St. Cloud was made. A parade was held in conjunction with that event. The Raymond Brothers then started a bus transportation system serving Sauk Rapids residents.

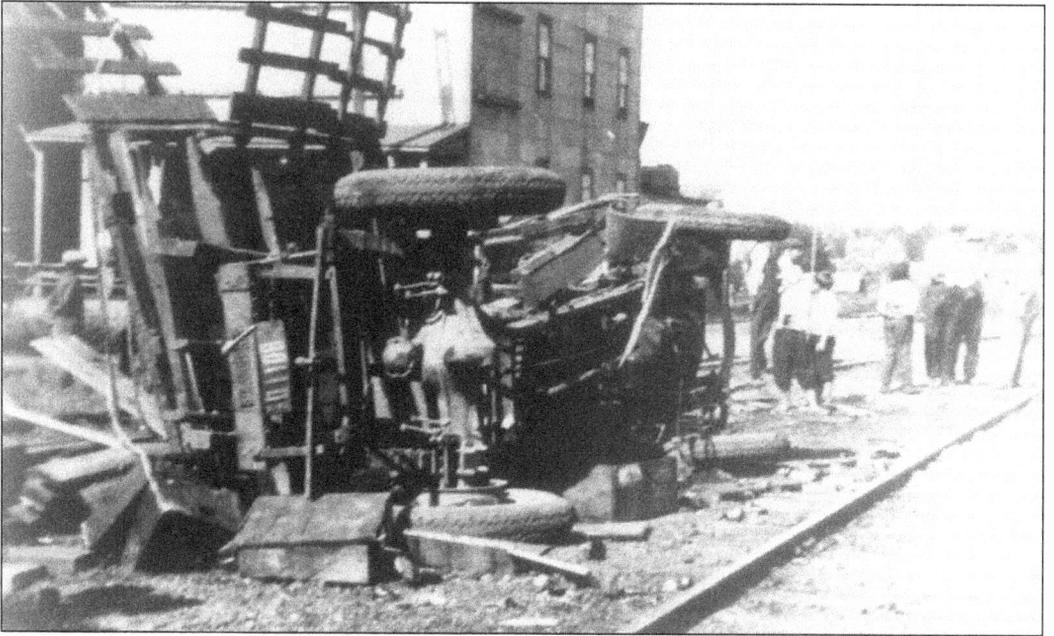

A westbound Great Northern train destroyed this delivery truck at the railroad crossing on Broadway Avenue, estimated in the late 1920s or early 1930s during the summer. The contents of the truck can be seen in the picture, scattered along the tracks. A number of people were at the depot and witnessed the accident. The condition of the driver or any passengers is unknown.

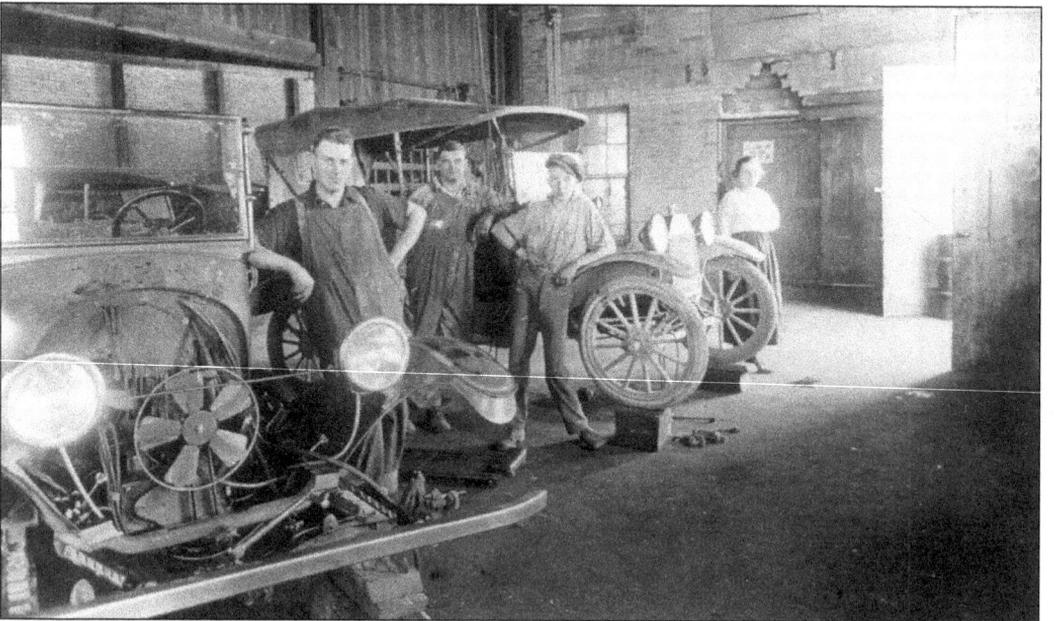

After World War I, many businessmen felt there was a good future in the auto repair business because of the increased production of automobiles. Shown here in the interior of the Schlough Garage in Sauk Rapids, from left to right, are Fermie Arensberger, Barney Deppa, Bill Kosloske, and Eleanor (Albright) Sartell.

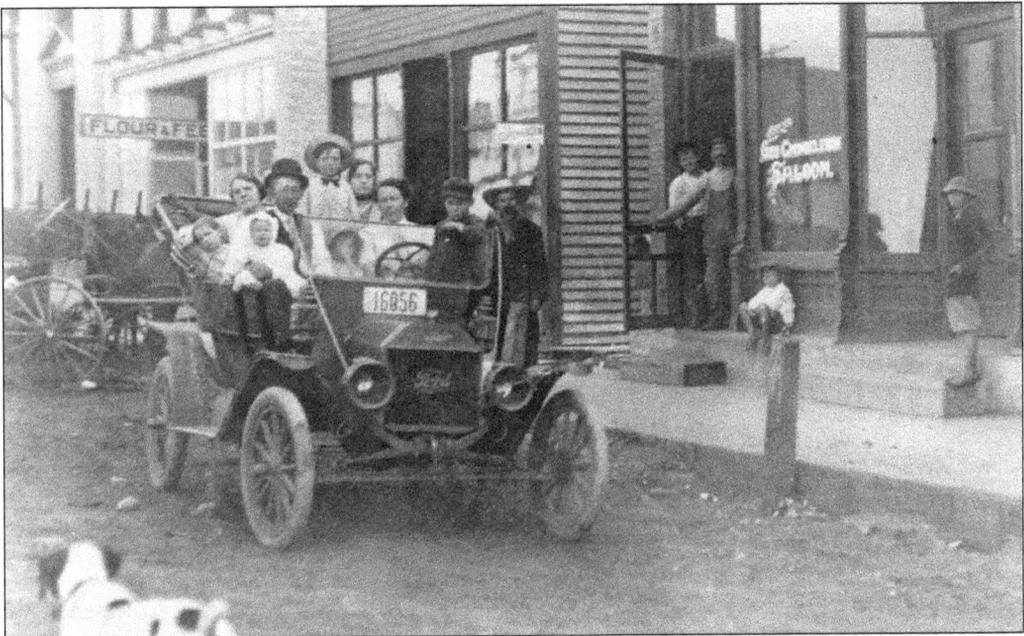

George Chmielewski with a group of passengers in his auto passes the Chmielewski saloon, a popular gathering spot for the men. Here it was not uncommon to transact business, talk about community events, and have stimulating political discussions. The photo below shows the interior of the saloon.

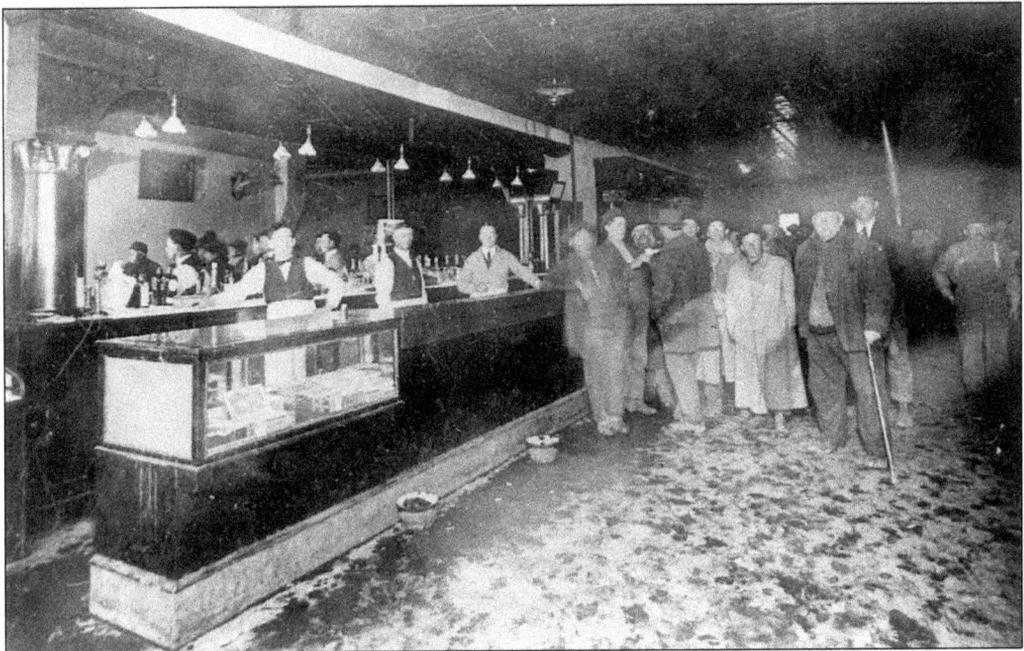

Spaced on the floor in front of Chmielewski's bar were brass cuspidors, also known as spittoons, for the purpose of keeping the floor clean. Patrons could get a drink at the long bar then gather in groups to converse about the topics of the day. Located in back of the saloon were some tables and chairs.

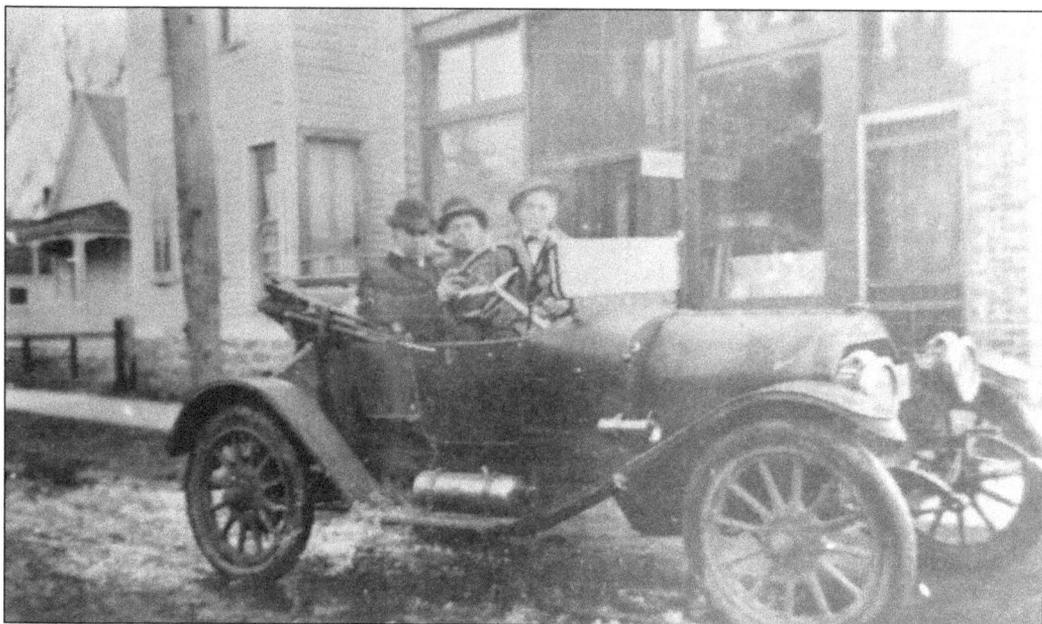

Peter Jansen is shown driving a 1907 automobile in front of the *Sauk Rapids Herald* office on Second Avenue South. The *Herald* was established in 1932 by Fred Agather and sold to Lee Batcheler in 1935. Mr. Batcheler then purchased the *Sentinel*, which had moved to St. Cloud, and consolidated the two newspapers under the *Herald* title in October 1948.

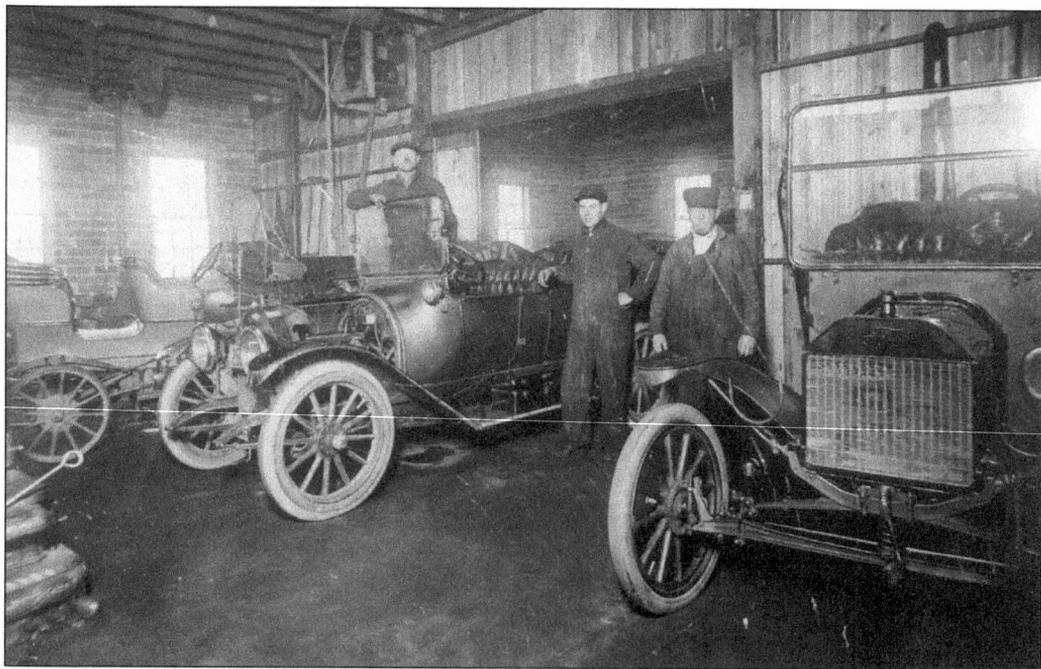

Schlough's Garage, when located at North Broadway (today's Benton Drive) and Warren Street (today's Second Street North), as it looked between 1917 and 1918. Men in the photo are unidentified. Henry Ford of Detroit, Michigan, began mass-producing his Model T in 1908. In 1927, when the model was discontinued, over 18 million had rolled off the assembly line.

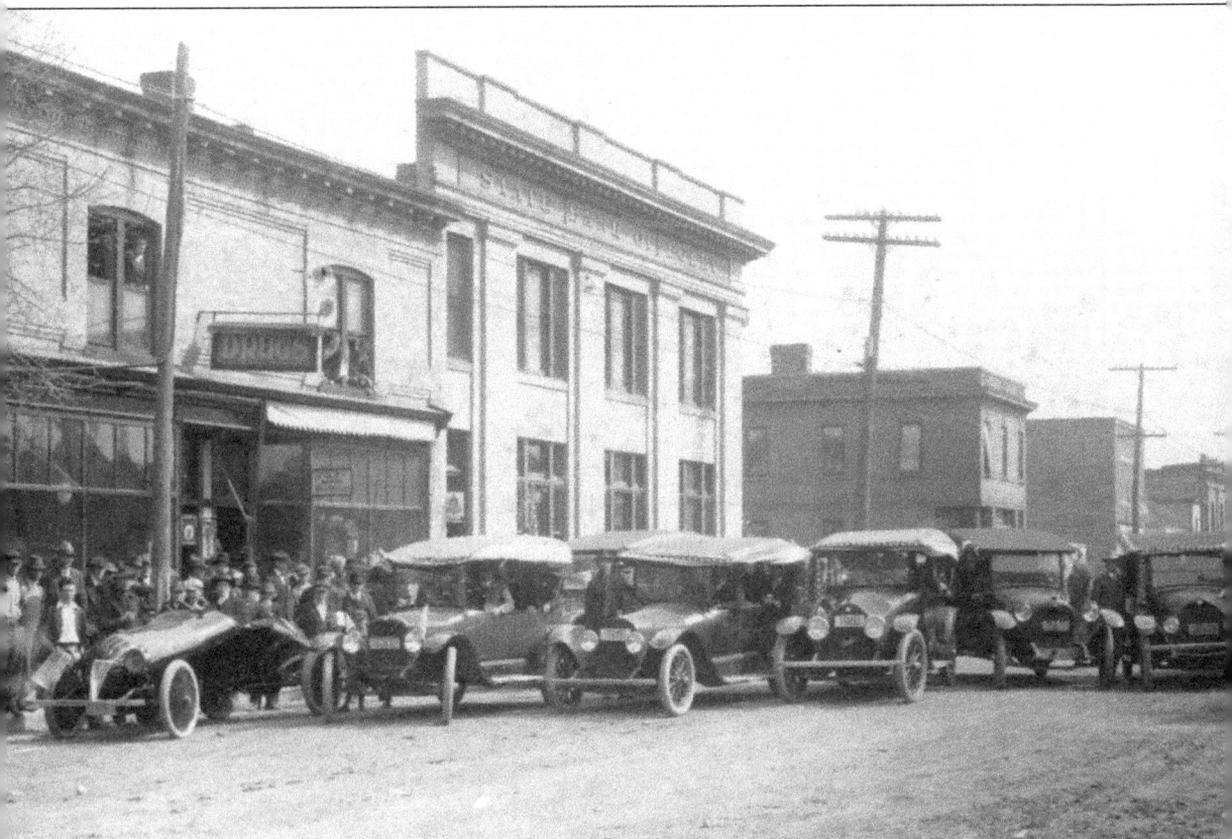

War was declared against Germany on April 6, 1917. All males between the ages of 21 and 30 had to register for the draft. Area men drafted into the service are shown leaving from downtown Foley. They are, from left to right, Harold Baskfield, Frank Bible, Paul Bible, William Buckley, Lee Campbell, Richard Dedic, Joe Gamroth, Ray Howe, John Mushel, and Paul Plombon, all of Foley; Edmund Bielejeski, Frank Gorecki, Stanley Jurek, John Malek, Mike Moulzolf, Anton Orzchowski, all from Gilman; Martin McGuire of Gilmanton; Clifford Freeman from Granite Ledge; and Fred Anderson, George Demaires, and Royal Matson from Maywood. There would always be a good crowd of residents seeing the men off for training. The tree on the left was there for many years and the only one on the Foley downtown street for a long time.

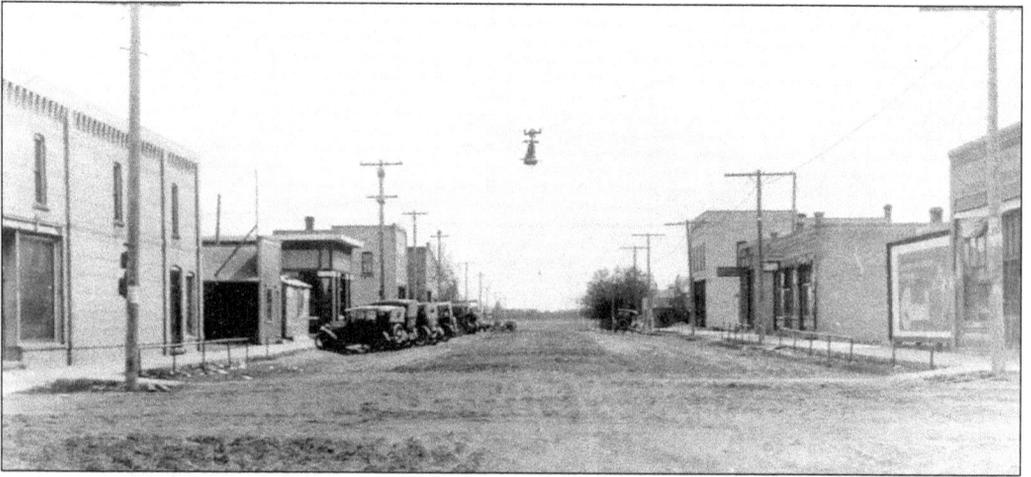

Early vehicles can be seen parked in the distance in this scene of Rice. Laws were passed to prevent speeding. Automobiles were forbidden to travel more than 15 miles per hour or 8 miles per hour within two blocks of the post office. Motorists frequently were fined $1 plus costs for violations.

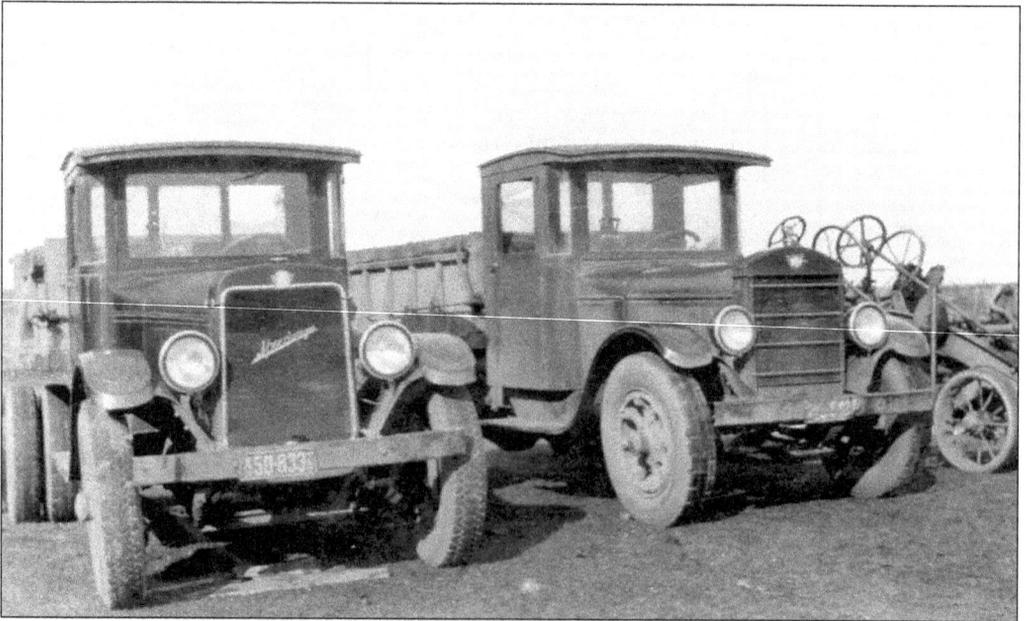

Farm trucks and other implements such as tractors are lined up for service. In 1918, according to official records, Benton County had 835 automobiles, the majority of them owned by farmers.

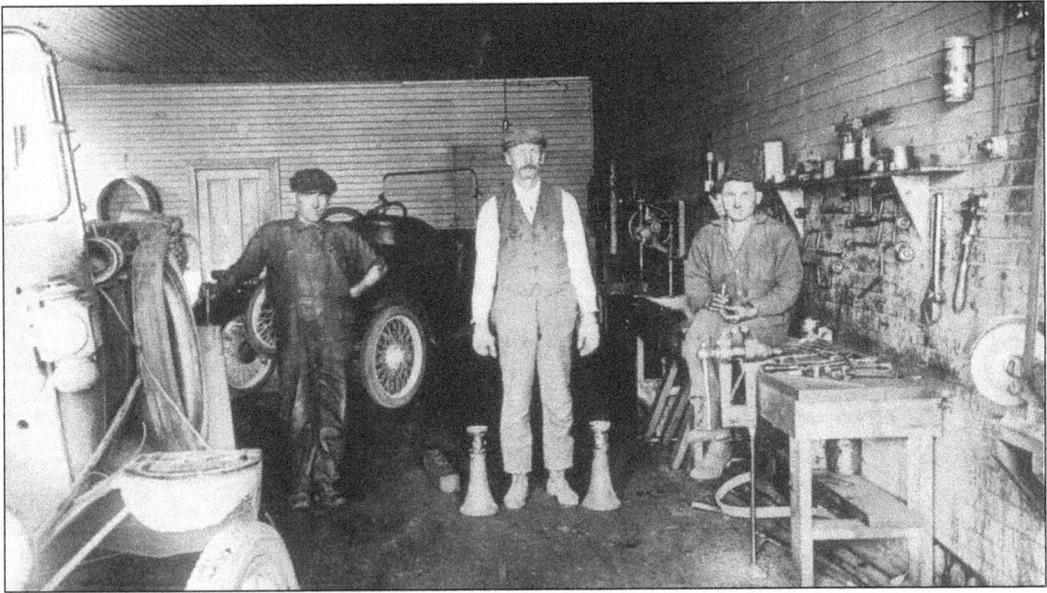

The Bolagek Brothers Garage started in Foley in 1920 and was located on the southwest corner of Third Avenue and Dewey Street. Pictured here, from left to right, are John Bolagek, Ed Latterell, and Joe Bolagek. The Ford vehicle with the wire wheels at the back belonged to John Bolagek and was a fancy auto in the early days. Ed Latterell's vehicle (on the left) was being repaired at the time. His Ford had wood wheel spokes and a brass radiator. Repair equipment was very limited. A workbench ran along the wall with a variety of tools hanging ready for use.

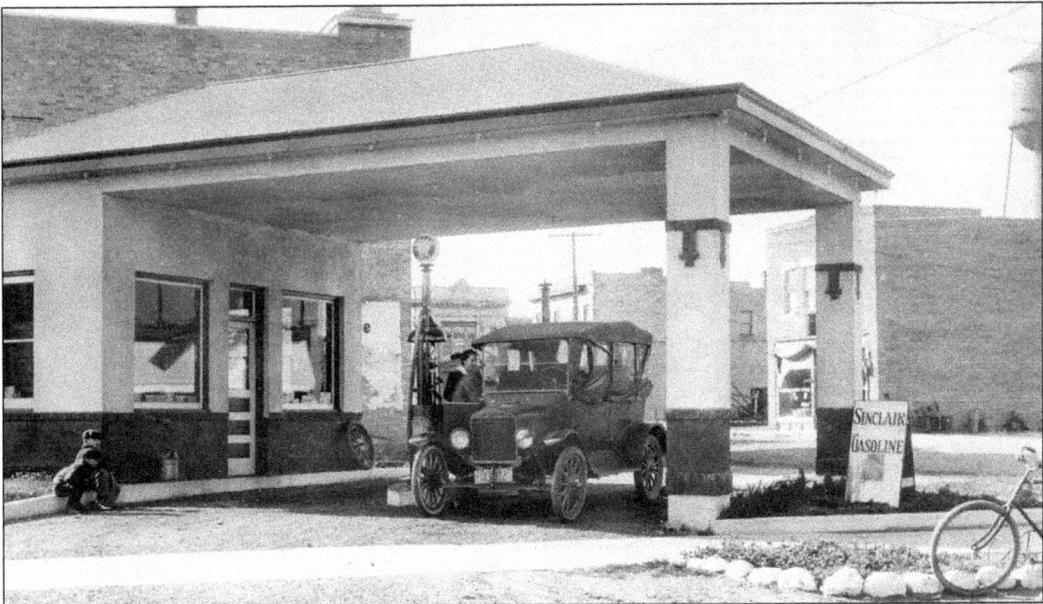

Thomas O'Rourke Sr. built the Sinclair service station and opened it on October 26, 1921. It was the second station built in Foley. Walt Frende and Frank Dzuik had started the Foley Oil Company a few years earlier. Thomas is filling gas for a customer in this picture. For this 1917 Ford, it was necessary to take out the front seat cushion to fill the gas tank under the seat. A hand crank operated the early gas pump, with a dial recording the amount of gas pumped.

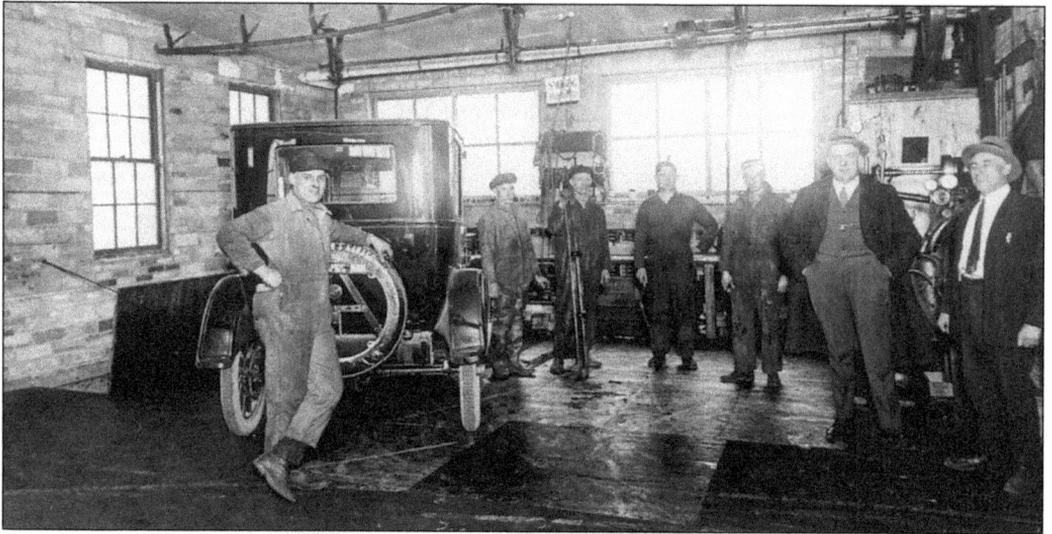

Fermie Arensberger stands next to a 1922 Chevrolet sedan in the interior of the Schlough Garage. In the background, from left to right, are unidentified, Walker, Jack Johnson, Dutch Kutzorick, Billy Kosloske, an unidentified Chevrolet representative, and Joe Schlough. The garage was located on the corner of North Broadway and Warren Street. It was owned by J.C. Schlough from about 1914 and was a major auto repair garage in Sauk Rapids for many years.

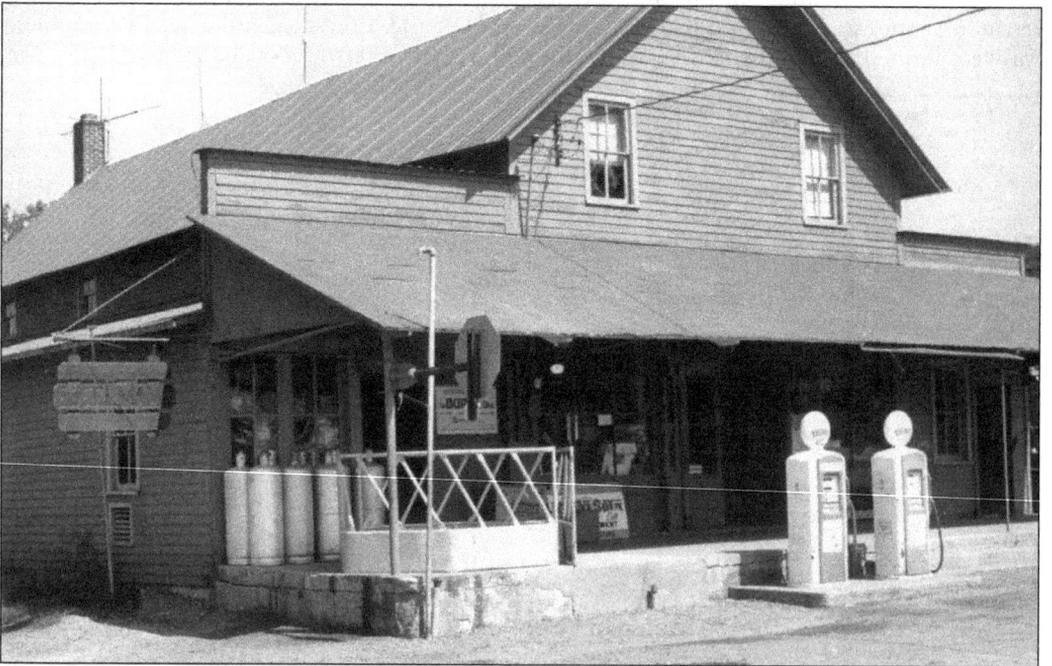

The Esselman Brothers General Store is an example of businesses that popped up as ethnic settlements expanded eastward during the late nineteenth and early twentieth centuries. These one-stop shops served the needs of the surrounding communities by offering hardware, gasoline, and groceries. This store originally opened with $65 worth of merchandise in 1897. The building and counters essentially look today as they looked at the turn of the century. The Esselman Brothers General Store is listed on the National Register of Historic Places.

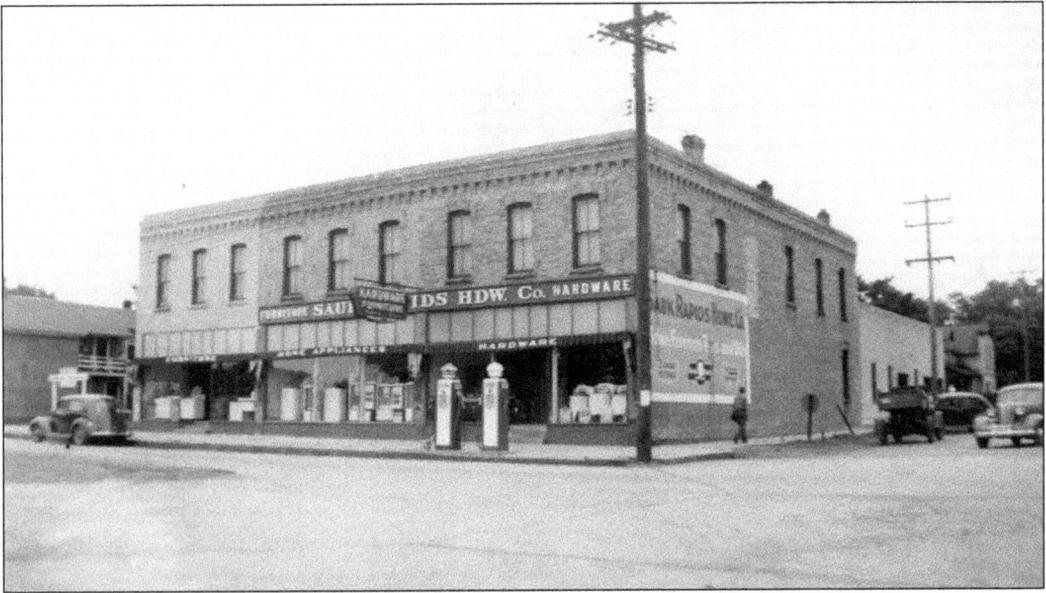

This photo depicts the Sauk Rapids Hardware store in the earlier days. Besides carrying a variety of tools and other items, the store carried appliances and furniture. You could even purchase gasoline from the gas pumps on the curb. Notice the height of the stop sign near the man walking on the sidewalk near the right of the picture.

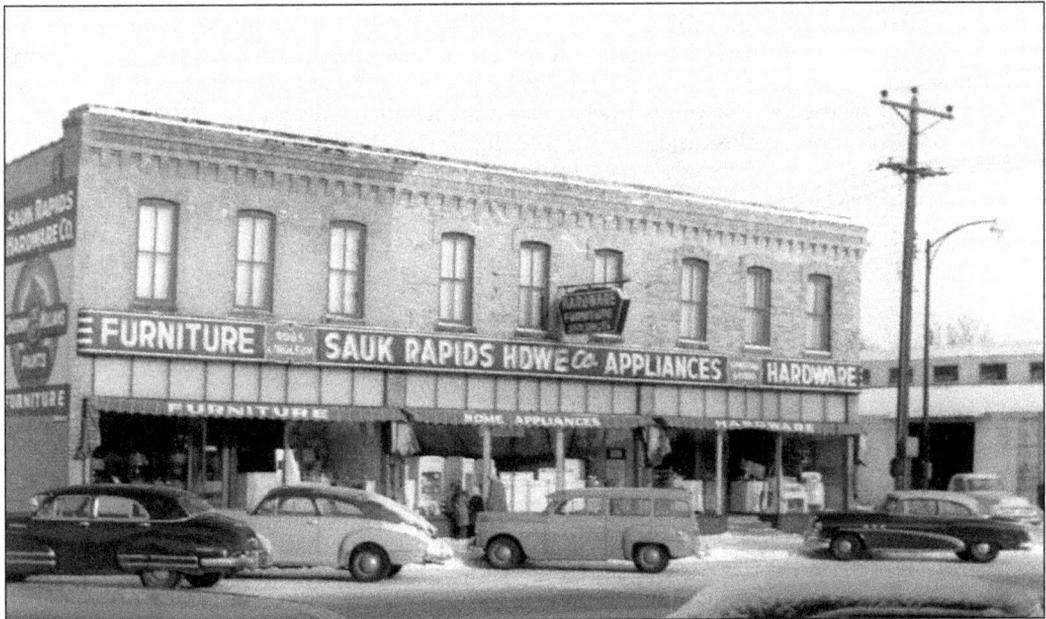

From a different angle, the Sauk Rapids Hardware store being seen a few years later. Notice the more modern looking cars parked in front of the store and the street light. You can see some of the appliances in the store window, such as wringer washers and refrigerators in the center and right of the store, and dressers and lamps in the furniture section to the left.

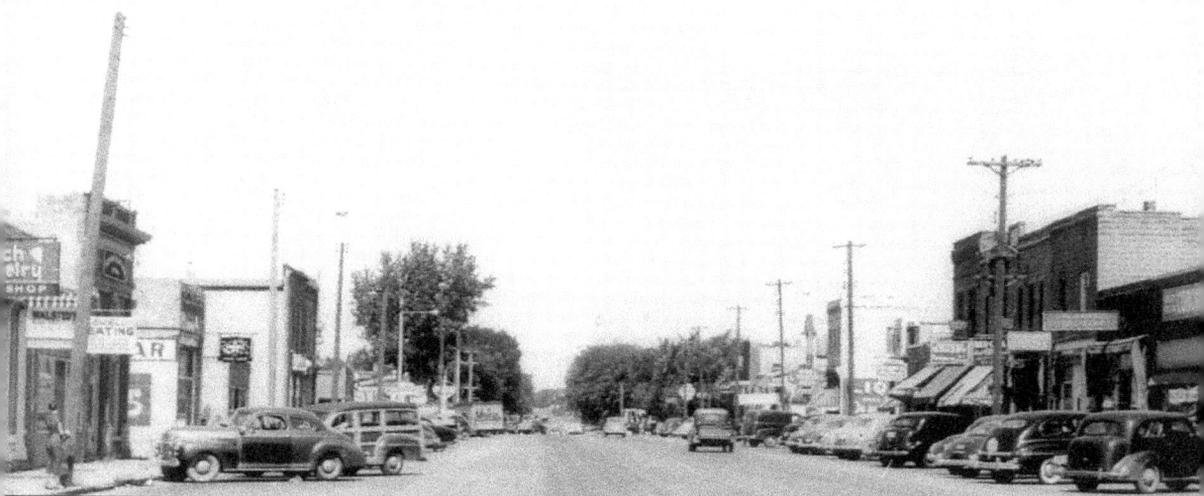

Here is a street scene of a busy downtown Sauk Rapids, where cars with wide whitewall tires and glistening chrome lined both sides of the street. In the later half of the 1950s, a number of events occurred that affected vehicle travel: Chevrolet unveiled an eight cylinder engine with more horsepower, a brand new automatic transmission, and reliable tubeless tires; gasoline was plentiful at 25.9¢ per gallon; new snow removal equipment helped clear the roads in Benton County in half of the time it previously took; and a new law was passed in Minnesota that prohibited open liquor bottles inside the car and disallowed drinking while driving.

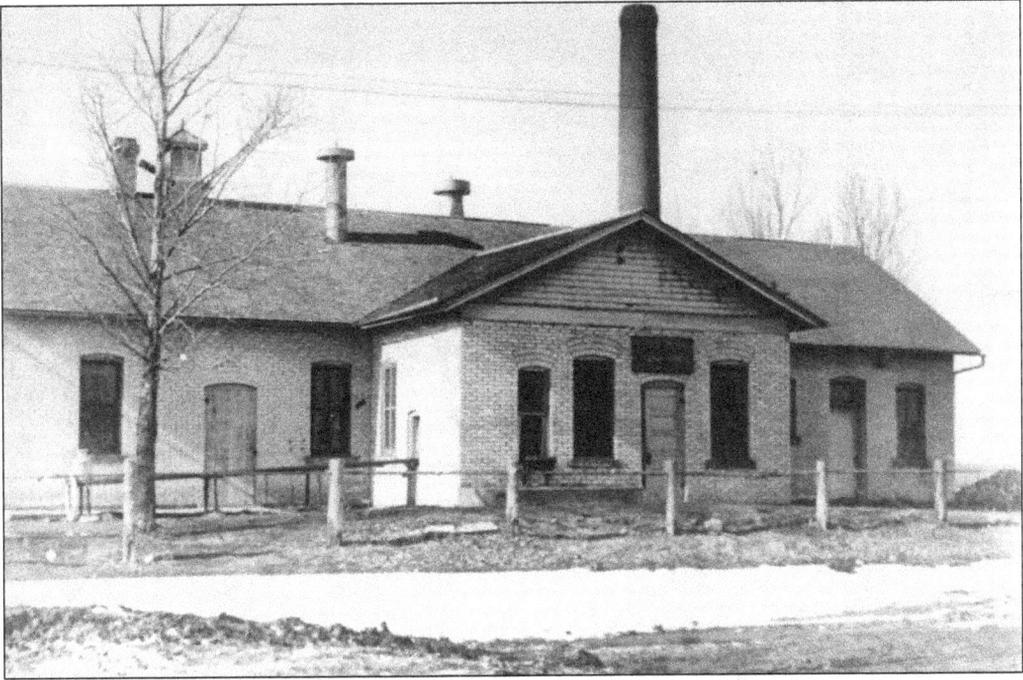

In earlier days, farmers hauled their cream to a creamery in town where it was purchased to make butter. Many of the creameries, such as the Rice Creamery pictured here, were cooperatives where the farmers had a share in the business and shared in the profits.

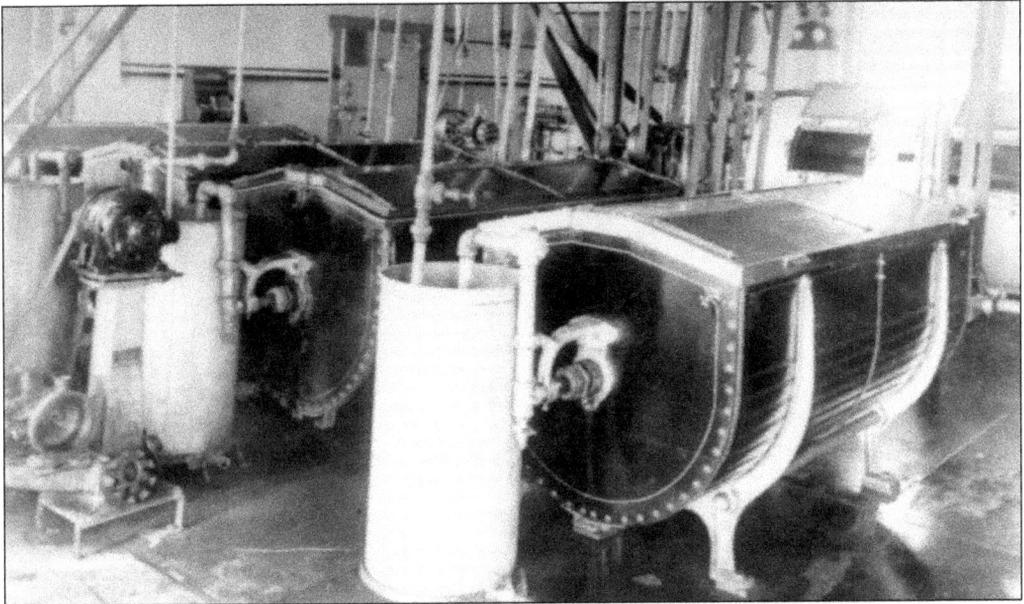

Butter is produced by agitation such as churning or whipping. Allowing the cream to sour produces a much more flavorful butter. As it is mixed, the soured cream separates into buttermilk with small pellets of butter. The buttermilk is drained and the butter is rinsed in very cold water, working the last of the buttermilk out of the butter. The butter is then molded and wrapped for sale.

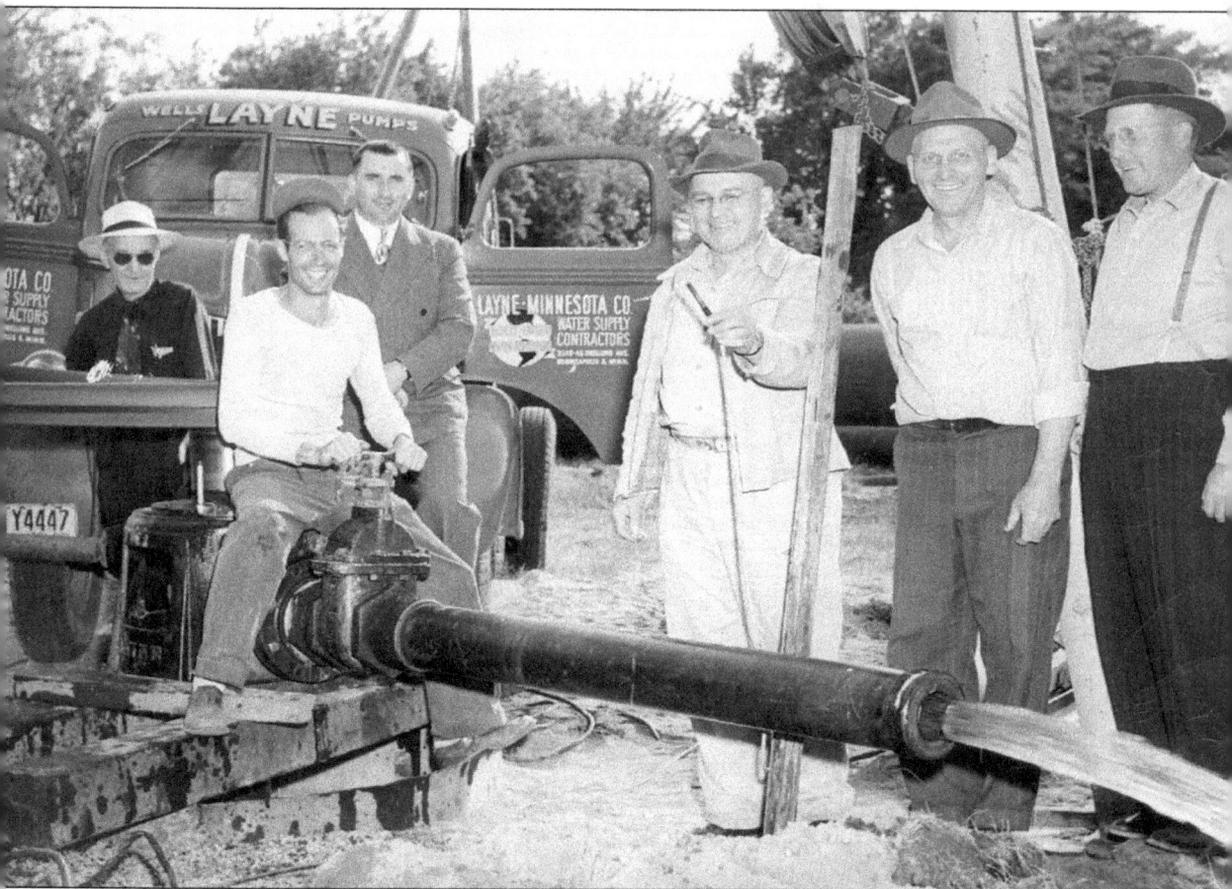

The Sauk Rapids Village Council inspects the new well at the south end of town in 1952. From left to right are O.L. Gifford, clerk; Harry Scott, superintendent of the village pumping station; Walter Koprek, reformatory guard; Bill Jahn, mayor; and trustees Aug. Bukowski and Ted Miller. Absent is trustee Theo Olson.

Six

EARLY INDUSTRIES

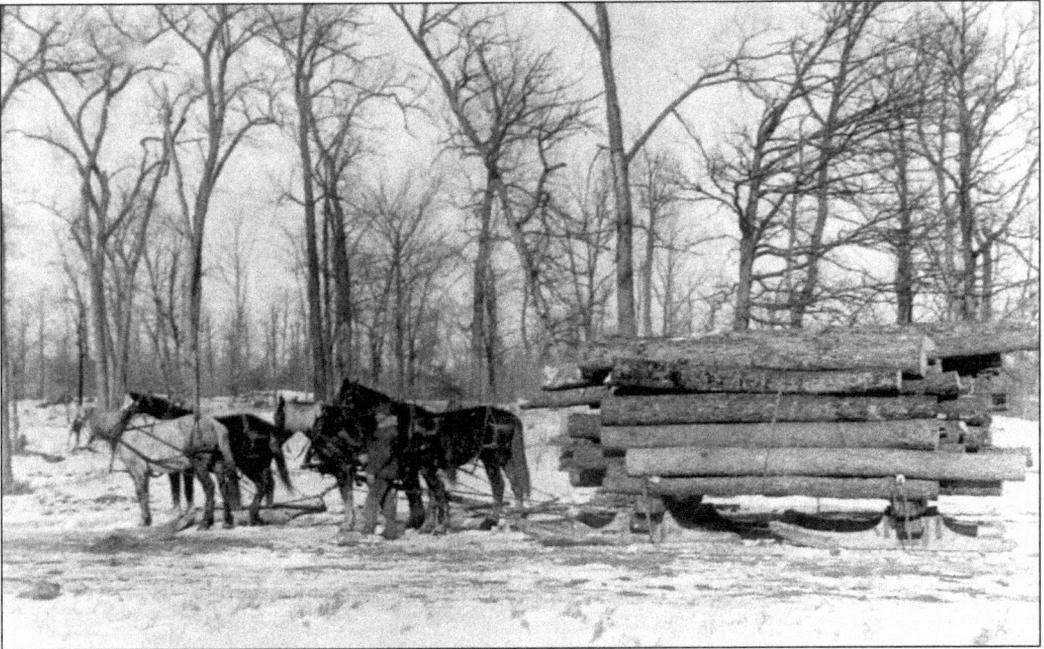

Former fur trader John L. Wilson built the first sawmill in Benton County. Horses hauled logs in the winter on sleds. The Foley Brothers built their sawmill in 1882. The Foley mill was the largest industry operated in Benton County, having the capacity to process 30,000 board feet per day. The mill operated for about 20 years.

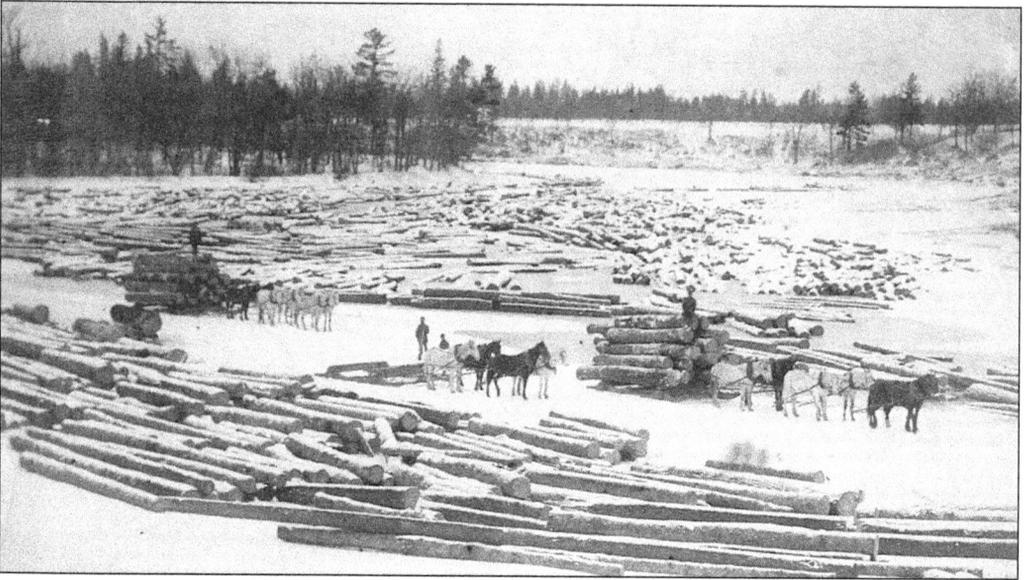

Just south of Gordon's Bridge at Pine Point in the mid-1880s, the wagons would haul logs over the ice to the sawmill, located on River Road north of Sartell. The Sartell Brothers also contracted the stumpage from owners of the Pine Point land. Timber was mostly harvested by the turn of the century and the industry started to die. As new tree plantings started to mature, new mills started to appear again.

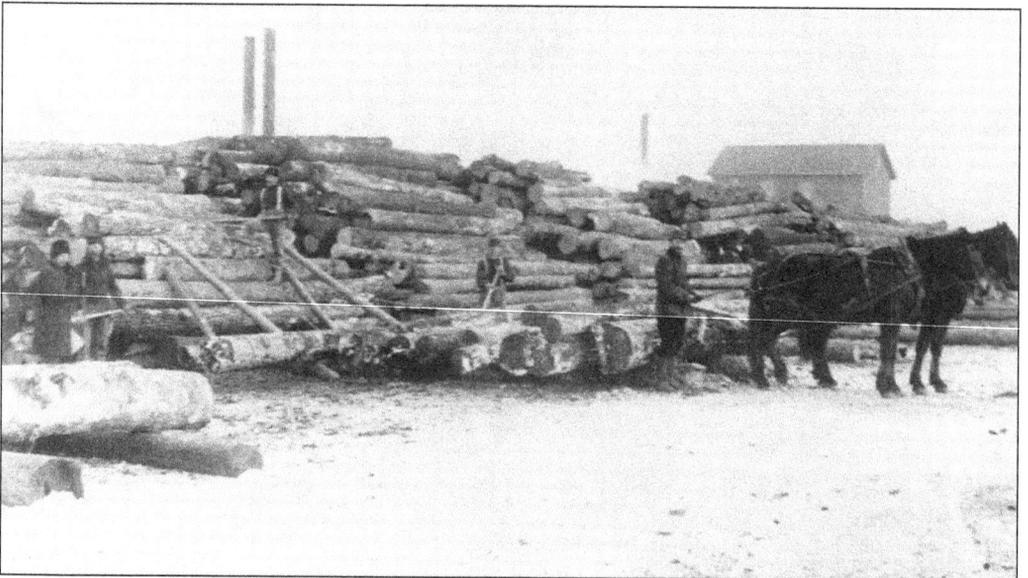

The village of Foley sits on land that was once part of the world's largest hardwood forests. Hardwoods such as oak, maple, and elm were in large demand. Here logs are piled up on Broadway Avenue in Foley, c. 1900.

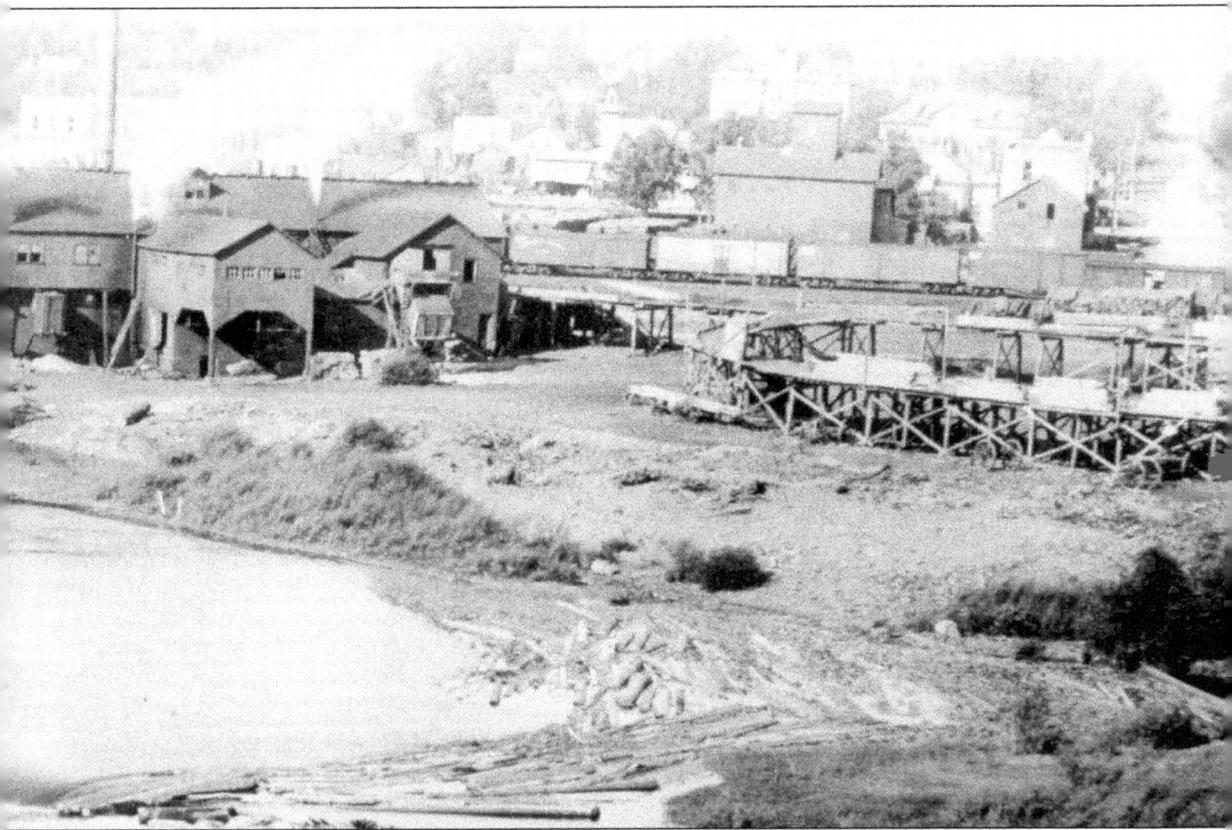

Thayer and Neils operated a busy sawmill in Sauk Rapids in 1885. The sawmill is shown looking northeast from a bridge over the Mississippi River. Piles of logs would surround the sawmill, some 20 feet high. The mill meant survival for families supplementing their farm income during the winter as they worked at the mill.

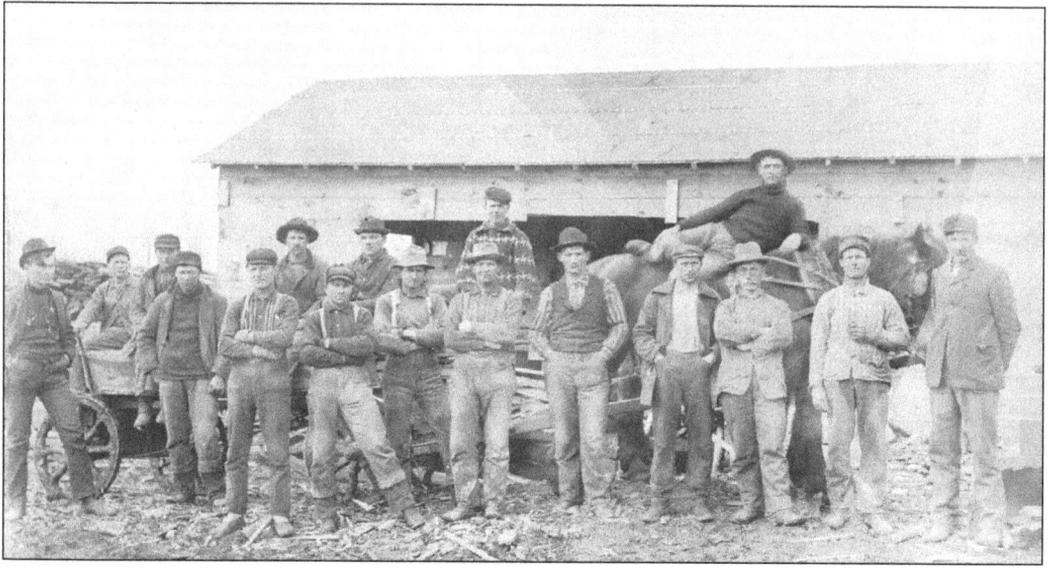

The crew gathers for a photo at the Charles H. Latterell sawmill when the operation was in Foley between 1902 and 1907. From left to right are Jim Kotsmith, Julius Popilek, Ignatius Stahonius, Albert Latterell, John Kampa, F.J. Kampa, Leon Axtell, Ben Latterell, John Landowski, Charley Dziuk, Joe Kampa, Emil Vanderkove, Perry Chase, and Charles Latterell. The three men in the back and the man on the horse are unidentified.

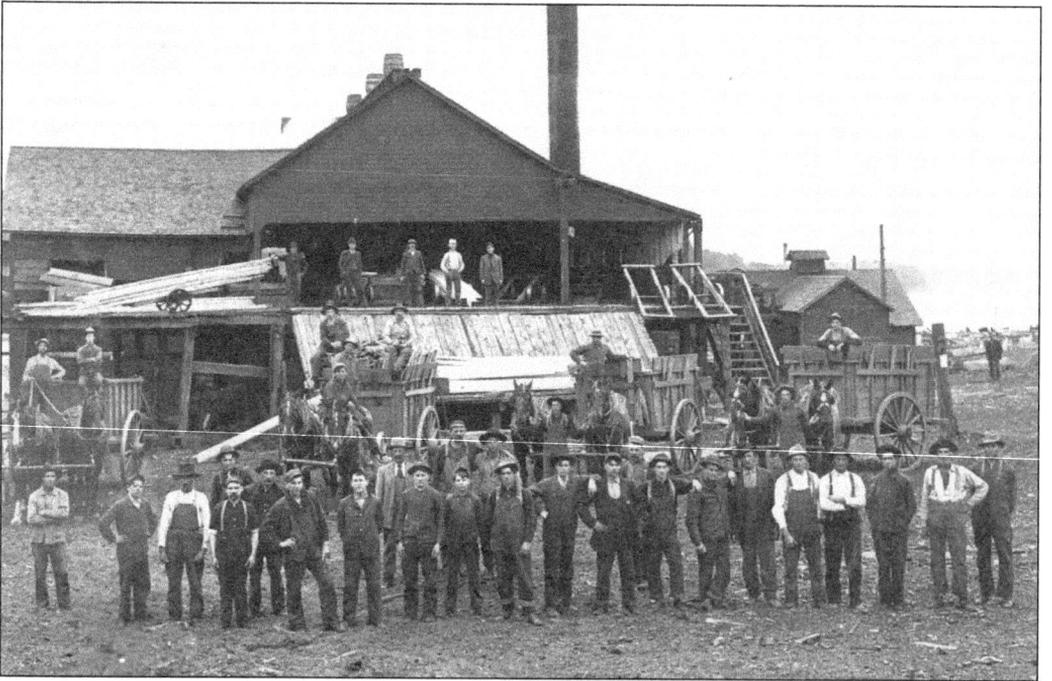

This photo shows the Sauk Rapids mill crew during the late 1800s or early 1900s. North of the sawmill was a closely knit Irish community, families with surnames such as Keefe, McGuire, Murphy, Murray, O'Rourke, Riley, and Thomas, that supplied much of the labor for the sawmill.

Unidentified workers at the Thayer and Neils Sawmill take a break at the end of a hard day stacking lumber from the planing mill. Here the logs were cut into the finished product. The freshly cut lumber was loaded and delivered on horse-drawn wagons.

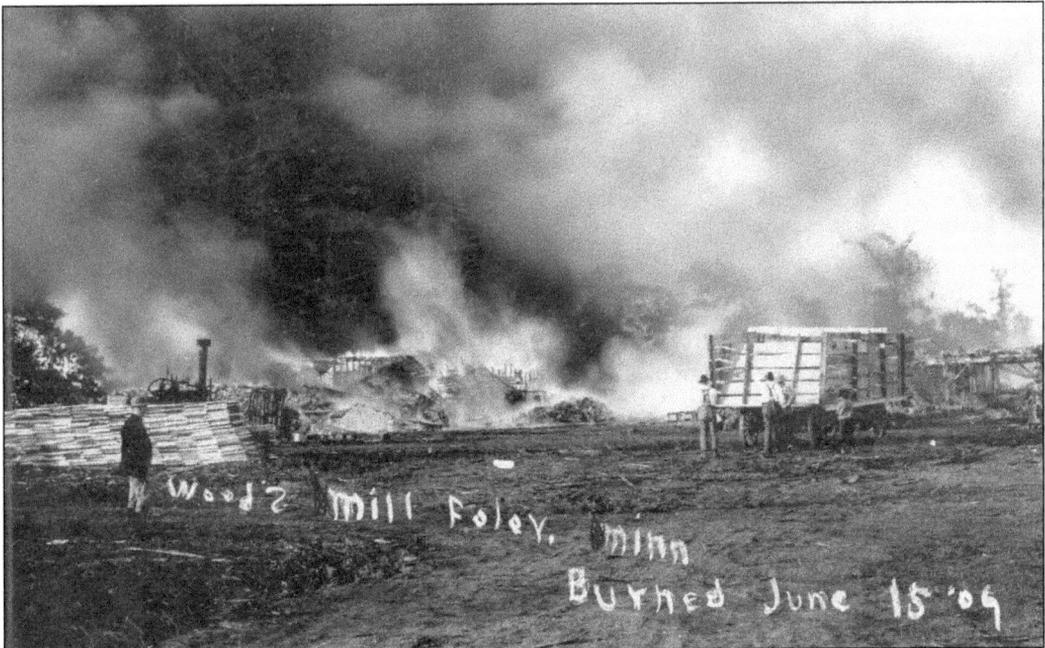

The J.M. Woods Manufacturing Company in Foley was destroyed by fire the night of June 15, 1909. The blaze at the mill was so intense that it lit up the night sky and could be seen for miles. This was a severe blow to the local economy, sending 55 employees into unemployment.

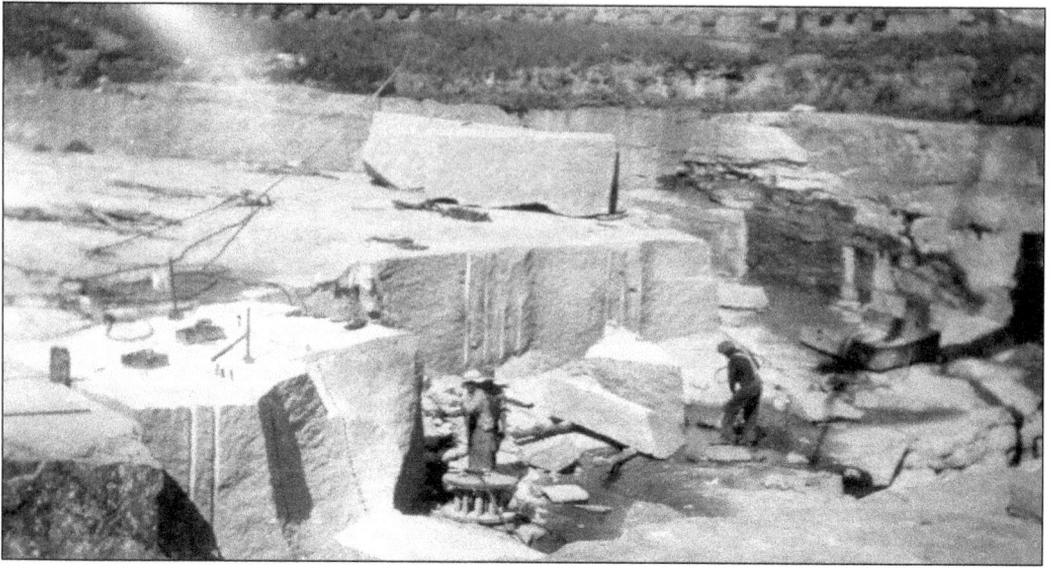

Granite was quarried for its use in buildings such as churches, city halls, and courthouses built in the early 20th century. Early pioneers from Germany, Sweden, Norway, Scotland, and Italy brought stone cutting skills with them to the quarries of Minnesota. Geologists define granite as a type of rock from volcanic origins that solidified in the crust of the earth. The main components of granite are colored feldspar, white quartz, and black ferromagnesian minerals.

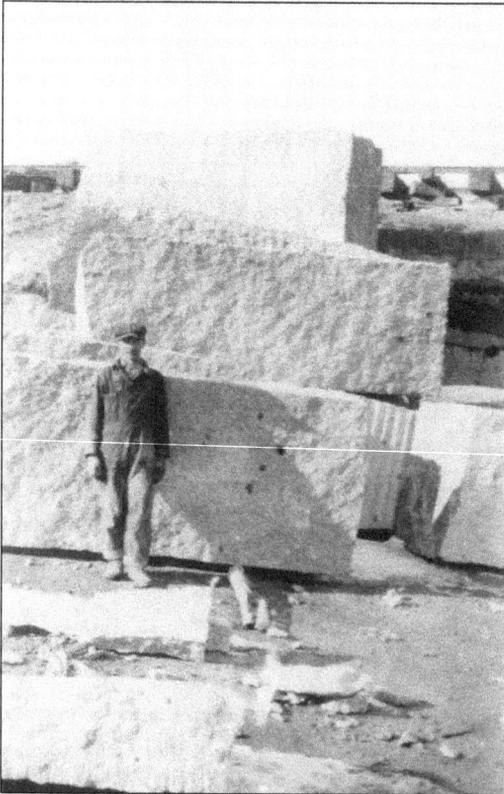

Huge blocks of granite were separated from the surrounding rocks by explosive charges of black powder. Granite blocks were split into manageable sizes in the quarry and used either for building or ornamental stone. Modern uses include interior tiling, fireplace hearths and surrounds, counter tops, structural panels for buildings, and even ballast for ships. Here an unidentified man stands next to the cuttings for scale.

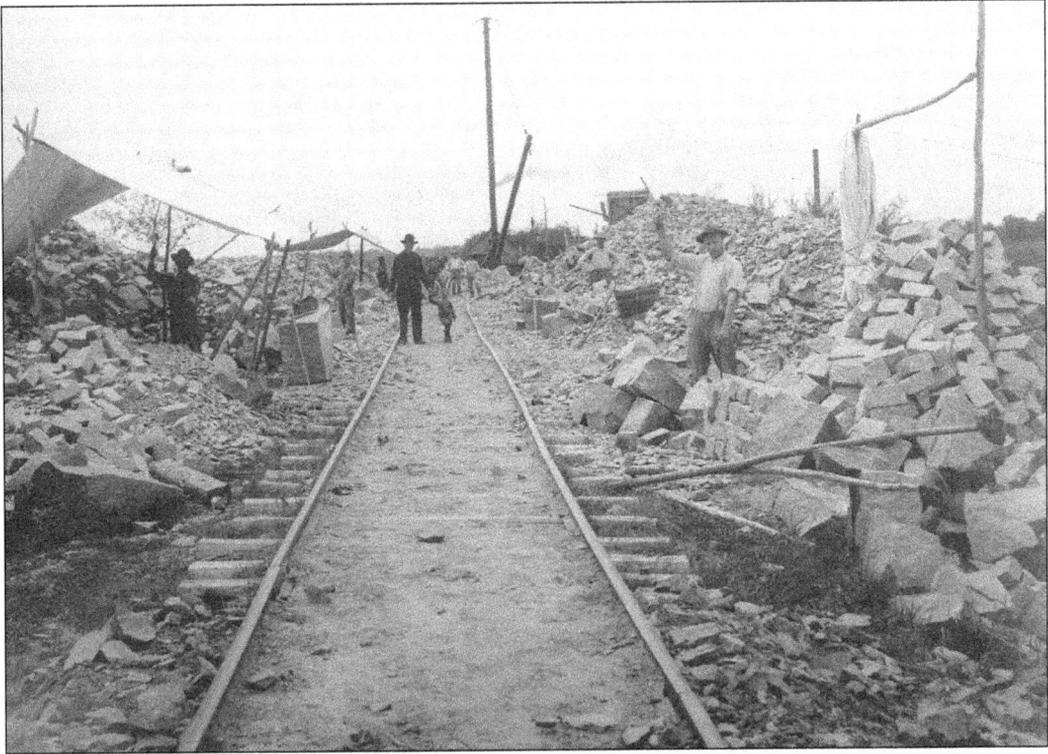

Slabs of quarried granite were gathered by train to be taken to the storage sheds where they were split for specialty work. As technology advanced, fabrication plants produced thin panels that lowered the installation costs and provided designers with unlimited possibilities.

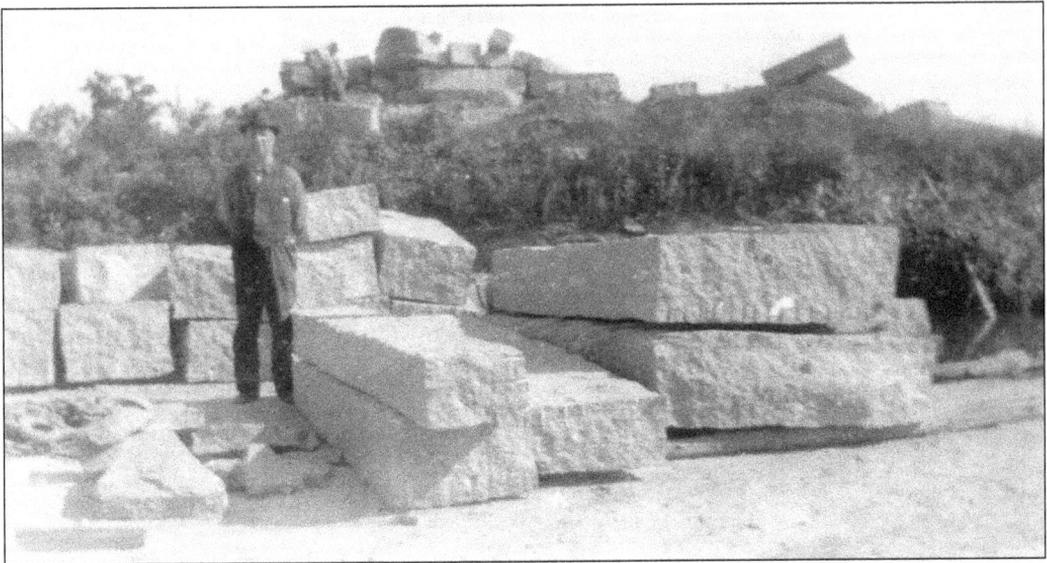

Smaller pieces of granite were cut for grave monuments and memorials. In the industry, granite is defined as any igneous rock suitable for cutting and polishing. As St. Cloud's granite industry moved into monumental work in 1900, the city received the name "the busy, gritty, granite city."

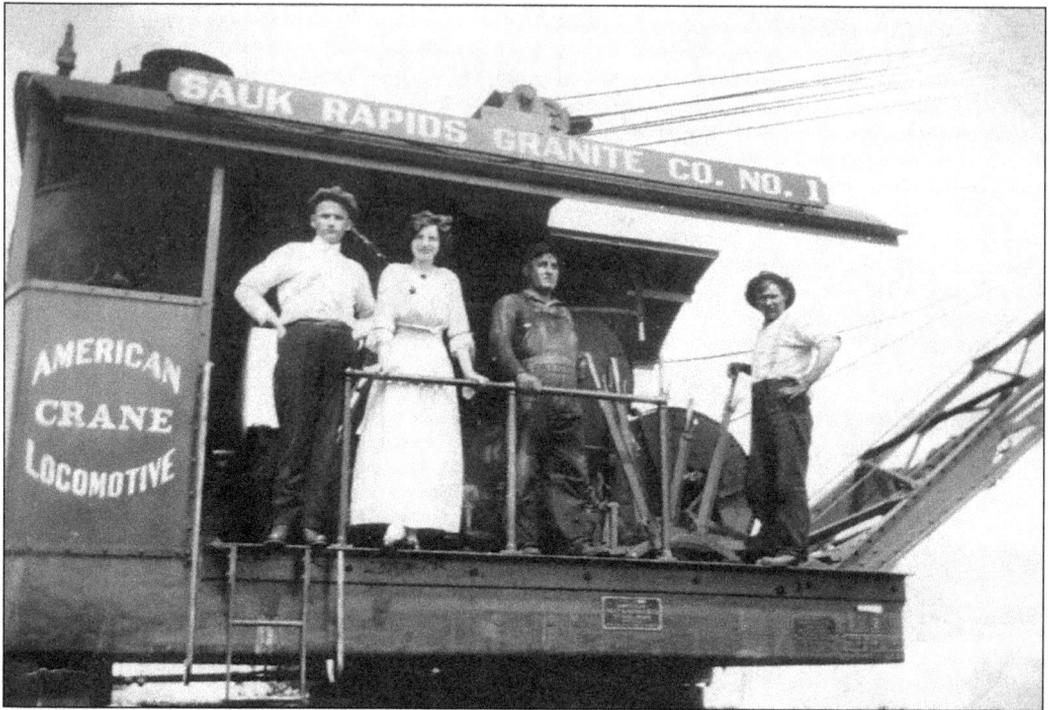

The Sauk Rapids Granite Company owned their own locomotive, which was used to haul the quarried granite from the quarries east of town to the sheds located on North Benton Drive. The hoist on the train brought the rock to the shed. The people on the locomotive are unidentified.

The first granite quarry was opened in the St. Cloud area in 1868. Limestone, marble, sandstone, and granite were important in the construction of bridges and buildings. Pictured here is the Misho Brothers Granite Works, located at the corner of present day First Street North and Second Avenue North.

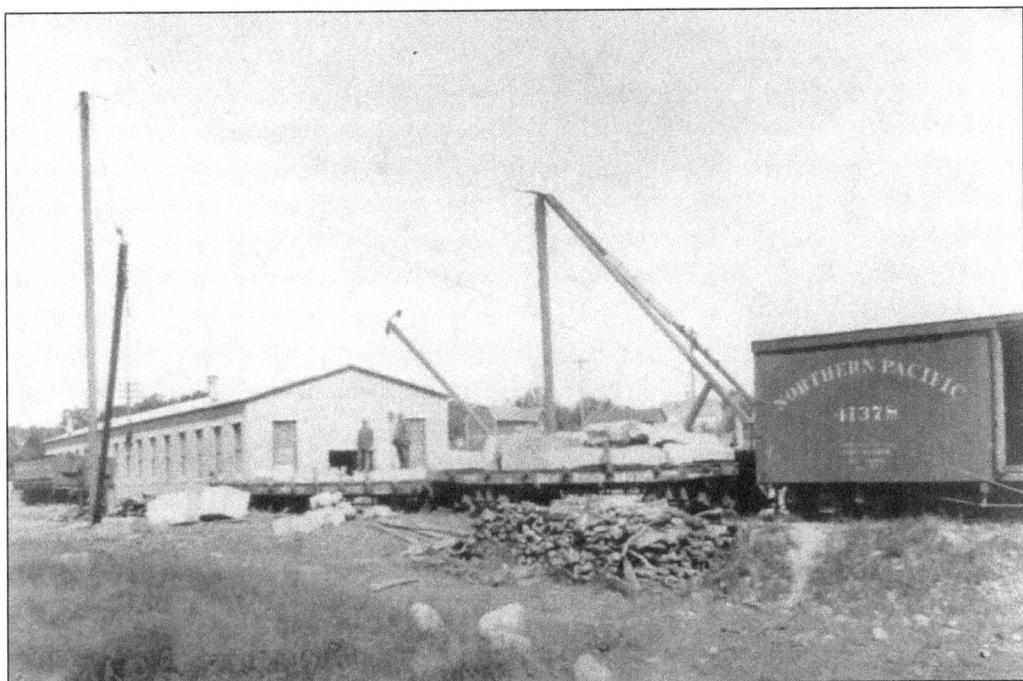

Here are the Sauk Rapids granite sheds, north of Broadway in Sauk Rapids. The large barn in the background belonged to Adam Kosloske, who put up horses for hire. Fresh teams of horses were used to pull wagons loaded with smaller pieces. The railroad was used for transporting larger pieces across the country.

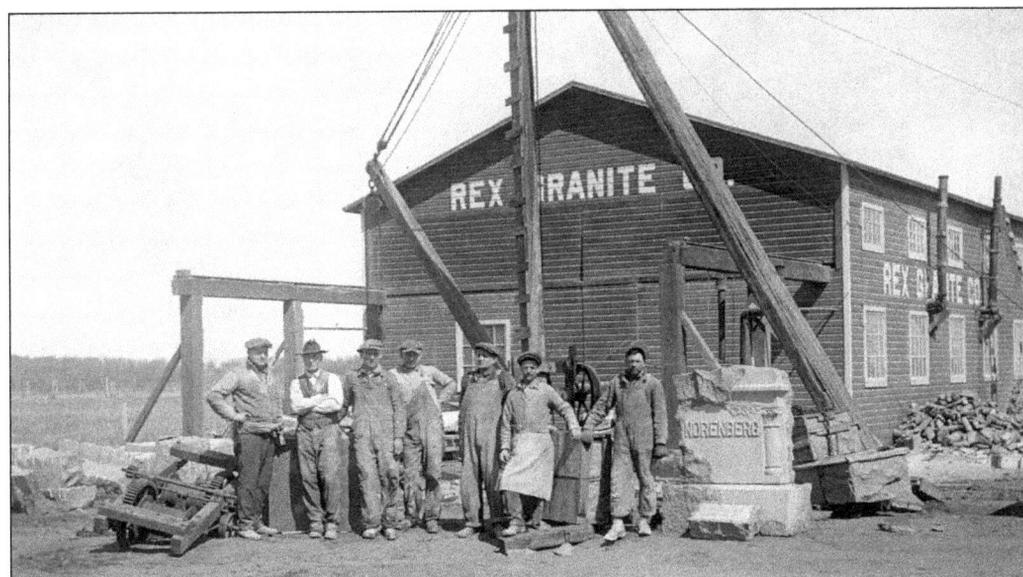

The Rex Granite Company, located in St. Cloud, was founded in 1920. The company makes grave memorials; an example of their work is at the right in the photo. Today the company, still operating, specializes in personalized pet memorials with a wide choice of designs.

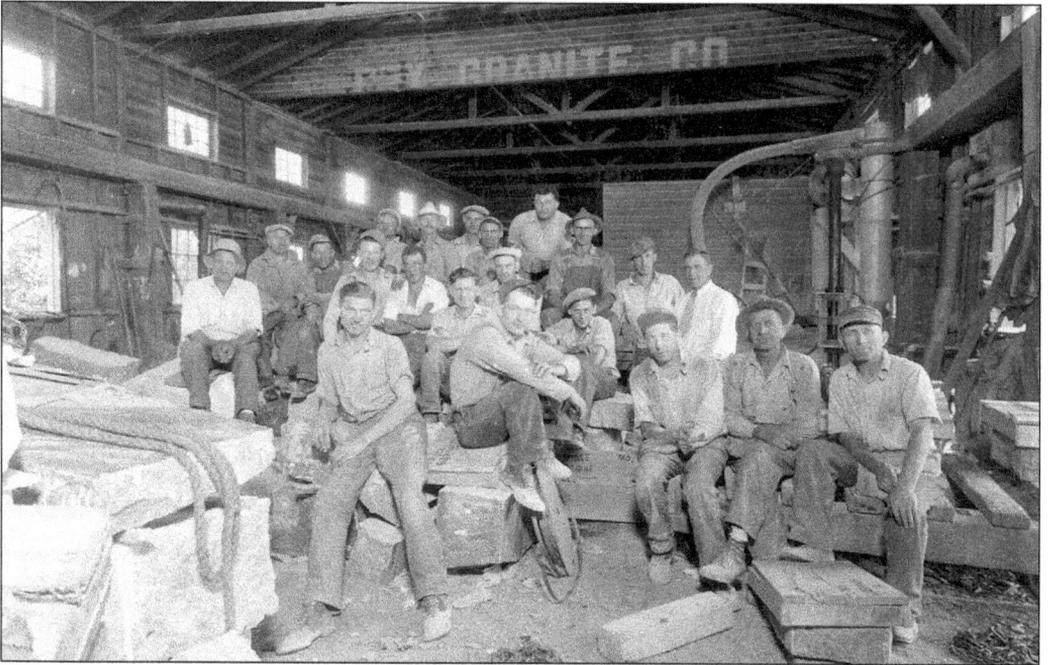

Pictured here is a group of workers in the Rex Granite Company sheds, where slabs were delivered by rail from the quarry then further processed. Here pieces were further split, cut, sliced, crushed, or polished. Water was used on the saws to eliminate airborne dust. It was hard and dirty work.

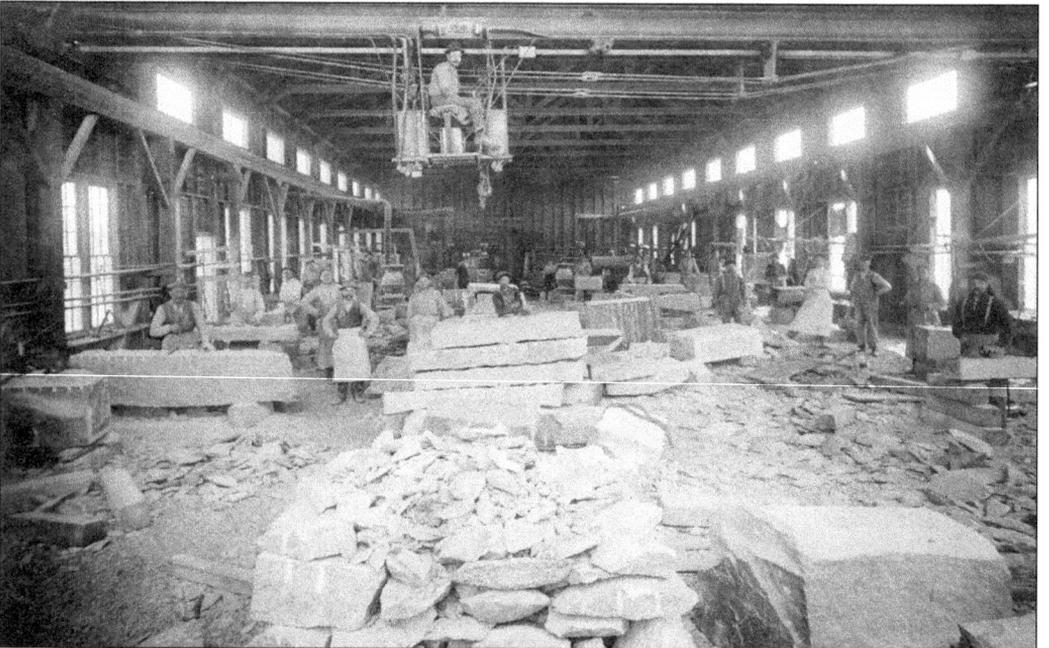

Granite processed in the Sauk Rapids shed was sorted by type, size and color. The man in the crane above the piles was able to locate pieces for a customer's order, lift them up, and move them to the transport vehicle for delivery.

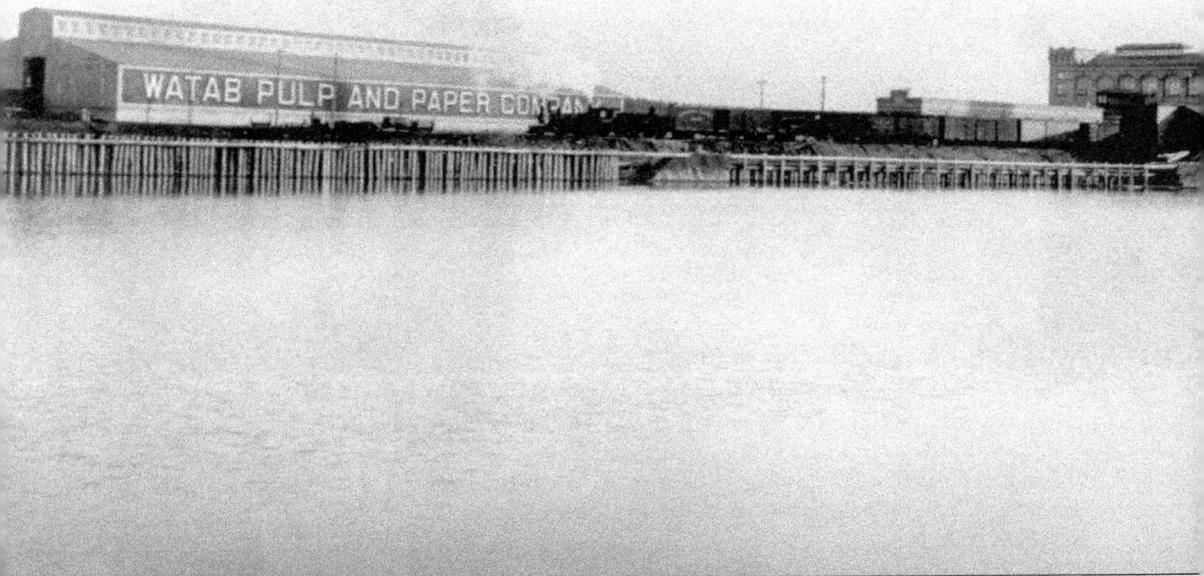

The Watab Pulp and Paper Company produced its first paper in 1907. They continued to produce newsprint until 1930, when conversions to groundwood book and magazine papers were started. There was a park on the grounds where deer could be seen. The area was fenced in but not visible in this photo. St. Regis Paper Company acquired the properties of the Watab Paper Company in 1946.

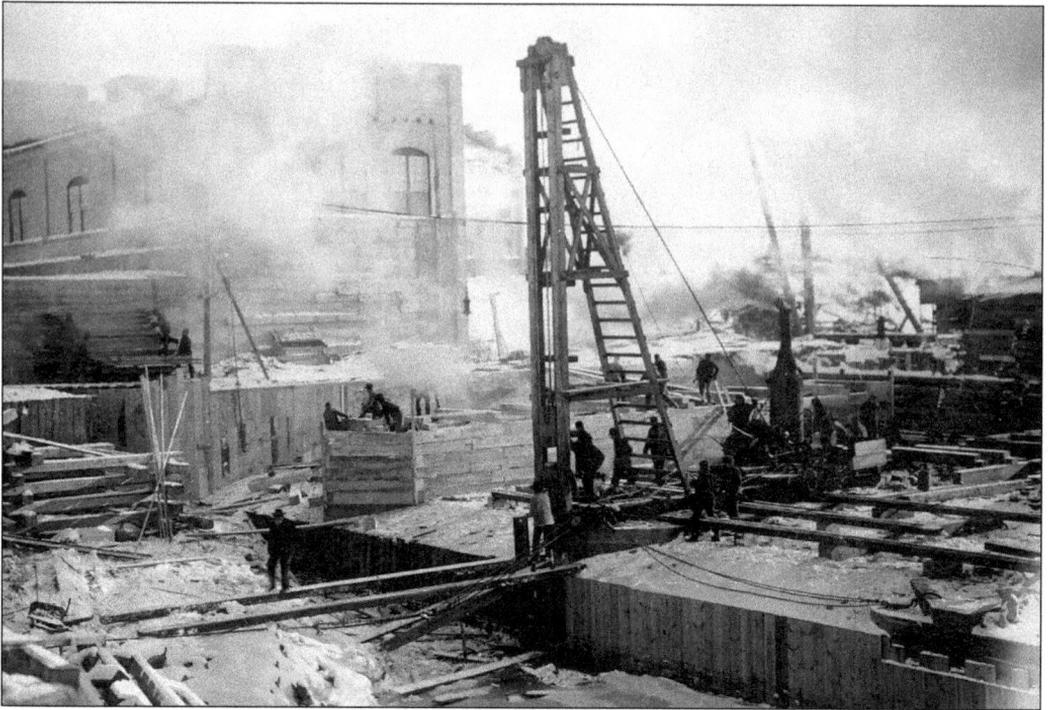

In the 1850s and 1860s, St. Cloud was the upper limit of Mississippi River traffic that brought the town into prominence as an outfitting post for the fur traders. Furs from territories to the west and north were loaded onto steamboats, which brought supplies for wilderness forts and Canadian posts of the Hudson Bay Company. The last regular steamboat trip was made in 1874. Shown here is construction work on the dam near the paper mill in Sartell, c. 1907.

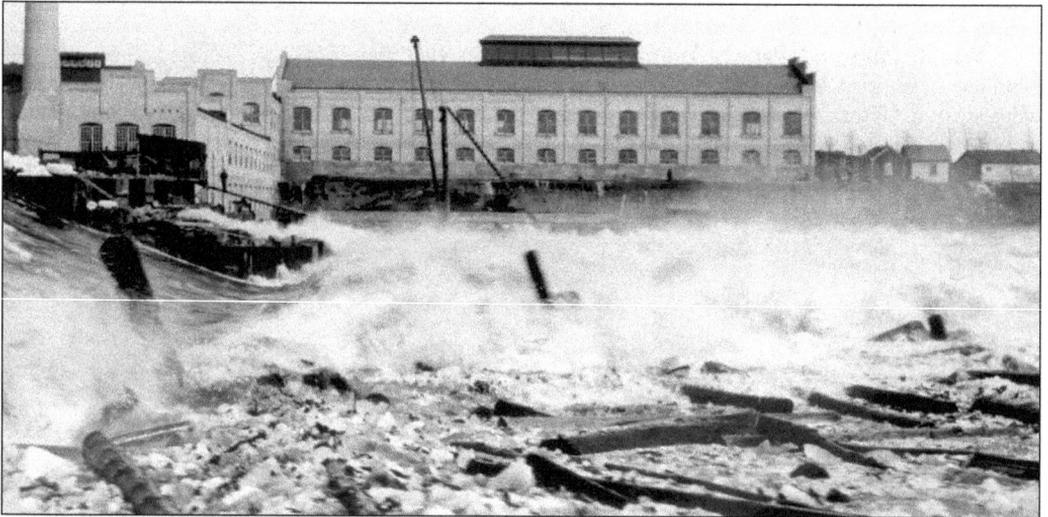

Occasionally, when the water level got too high behind the dam, the water was released. Tons of submerged rocks at the foot of the dam cushioned the impact of the water as it plunged downward. As a modern example, during the harsh winter of 1996–97, water ran through with such force that the rocks were displaced and had to be replaced with boulders, some weighing as much as 9 tons.

100

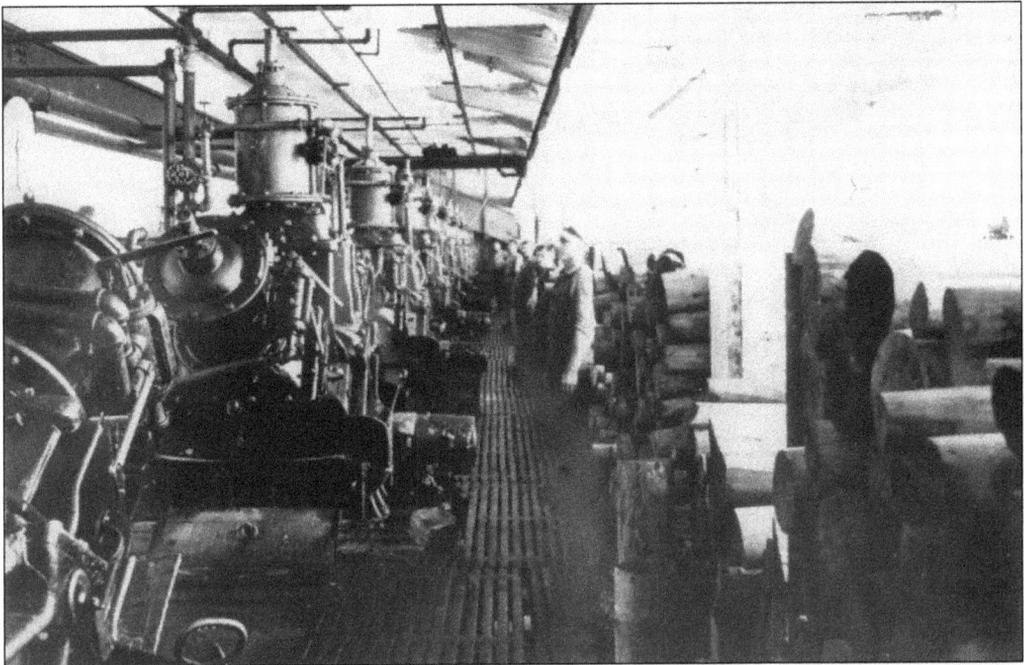

Logs were delivered by truck or rail and comprised most of the mill's raw materials. The logs were soaked in water and the bark was removed. This was the grinder room where wood was ground down into pieces and eventually into pulp.

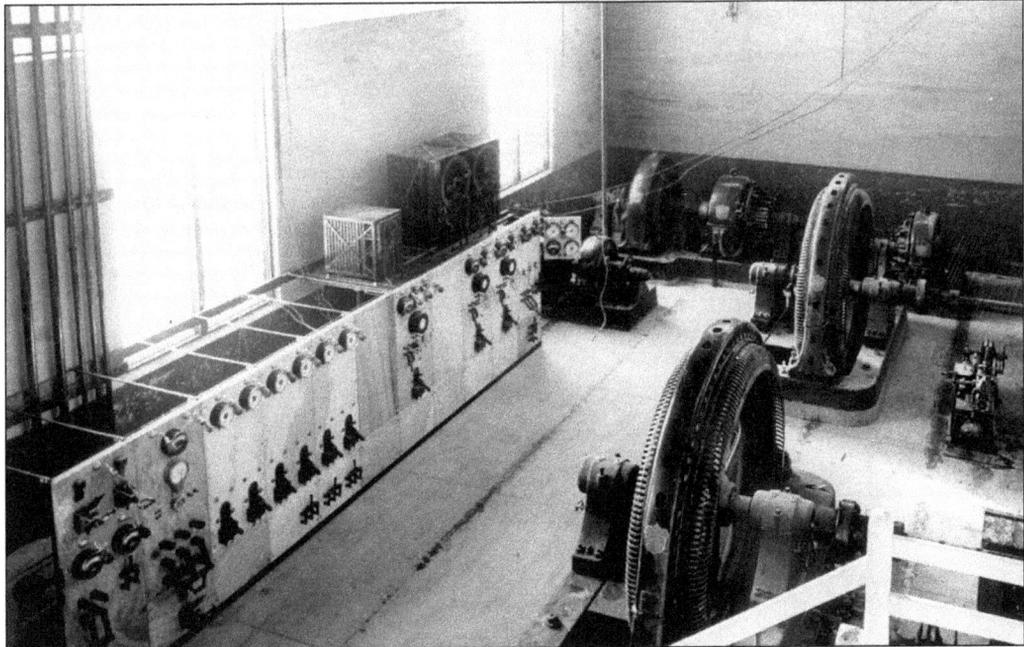

Papermaking uses a great deal of water and electricity. Water from the river was used to make electricity by turning the water wheels that were connected to the company's three generators. The water was then pumped to other areas of the plant, where it was mixed with the wood pulp as the first step in making paper.

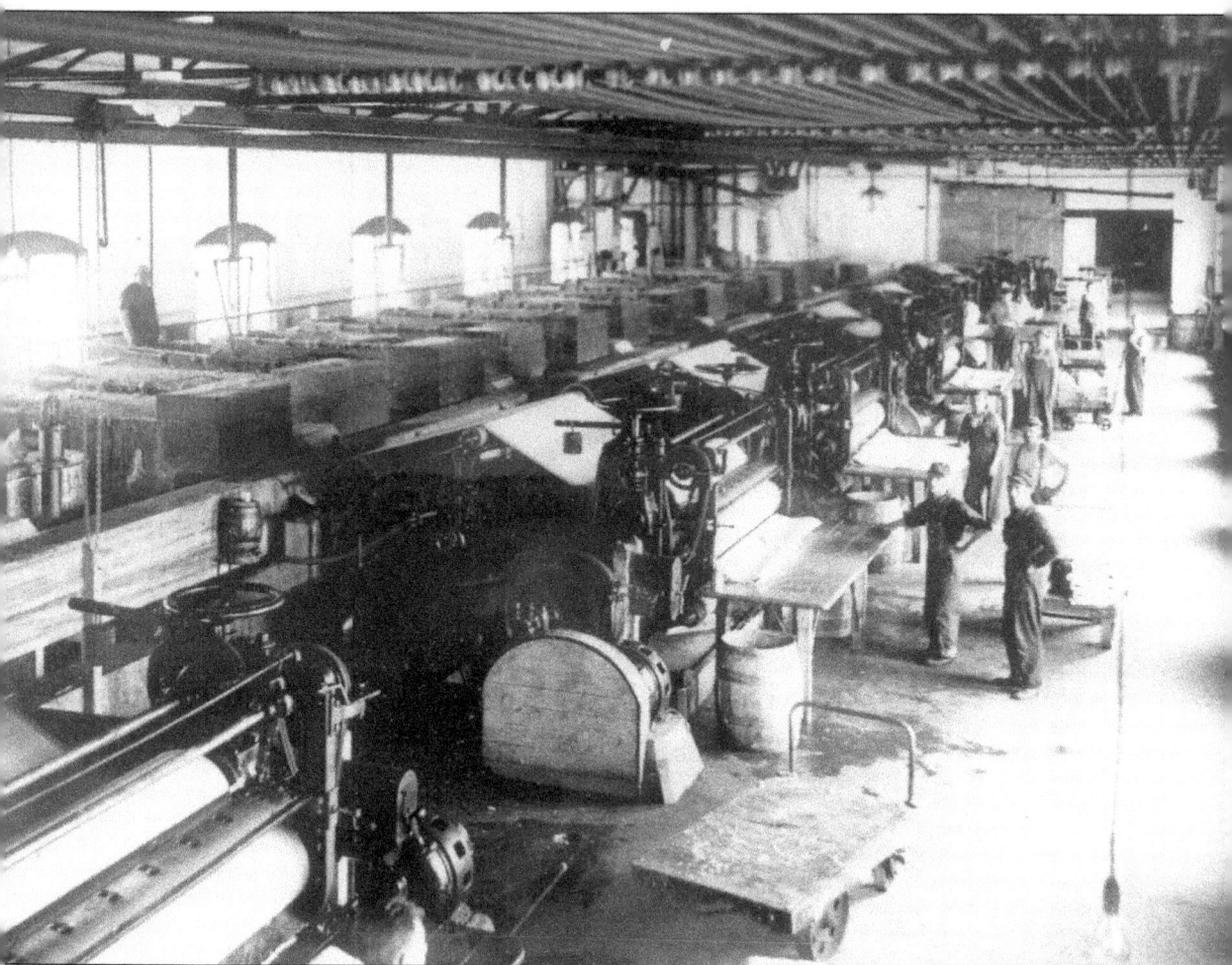

Here in the wet machine room the pulp was turned into laps, dried pulp ready for conversion into paper. Laps (a sort of folded blanket of pulp) were a convenient way to store the pulp, and were stored outside. You would see large piles of laps around a paper mill.

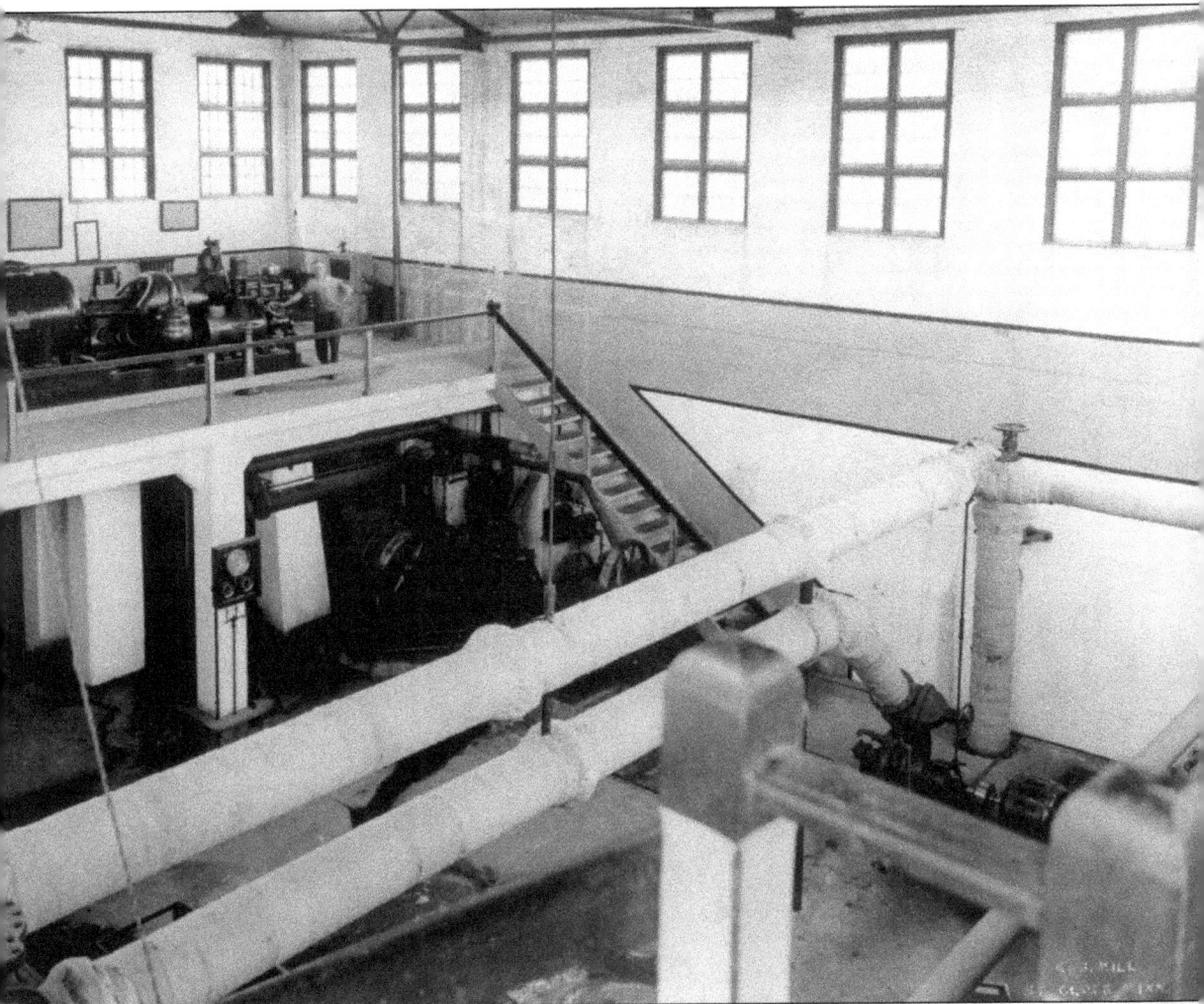

Water was pumped from the river and diluted the pulp that is 99 percent water. It was then distributed to a fast-moving screen where it began its trip through the plant to take the form of paper. After this, the drying process begins where the water is removed using several steps, and then it is dried. After the dryers it is 6 percent water and 94 percent paper. The paper finishes its journey by running through a stack of rollers, where it is further dried and smoothed for printing.

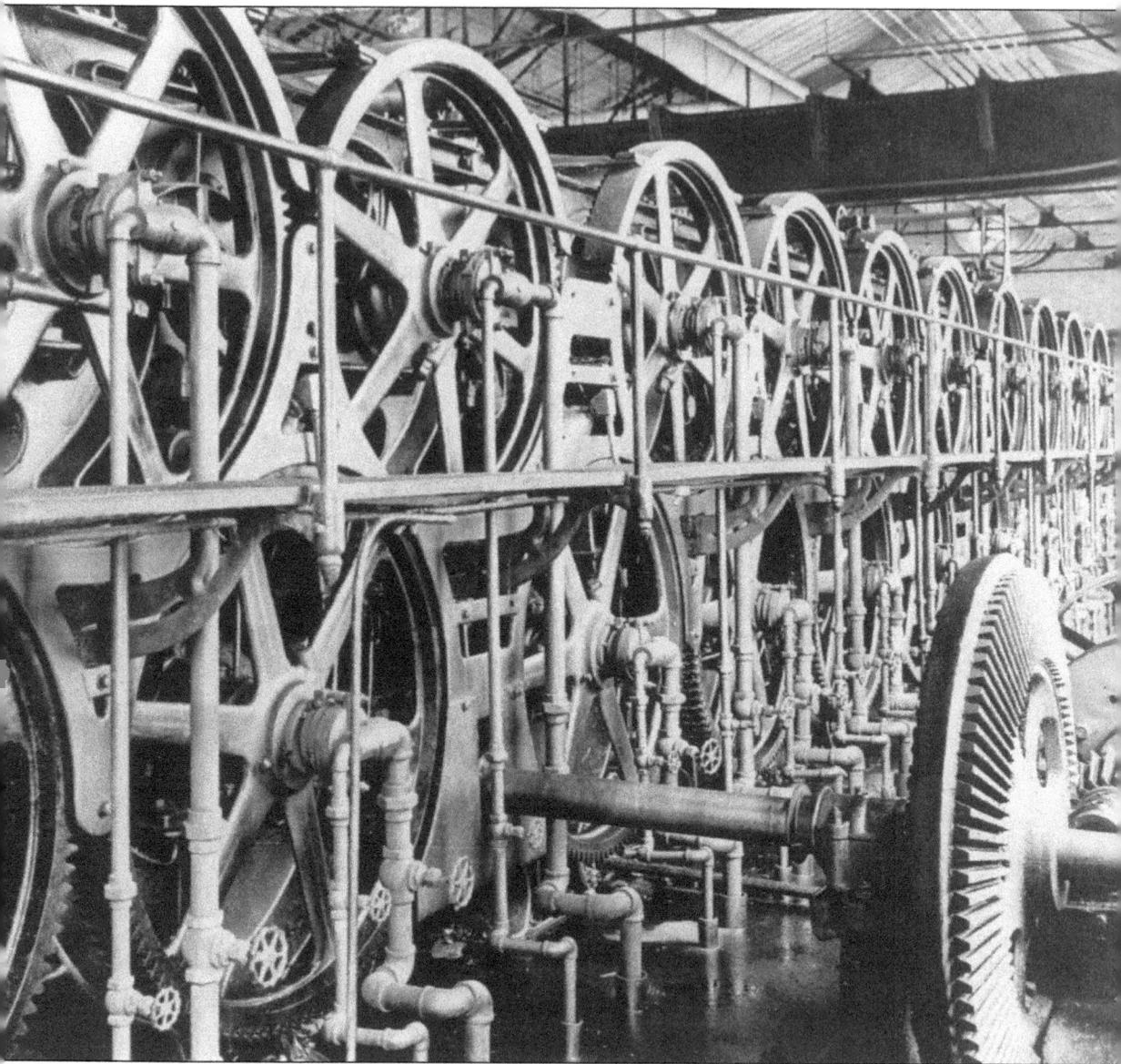

The paper machine room is where the paper is run over large hollow metal cylinders as steam is produced to dry the paper as it goes along. The sheet will be wound up and down over many cylinders in the drying process. Between dryer sections, the paper may be coated to give it a higher gloss or other characteristics. After further drying, the paper is passed through a series of polished, closely stacked metal rollers called a calendar, where it is pressed smooth. Then the sheet is rolled up and removed from the machine.

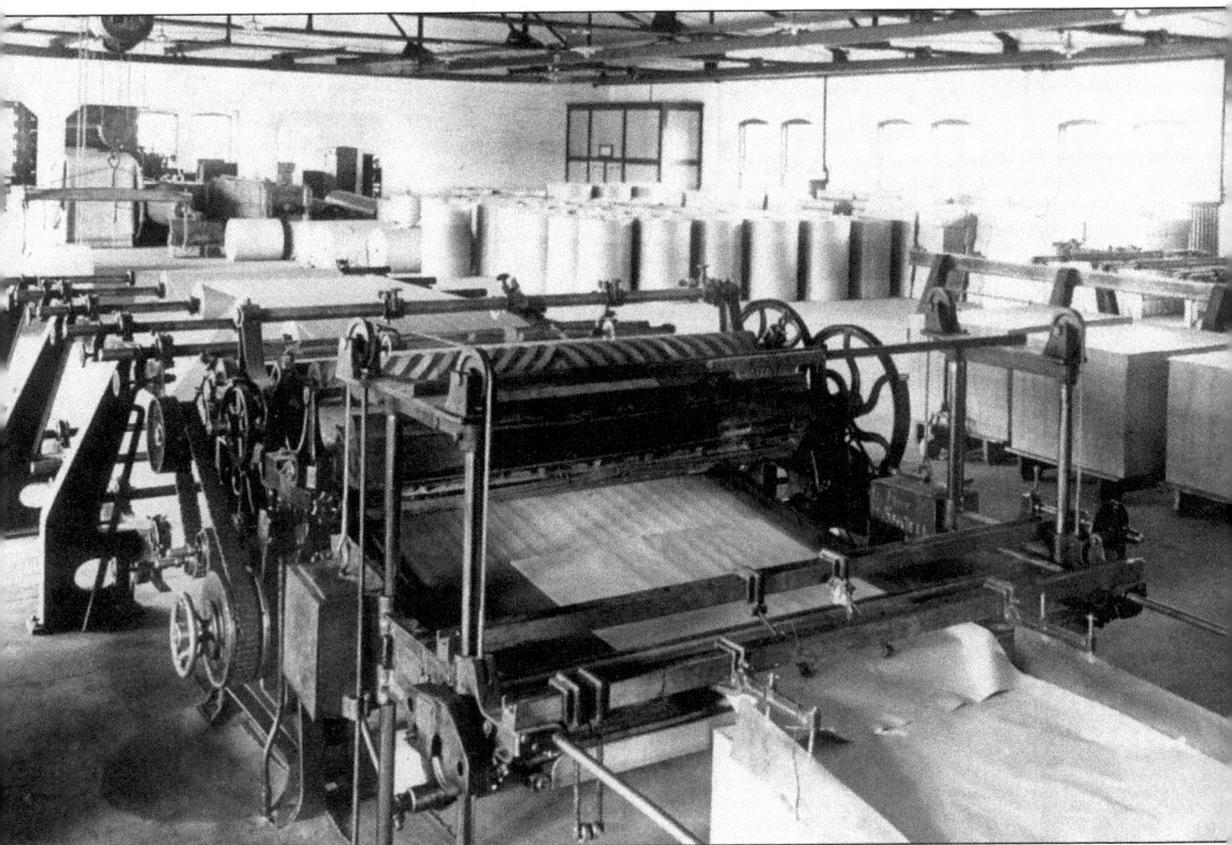

The new paper roll was most often rewound on a new core, inspected, and shipped directly to the customer. Here in the cutter room the paper was cut into sheets where pieces were boxed and wrapped for shipping. Other paper grades were further processed by polishing the paper between steel and hard cotton rollers or embossed with a decorative pattern.

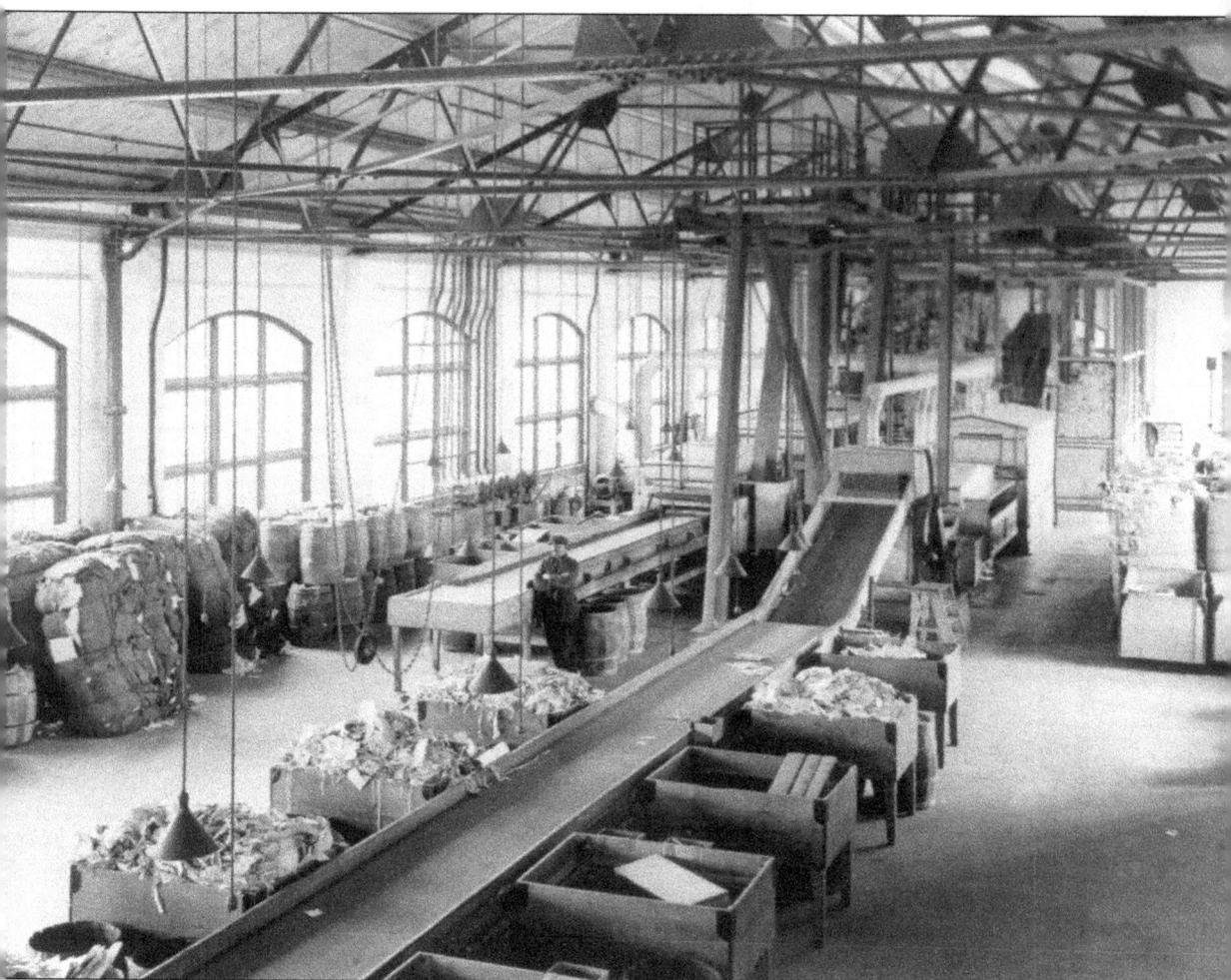

The conversion room was used to gather used paper brought in from other places, before being sorted and baled. The bales of sorted waste paper were soaked in large vats, where they disintegrated into fibers. The pulp was screened to remove coatings, additives, loose ink particles, and other small contaminants. Chemicals were added to separate the ink from the paper. The deinked pulp was sent through several cleaning stages then treated just the same as if it had been made from wood chips. Paper can be recycled only 5 to 8 times before the fibers in the paper become too short and weak to be reused.

Seven

DAILY LIFE AND ACTIVITIES

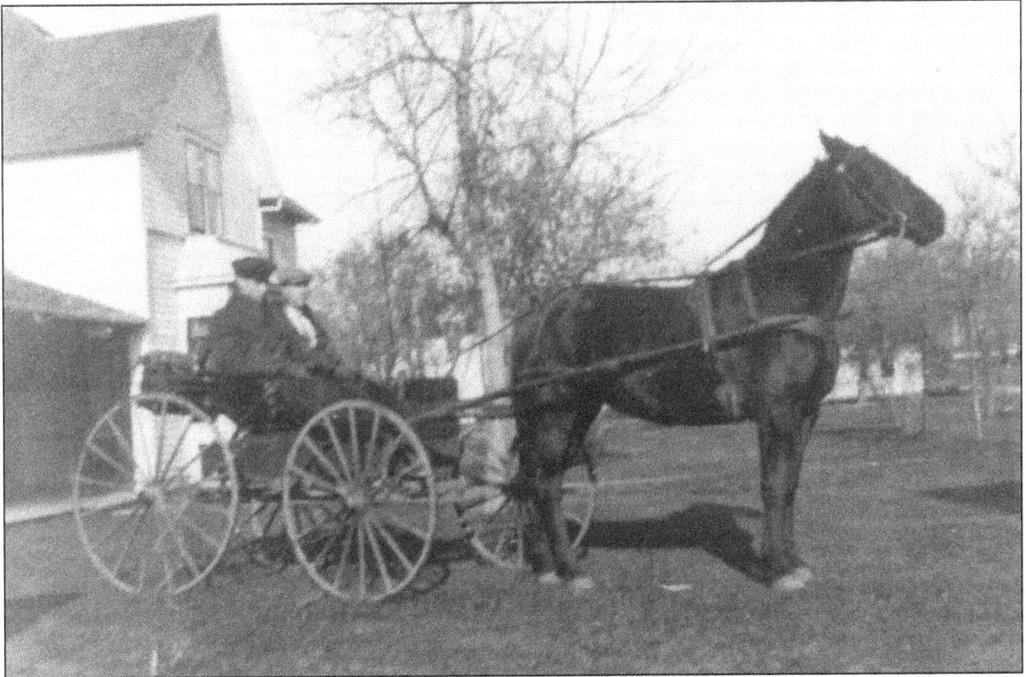

Jim Carpenter (left) and Fermie Arensberger (right) are seen here in a horse carriage in front of the Arensberger home in the 200 block of Second Avenue, Sauk Rapids. Fermie eventually became a big supporter of the horseless carriages and worked repairing them at the Schlough Garage in Sauk Rapids.

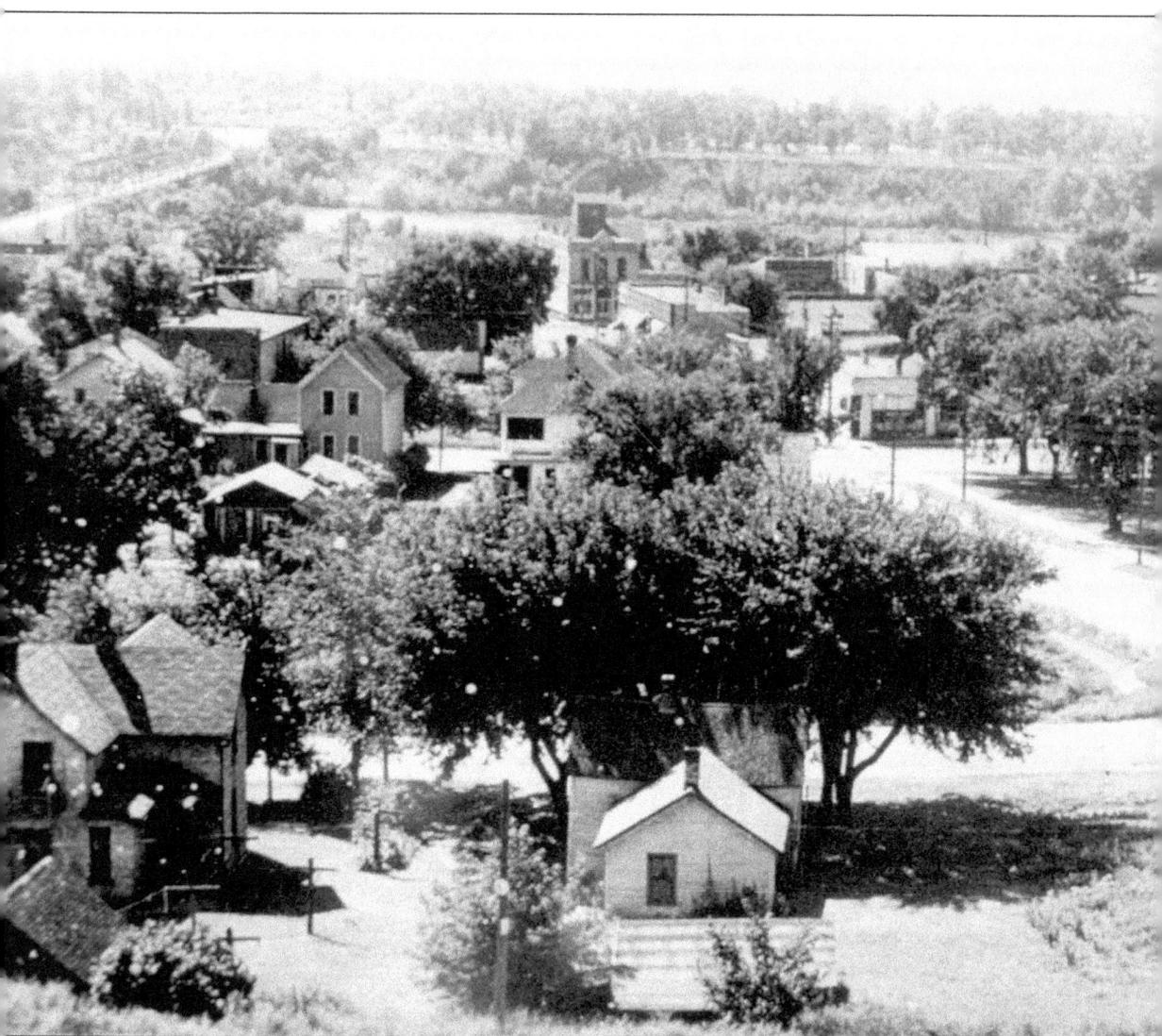

Here is a birds-eye view of Sauk Rapids in the area of present day Division Street and Second Avenue North. An octagonal shaped bandstand was erected on the vacant lot on the northeast corner of this intersection. For many years, the Sauk Rapids City Band gave weekly concerts during the summer months. The brick building in the center of the photograph was the former Sauk Rapids Fire Hall, which now houses kindergarten students in a remodeled building.

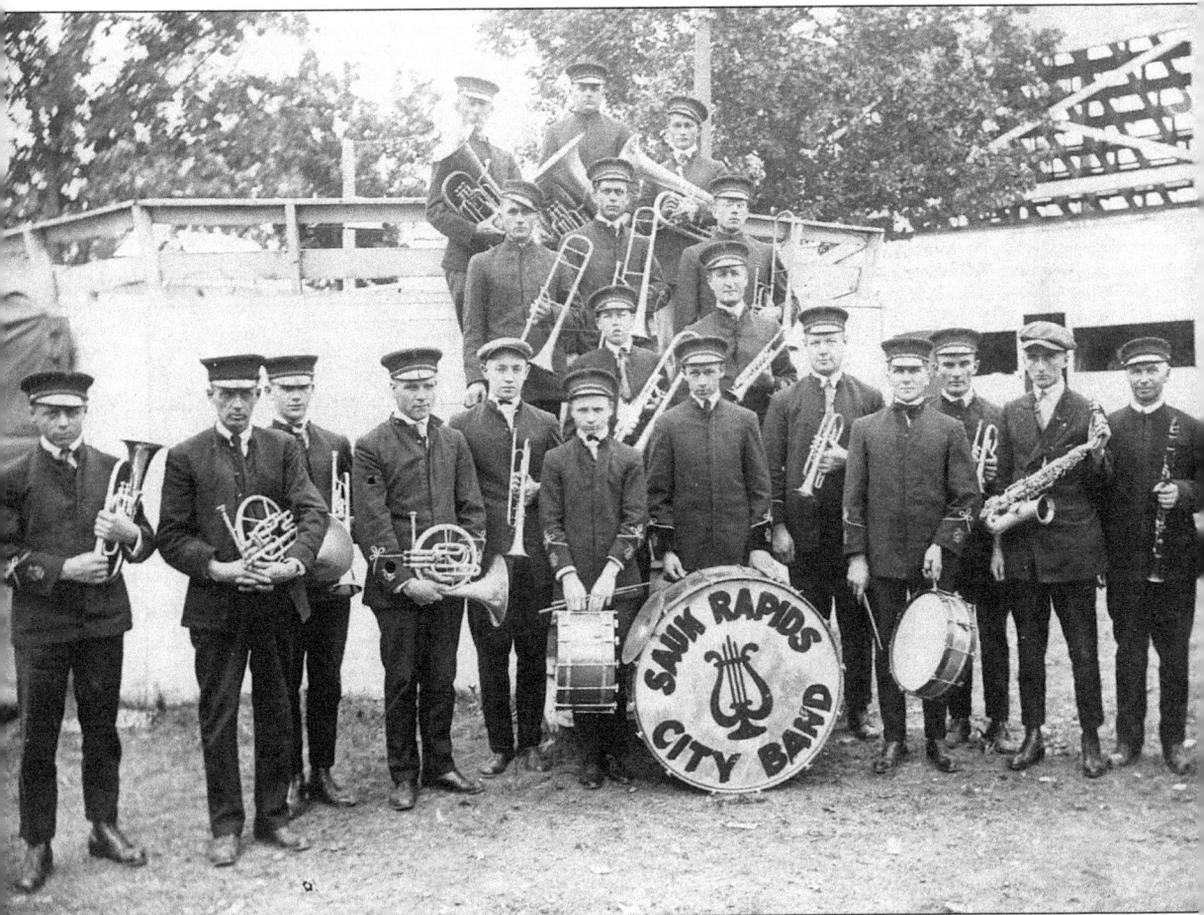

The Sauk Rapids City Band was a well-organized group under the direction of P.A. Thayer in the late 1880s. It grew to 12 members in 1902, with George Homan as the director. By 1906, William A. Scherbert had assumed the role of director. William is holding the cornet one row down from the top. One other band member identified in the photo is Herman Klahn (top row, left).

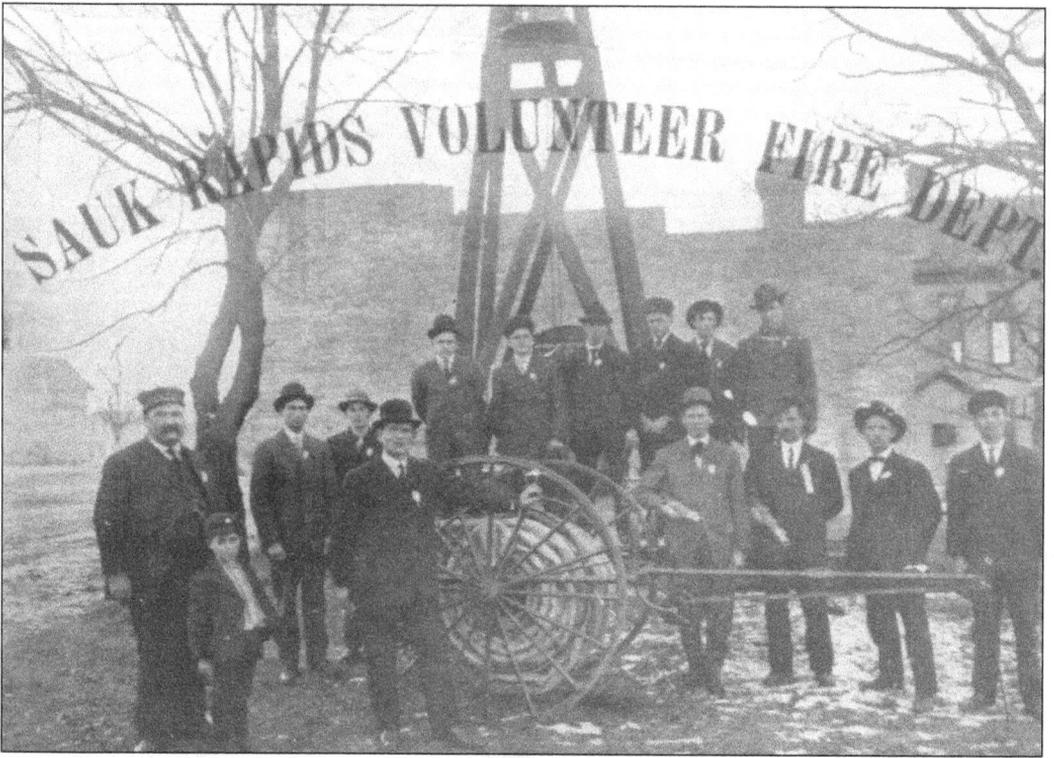

Here the Sauk Rapids Volunteer Fire Department, in the early years, is shown standing next to their fire fighting apparatus. When an emergency arose, the bell at the top of the tower was rung calling the volunteers from their homes and places of work to the station. The men took their equipment and were immediately dispatched to the location where a bucket brigade was formed to fight the fire.

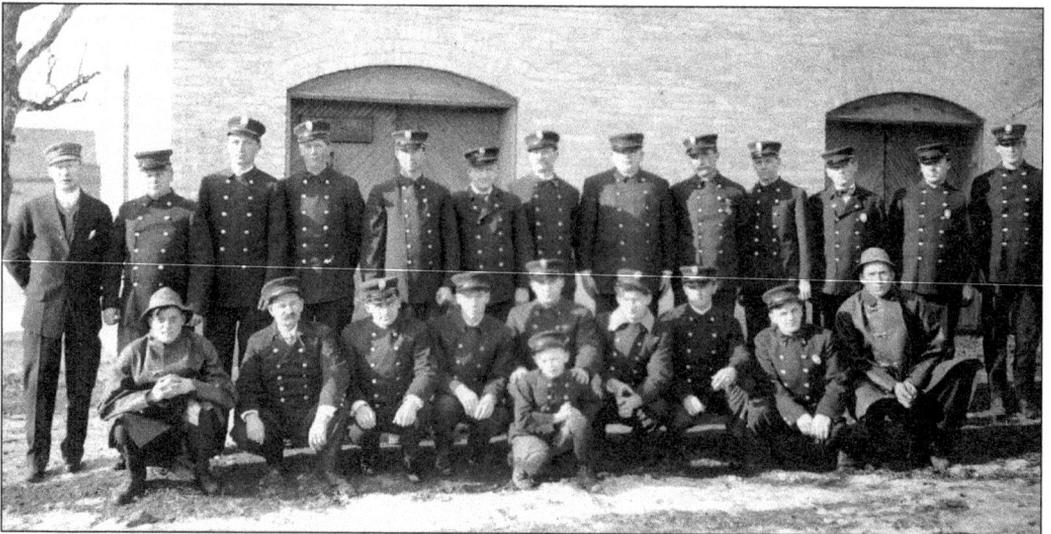

The Sauk Rapids Fire Department, wearing their uniforms and work gear between calls, pose for this photograph, c. 1910, in front of the fire station. To help keep dry when they fought a fire, they wore slickers, boots, and hats as shown by firefighters at either end of the front row.

110

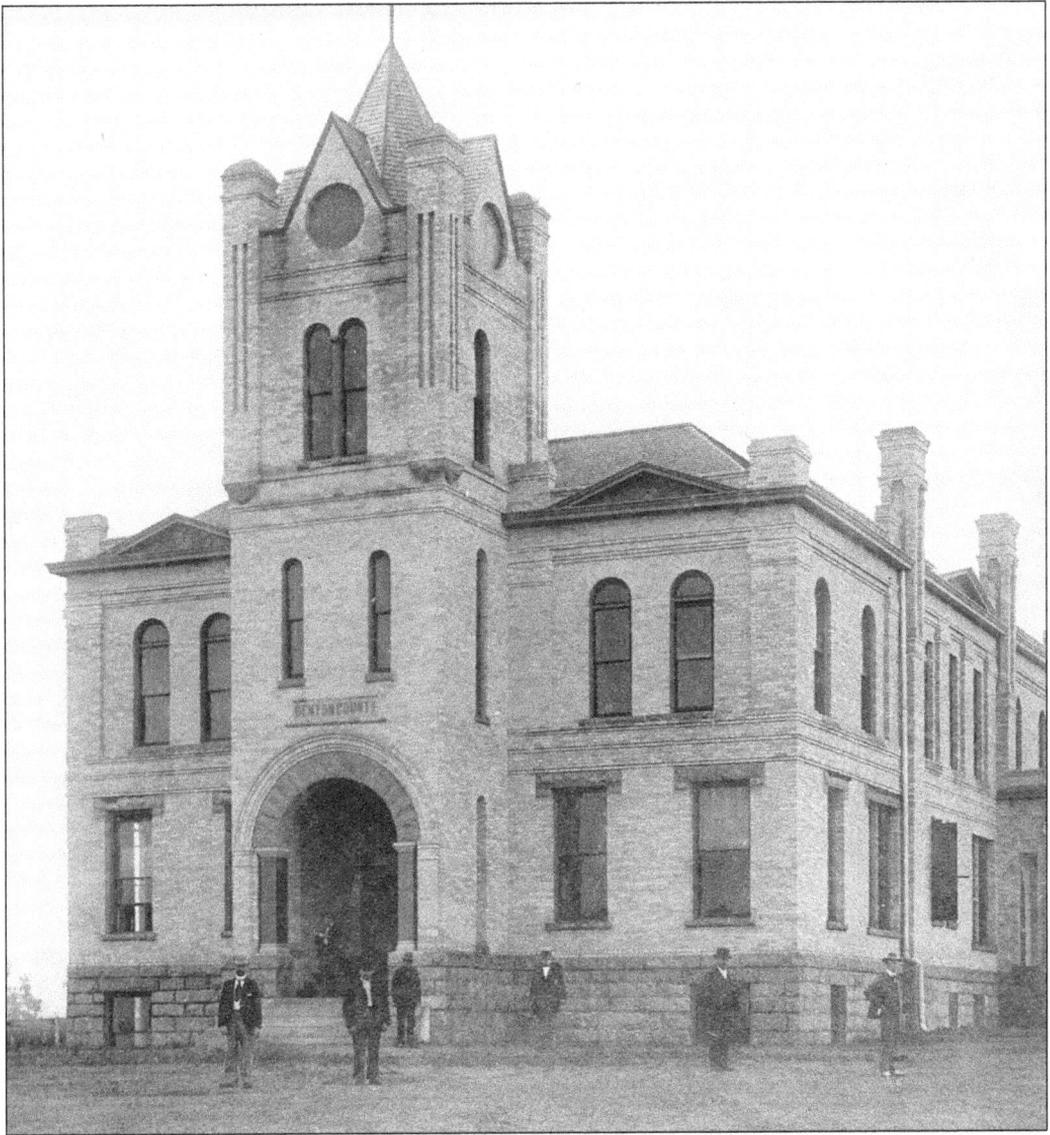

The Board of County Commissioners in June 1901 authorized Architect A.S. Haas of St. Cloud to prepare plans for a new courthouse. One month later, Sauk Rapids notified County Commissioners of their intention to contest the re-location of the county seat to Foley. Despite allegations of monies used to bribe voters, the building went on as scheduled. The Commissioners appointed Chas. A. Latterell as superintendent of construction for the building that had cost $20,000 by the time it was finished the following year. The building was constructed of solid brick with granite trimmings and had a full basement. The building was on-schedule for the December term, but not on budget. Judge Searle was said to be pleased with the furnishings and warm reception he received from the community.

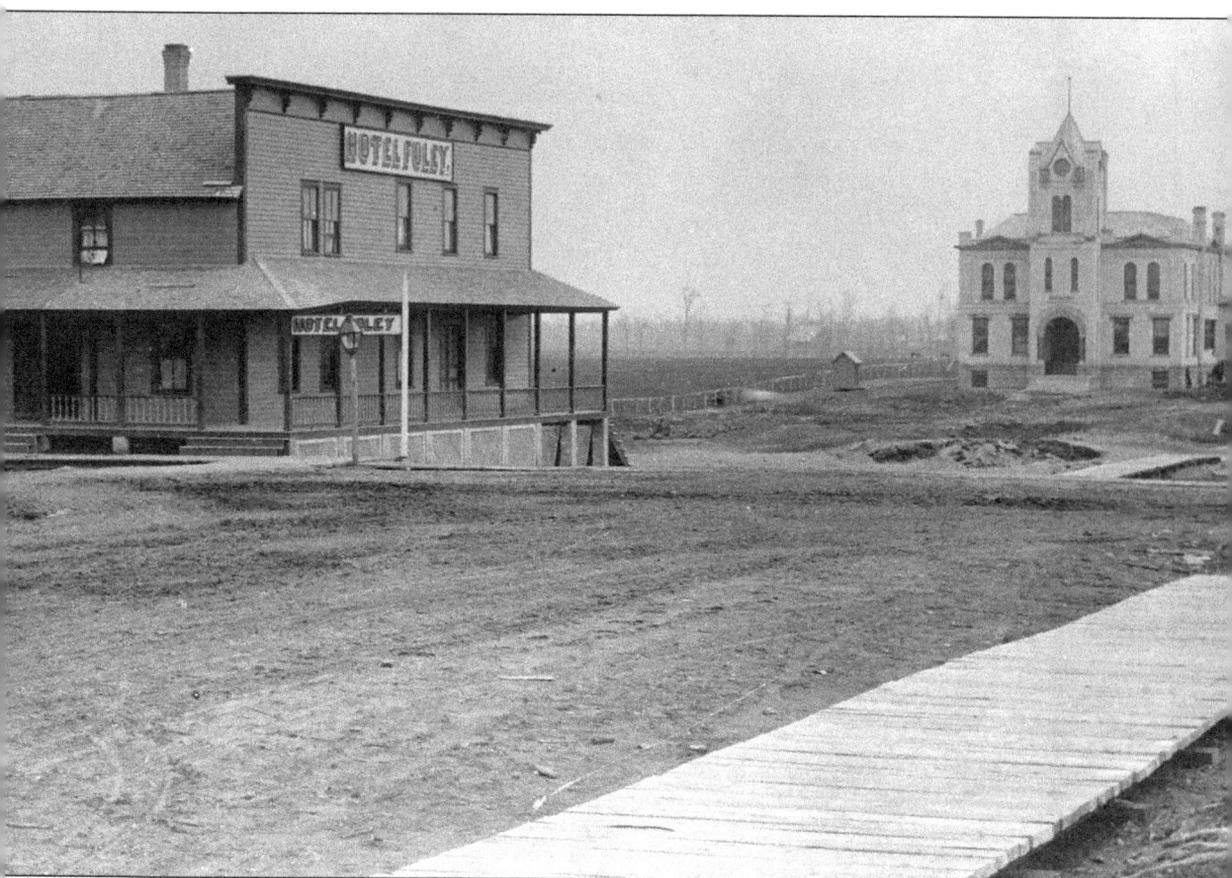

Pictured here are the Hotel Foley (foreground) and the Benton County Courthouse (background). Notice the construction of the new wood sidewalks that were laid as far as the creek by the Foley Brothers. The sidewalks improved the layout of the village and provided a place to walk from building to building. The Village Council mandated the sidewalks, and in 1903 $1,000 was appropriated from the government for the purpose of constructing and repairing roads in certain parts of the county. Cement sidewalks began to appear in 1906.

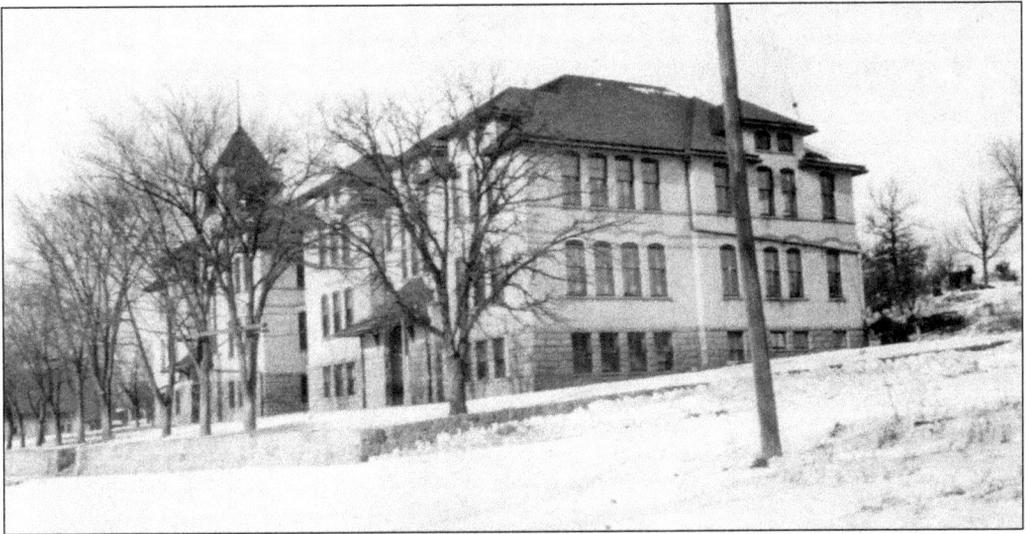

Shown here is Russell School, where children in the elementary grades attended in Sauk Rapids. The school is named after Jeremiah Russell, "the father of Sauk Rapids," who in 1854 started the first newspaper north of St. Paul. The paper was named the *Sauk Rapids Frontiersman* and George W. Benedict was the associate editor.

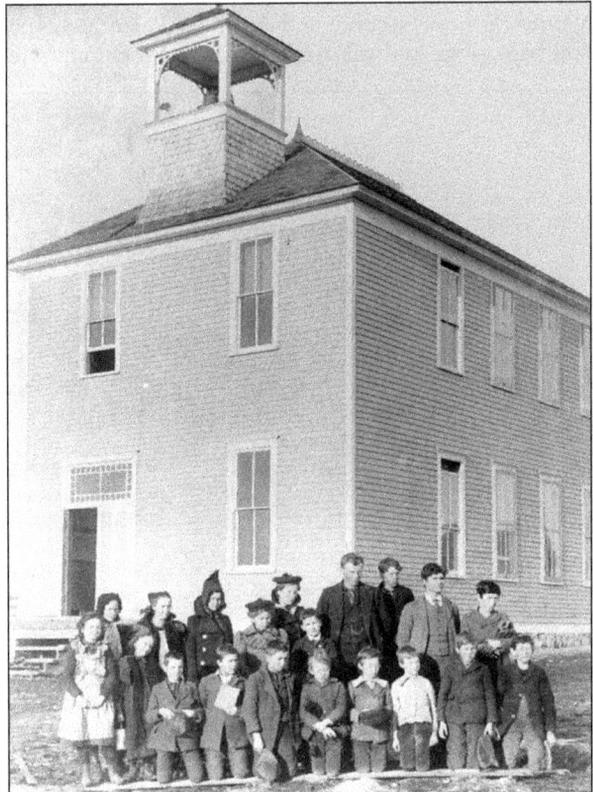

The first schoolhouse in Foley, built in the 1890s, was located across the creek near North Fifth Avenue where the school bus garage stands. Around 1904, it was moved uptown to Fourth Avenue, south of the Legion Club, and was torn down in 1959.

Horseracing was a popular spectator sport. On October 26, 1907, there was a free-for-all trot or pace race with three entries. J.D. McKenzie's horse won first prize; Wilkes stallion, owned by Varner Bros. was second; and Archilles Parent, who proudly shows off his harness racing rig and colt here, came in third. Archilles owned the flour & feed and cream station in downtown Foley.

William Rice, son of the man whom the town was named after, and his partner James Demerritt operated a ferry crossing the Mississippi River. H.B. Smart of Brockway Township purchased the ferry crossing the river west of Rice. This photo was taken around 1915, when it cost about 5¢ to cross by foot and 35¢ to cross with a vehicle. The ferry was a wooden catamaran that could carry two or three vehicles and a few passengers. The connecting cables prevented the catamaran from drifting downstream. Logs can be seen floating down the river.

By the late 1850s, numerous settlements started to develop along the Sauk River. The river provided the means to log the hardwood forests by transporting the wood from western and central Stearns County to the St. Cloud area. Today, the Sauk River provides an enjoyable canoe experience for all levels of canoeists, with a challenging stretch of whitewater for the last nine miles leading into the Sauk River rapids of the Mississippi.

Shown here is an old school house on Highway 25 next to George Quade's farm, three miles north of Foley on the west side of the road. Early settlers seemed to have large families of six or more children. As families grew, new schools were built to accommodate them.

Many political and civic activities took place in the early days here at Glendorado Community Hall. Edward Allen was one of the early organizers of Glendorado. He built a water powered sawmill on the St. Francis River in 1876, and helped to build most of the frame houses as well as all the wooden bridges across the St. Francis that were then in use.

This brick home was built for the John B. Homan family in 1886, after the devastating cyclone of April Fourteenth. John was a shoemaker by trade and came to Minnesota in May 1860 from Prussia, after working a short while in Indiana. The house was still occupied one hundred years later and was located on County Road 29 near Sauk Rapids until it was demolished.

The Cota Round Barns are located north of County Road 48, one mile west of Duelm in south central Benton County. Al Cota, a veterinarian and builder of concrete silos, constructed these barns. The barn pictured here was built in 1921, and a second barn was constructed in 1923. The interior of the barns originally consisted of several stalls. Several interior features remain intact. The barns were designed for use on the Cota stock farm and for advertising the advantages of concrete as a construction material. The Cota Round Barns are listed on the National Register of Historic Places.

This Ronneby charcoal kiln is believed to have been constructed in 1860. It has been called everything from a giant beehive, to a brick wigwam, to a bomb shelter. It stands about 30 feet tall and 15 feet wide. Lumbering hardwood trees during that time was at its prime, and wood scraps were probably used to make charcoal. The kiln was stacked with hardwood, leaving a shaft for the fire. Enough heat was generated to remove the moisture and chemicals from the wood while letting the gases escape. Once the gas escaped, the vent holes were closed before the wood turned to ashes.

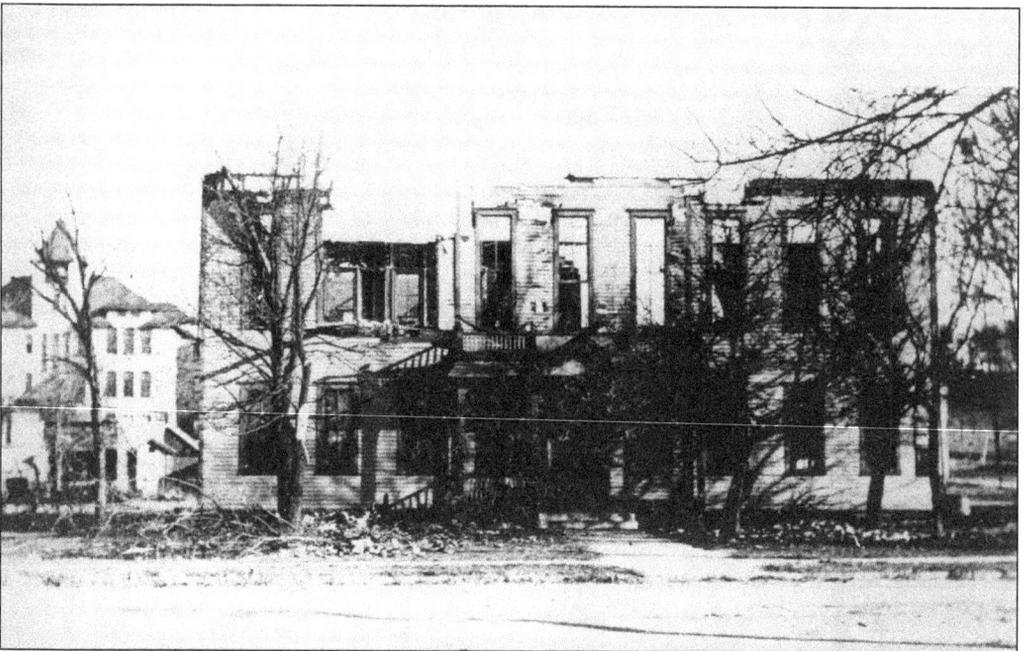

Seen here are the remains of the old Sauk Rapids Courthouse after a 1915 fire. The Courthouse was built in 1866 of wood cross-wing construction with a hallway between the wings, a stone foundation, and fireproof vaults. County records had already been moved to Foley in 1903. The Russell elementary school is in the background.

John "Spuds" Lindblom was the only Sauk Rapids police officer for 20 years, when he protected and served the community from 1925 until he retired in 1958. John originally came to Sauk Rapids to work as a potato buyer in a local warehouse, hence his nickname. During the first 20 years on the job he was the entire police force, drawing as little as $85 per month. Being the only man on the force, he was still successful in raising a family of six children and purchased a home on Second Avenue.

During Prohibition, in the early 1920s, many area farmers starting making moonshine. Although illegal, it was a great cash crop. The recipe consisted of whole rye, corn, apricots, raisins, prunes, sugar, and yeast. Raids on hidden operations were frequent, stills were moved constantly to avoid detection and farmers had unique hiding places for storing and aging their whiskey. Federal agents are shown with equipment taken after a recent seizure.

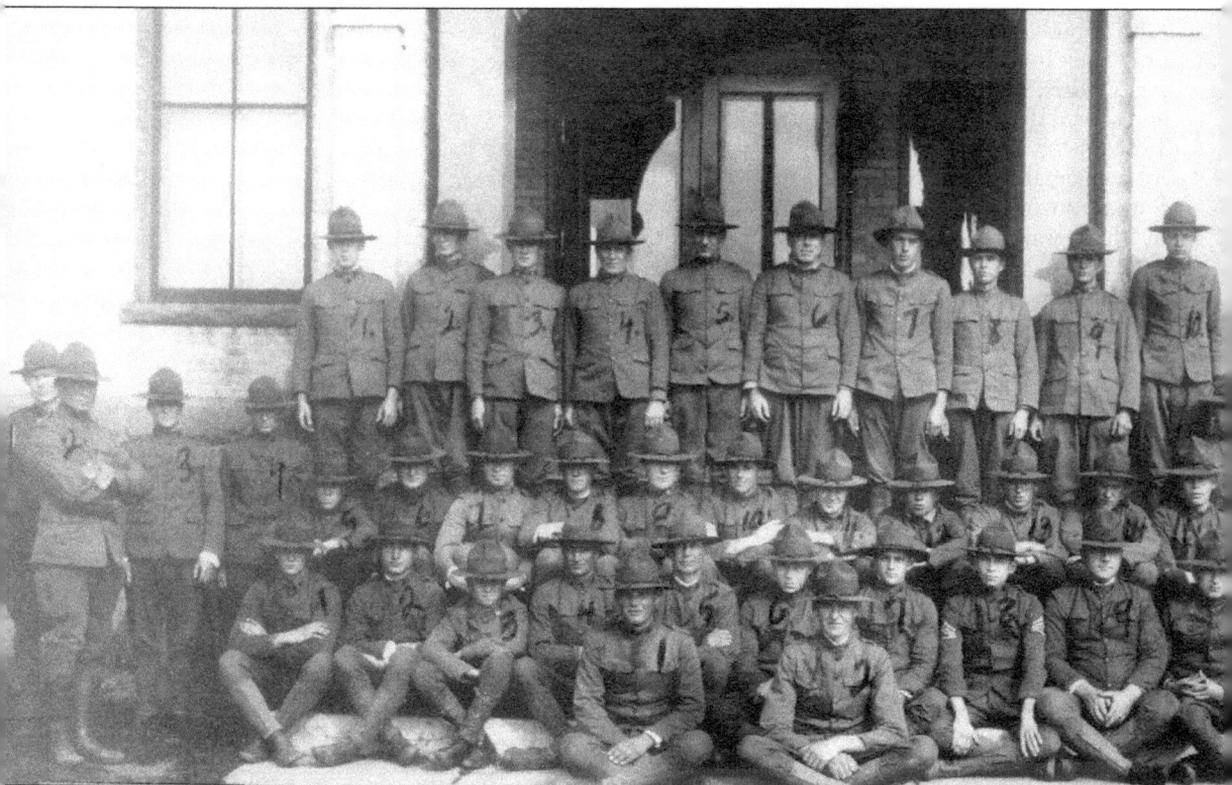

The Home Guard had a local unit in Foley during World War I that was started on November 22, 1917. The purpose of the Home Guard was very much identical to the modern National Guard units today. W.C. Murphy was the Captain; Jerry Healy, Lieutenant; Jerry Healy, Lieutenant; Max Cheeley, Duty Sergeant; Eugene Axtelle, Floyd Walters, J.E. Kasner, W.B. Callahan and Leslie Murfit were Corporals. Shortly after being organized the Foley Home Guard was called to Aitkin where they fought a peat ground fire that burned for a long time. Members of the Home Guard are pictured, from left to right, as follows: (front row) Joe Brenny, unidentified; (second row) unidentified, Joe Kornovich, Harry Elletson, unidentified, Joe Dziuk, George Lloyd, John Howe, William Stibal, W. Barney Callahan, and Rupert Stimler; (third row) Frank Wisniewski, W.C. Murphy, Leo Barthelemy, Dedic, Charles Callahan, Thomas Tischbirek, Earl Walter, Steve Hunt, Theo Plombon, Gene Murray, Leo Buttweiler, Jack Dziuk, William Baskfield, Ed Frende, Ed Murray, Oscar Freude, Ben H. Mushel, and Max Cheeley; (back row) Harold Baskfield, Paul Latterell, unidentified, Frank Campbell, A.C. Kasner, William Lord, Jack Wruck, Leo A. Latterell, unidentified, unidentified, and Anthony Kroska.

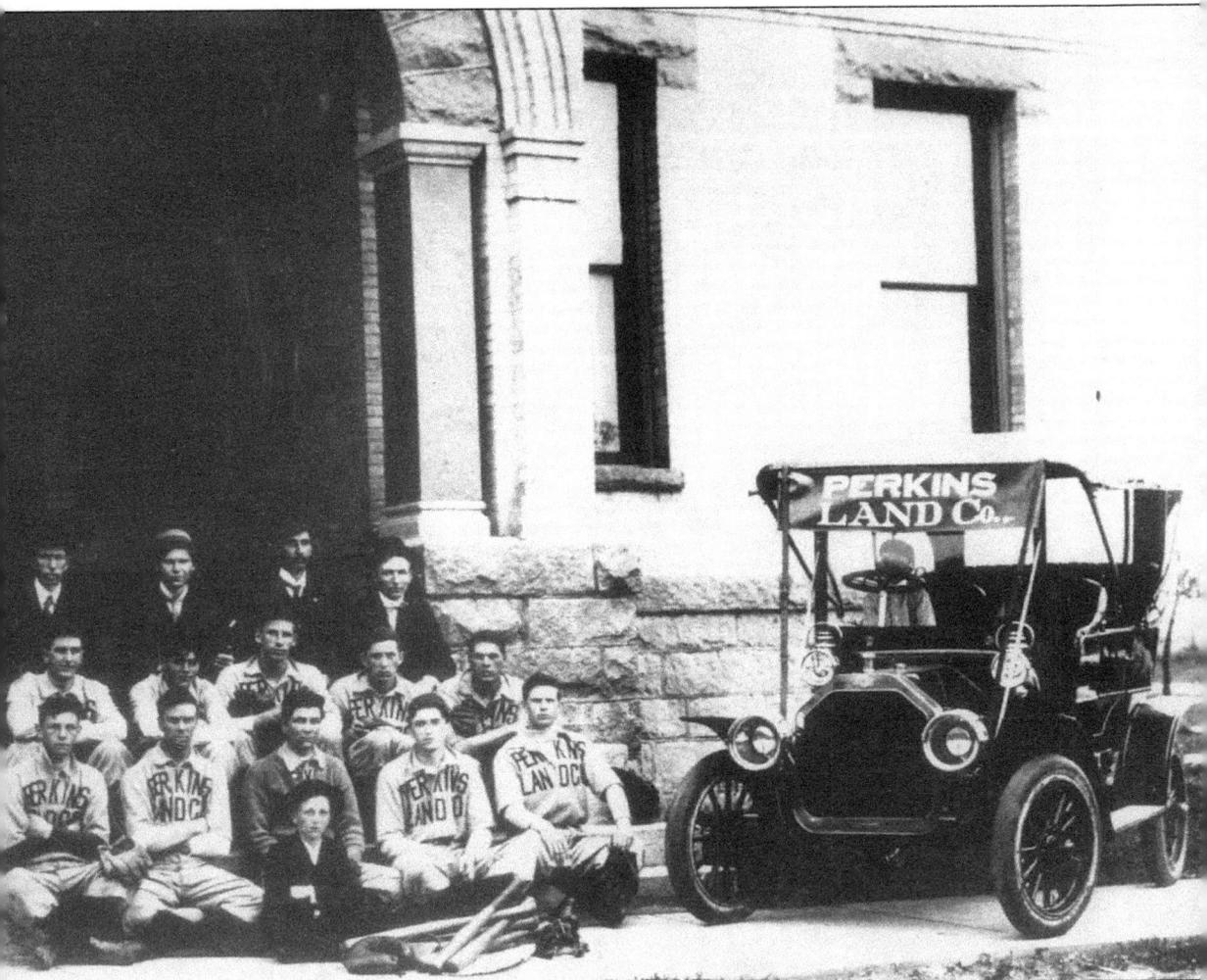

Perkins Land Company sponsored the Foley baseball team in 1908, and had one of the first Buick cars for transportation. It had a brass radiator, and the high windshield had supporting rods connected to the front of the car. Perkins operated a land business in Foley and sponsored the team for advertising purposes. In the early 1900s, baseball held the interest of many and was the principal summer sport. Seated in the front was Felix Mushel, the batboy. Pictured behind him, from left to right, the rest of the team is as follows: (front row) John Kasner, 3B; Proctor, SS; Roy Latterell, P; Ben Mushel, C; and Henry Finney, RF; (middle row) Rol. Smith, 1B; Glen Strand, LF; Lockwood, 1B; Joe Mushel, 2B; and Rick Smith, CF. The four men in suits in the back row associated with the team were, from left to right, C.E. Gilbert, Frank Wisniewski (Manager), Perkins, and Frank Grausnick. The photo was taken in front of the Benton County Courthouse.

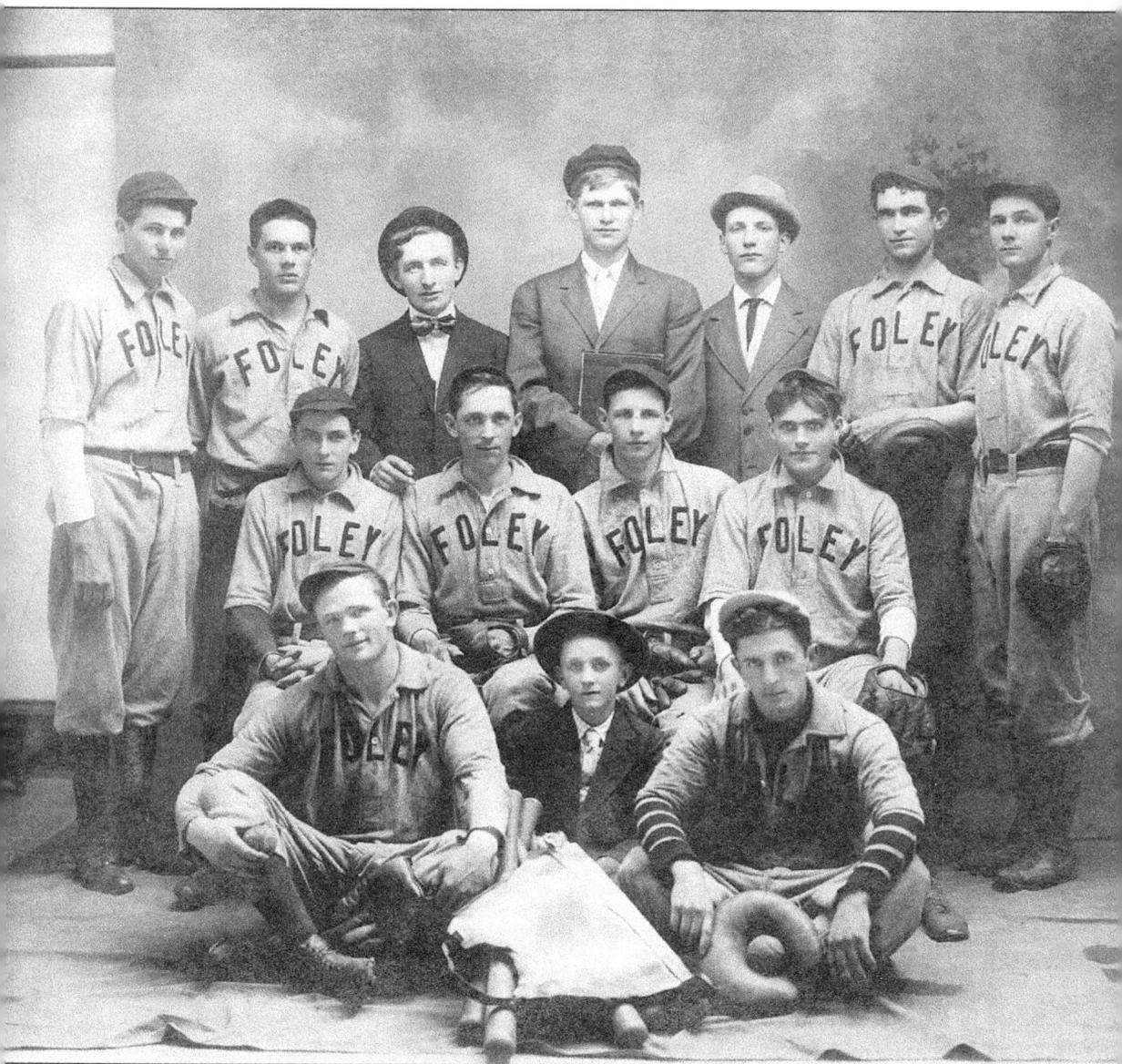

Pictured here is the Foley Baseball Team, 1909. Team members, from left to right, are posing as follows: (front row) George Davis, Felix Mushel (bat boy), and Curley Skaien; (middle row) Alex Mushel, Joe Mushel, John Kasner, and Glenn Strand; (back row) Joe Garneault, Rick Smith, Frank Grausnick, Frank Wisniewski (Manager), Paul Gamroth, Harry Lockwood, and Roy Latterell.

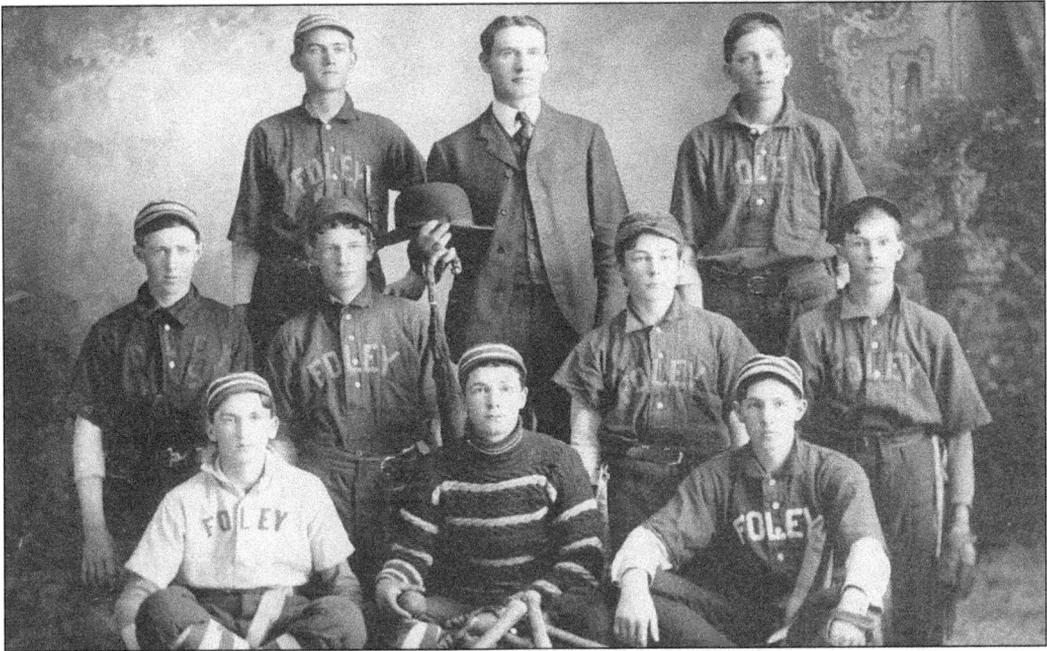

A source of players for the village team was Foley High School. Pictured here, from left to right, the Foley High starting nine are as follows: (front row) Ben Mushel, Roy Latterell, and Joe McNulty; (middle row) Mark Grady, John Kasner, and Stanley Bickford; (back row) George Towne, George Cunningham, and Joe Mushel.

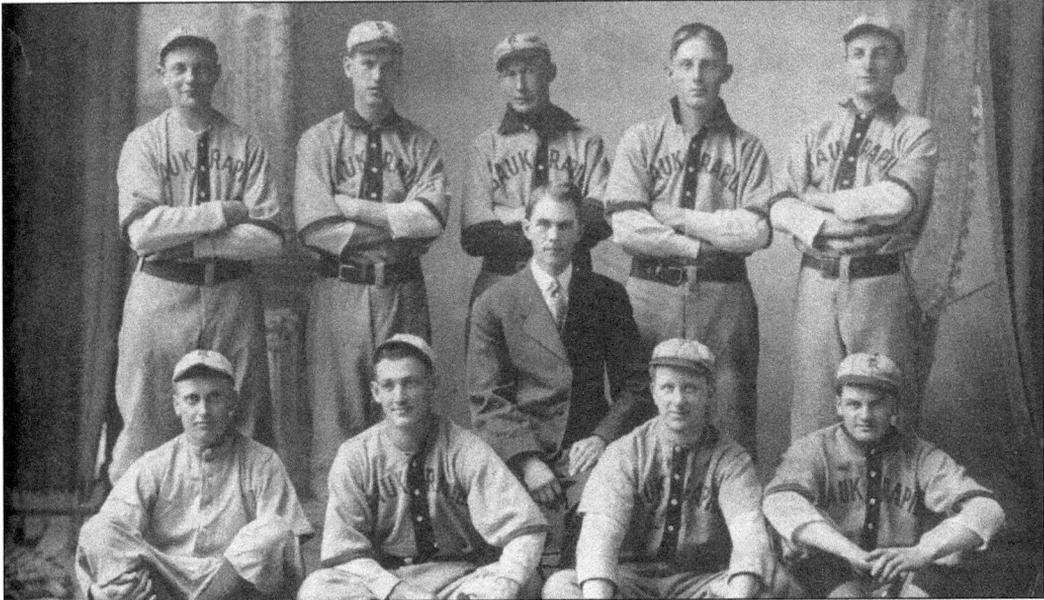

Promoters tried to organize a Sunday baseball league during the summer of 1911. Besides Sauk Rapids, other teams included in the league were from Alexandria, Foley, Little Falls, Melrose, Royalton, and St. Cloud. Members of the Sauk Rapids team pictured here are unidentified but past rosters included Carlisle, playing 2B; Kinkel, C; Anderson, 3B; Diedrich, SS; Fautsch, P; McNabb, 1B; Brogel, RF; Selke, CF; and Heinzel, LF.

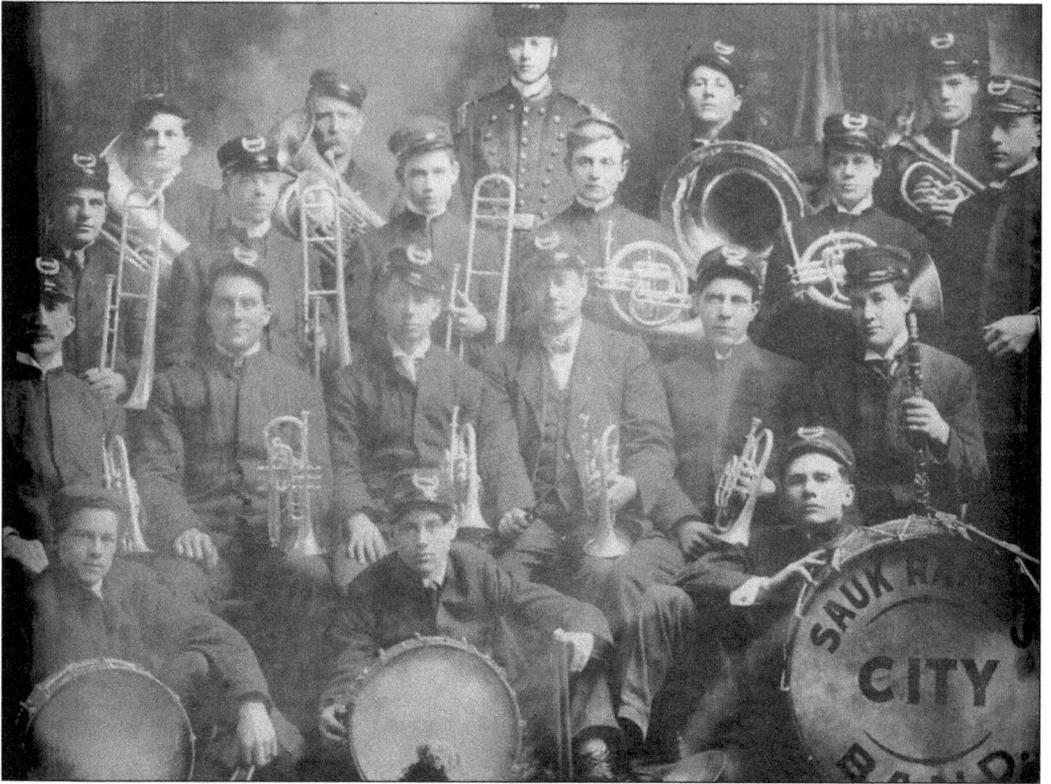

Pictured here is the Sauk Rapids City Band, 1913. Members of the band, from left to right, are as follows: (front row) Frank Heinzel, unidentified, and Robert Lyerly; (second row) Frank Homan, ? Roth, unidentified, Bill Scherbert (band leader), ? Przborowski, and Walter Miller; (third row): August Heinzel, unidentified, Cliff Sheldon, Jim Bergland, Leon Miller, unidentified; (back row) Herman Heinzel, Herman Kline, Percy Lindt, unidentified, and Clarence Miller.

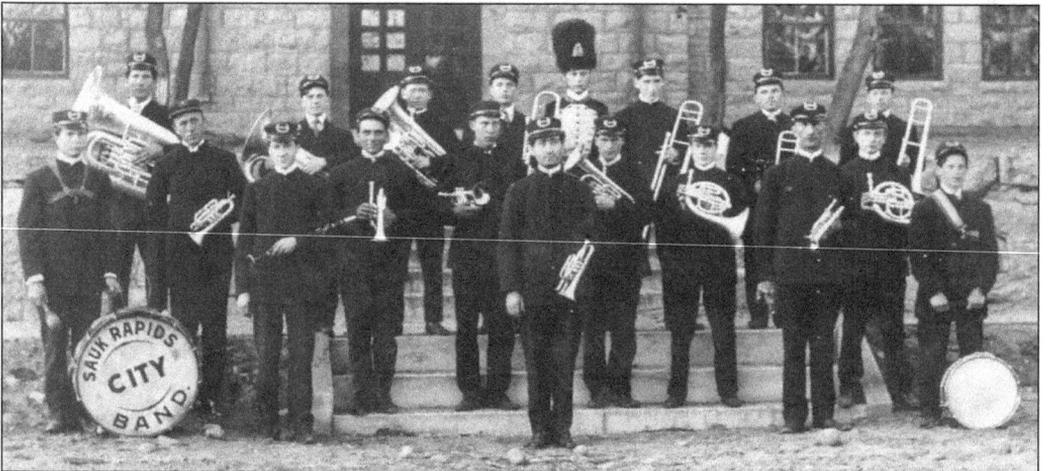

Here is the Sauk Rapids City Band in a later photo on the steps in front of a city building. Members are proudly showing off their new parade outfits and instruments. The Band marched through the streets and played at official city functions, appearing frequently at grand opening ceremonies of new downtown businesses.

124

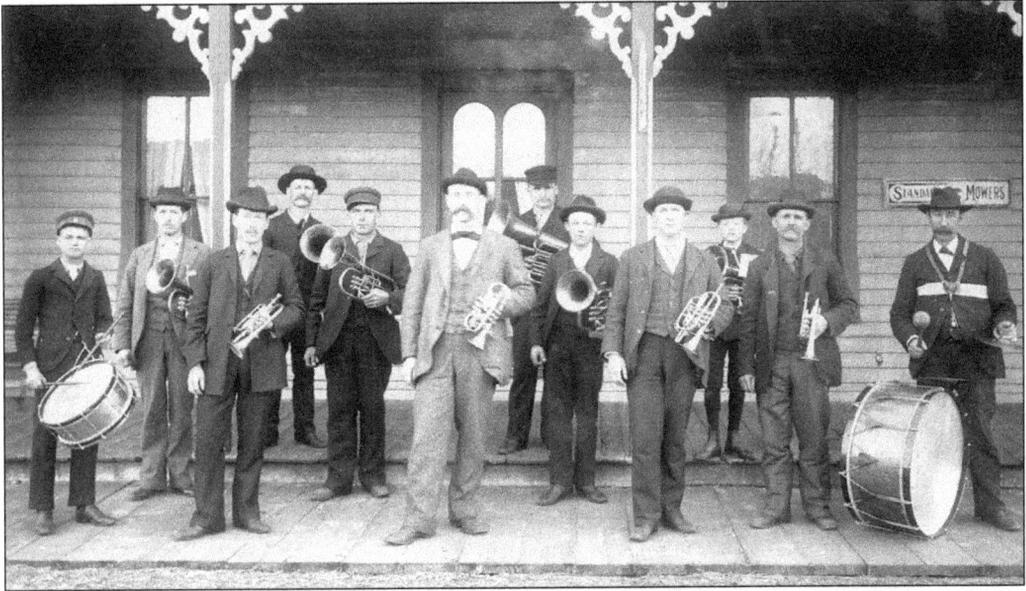

Rice was originally an open prairie located in northwestern Benton County populated by the early pioneers and the Ojibwe tribe. First known as Sand Prairie, the Village of Rice was established on July 18, 1890, as a farming community. Photographed here is the Rice Band taken about five years later in 1895.

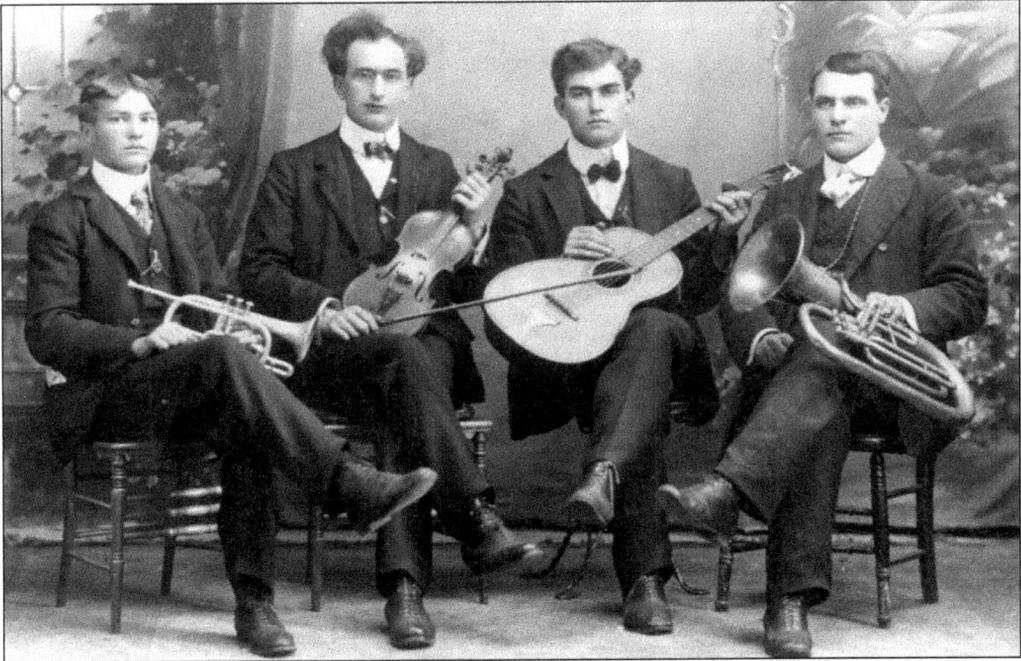

When farm work was in full swing, and men were in the fields from dawn to dusk, there was little energy left for play. But during winter season when farm work slowed down, and there were no movies, no radio, no television—no anything—dancing became the popular pastime. Members of the O.C. Greene's Orchestra from left to right are Hermann Fromelt, O.C. Greene, Golden Greene, and William Christl.

Sts. Peter and Paul Church in Gilman was rebuilt in 1930, after a fire destroyed the previous log church built in 1872. The present brick church has remained basically the same since 1930. The only major change was done to the interior, where the altar was moved forward in 1969. This change was made in accordance with the edicts of Vatican II. The change was made in a manner that allowed the retention of the traditional look preferred by the parishioners.

The first St. John's chapel burned down in 1894. This second St. John's Catholic Church in Foley was built in 1909 on land donated by John Foley. Mr. Foley also bequeathed in his will a large amount of money for the building. The church was dedicated in 1910, and John A. Kitowski became the first resident pastor.

On Christmas Eve 1884, members of all denominations from the whole community of Rice gathered for a Christmas party. In addition to celebrating the occasion, the members made their contributions to pay for the newly built church. Immaculate Conception Catholic Church in Rice was founded in 1885.

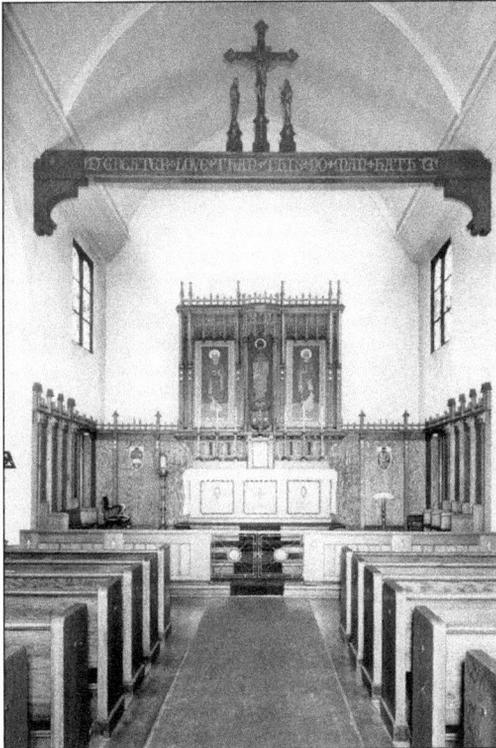

The first baptism was performed that same year; the first burial in 1888; the first communion and first marriage in 1891; and the first confirmation in 1898. The first Catholic parochial school was opened here in November 1898. There were 40 children and two classrooms. The present church with its slender, graceful spire was completed in the fall of 1921.

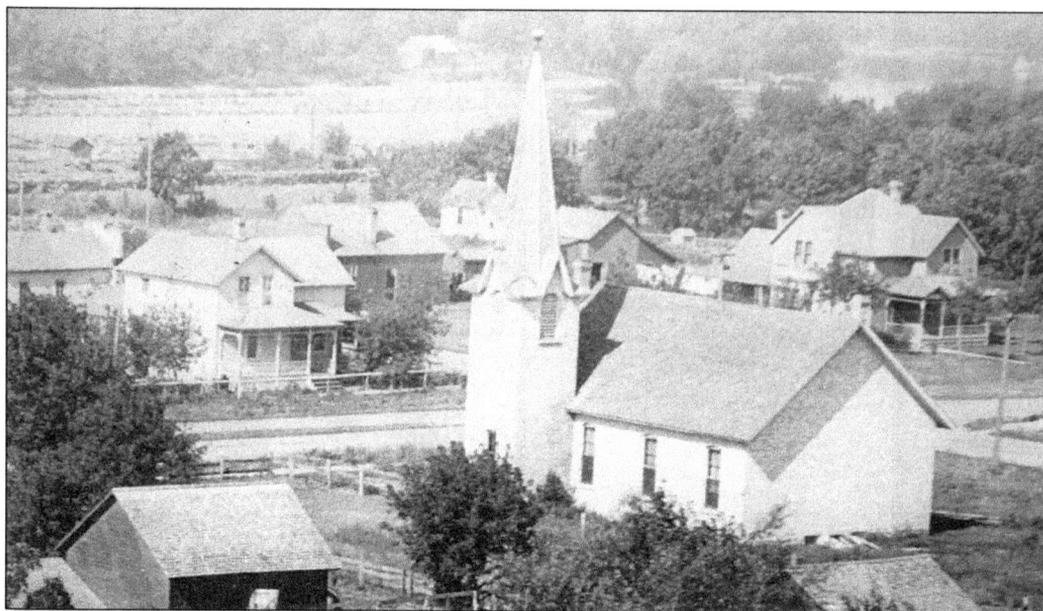

The original United Church of Christ in Sauk Rapids was founded in 1910. The church kept a library of records dating back to 1911. In 1940, a new congregation was established when the church that served the Sauk Rapids area was closed. Early services in this church were conducted in German.

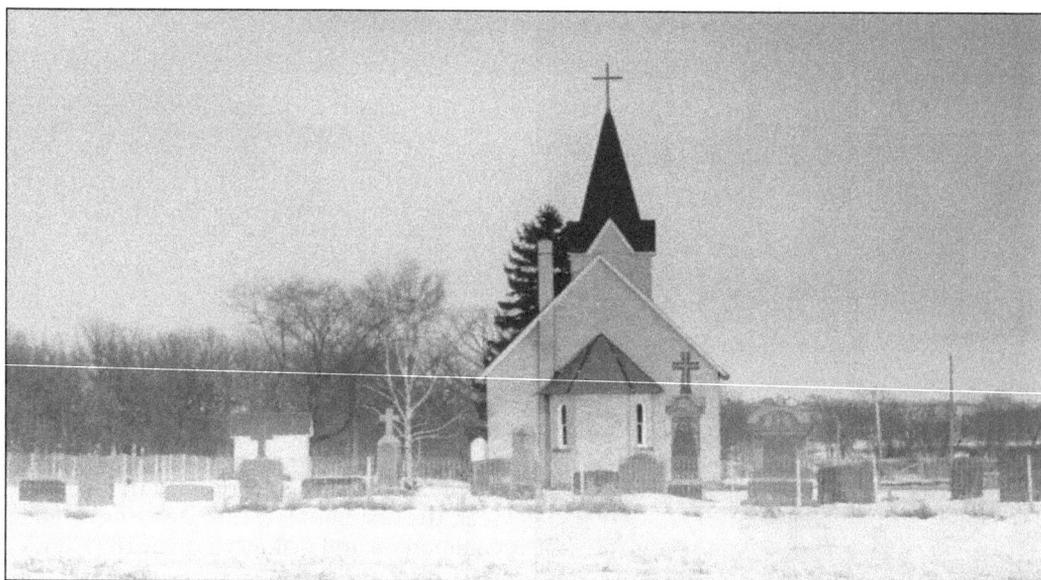

Church cemeteries vary widely in size and sometimes may be located in more than one place, as they outgrow the original plot of land. Cemeteries were often placed behind the churches and tend to include mostly people of that particular religion. Some also have a pronounced ethnic flavor. Cemetery records are a favorite resource of genealogists. They often contain clues to long sought for dates, family relationships, military service, and much more.

www.ingramcontent.com/pod-product-compliance
Lightning Source LLC
Chambersburg PA
CBHW050551110426
42813CB00008B/2322

* 9 7 8 1 5 3 1 6 1 3 2 9 7 *